A Woman's Guide to New Careers in Real Estate

Also by the Author

*Everything Tenants Need to Know
to Get Their Money's Worth*

A Woman's Guide to New Careers in Real Estate

Ruth Rejnis

Henry Regnery Company · Chicago

Library of Congress Cataloging in Publication Data

Rejnis, Ruth.
 A woman's guide to new careers in real estate.

 Includes index.
 1. Women in real estate—United States. 2. Real
estate business—Vocational guidance—United States.
I. Title.
HD1375.R45 1977 331. 61'33333 76-6284
ISBN 0-8092-8159-7

Published by Henry Regnery Company
180 North Michigan Avenue, Chicago, Illinois 60601
Manufactured in the United States of America
Library of Congress Catalog Card Number: 76-6284
International Standard Book Number: 0-8092-8159-7

Published simultaneously in Canada by
Beaverbooks
953 Dillingham Road
Pickering, Ontario, L1W 1Z7
Canada

For
John A. Rejnis

Contents

Introduction

TEN YEARS AGO THIS BOOK COULD NOT HAVE BEEN WRITTEN!
So goes the promotion for some of the more adventurous reading matter these days. Well, ten years ago *this* book would not have seen the light of day, either. Perhaps a brief pamphlet about women in residential sales might have been published, but almost all of the other careers in these pages were then exclusively male preserves. There would have been no story to tell.

As recently as five years ago, for example, no women were engaged in lucrative commercial brokerage in either of our two largest cities. Today there are too many to count in New York City, and Los Angeles is coming up fast. And who would allow women in the building trades, as carpenters, crane operators, workers on a road crew? A few intrepid women practiced appraising or were property managers, engineers, urban planners, architects, and auctioneers. But they had held their jobs for many years and were so exceptional that there may have been no other woman in a similar capacity in the same city—or state.

The women's movement has changed that stagnant picture. Because government directives bar discrimination on the basis of sex, many firms, if not motivated by the justice of the issue, are hiring women "to get the government off our backs." In the many instances where sexism is still very much present, stalwart women, determined to secure the jobs they want and have earned, are testing the discrimination laws in court. They are winning. In many areas of real estate, task forces of women have sprung up to ensure that female workers, once hired, progress fairly up the job ladder and are not shunted aside once the hiring quotas are filled.

There is even a new consciousness among women in residential sales, an arena that has traditionally been open to them but one where the term "woman broker" still can carry sexist overtones. Incidentally, residential sales is considered in a book of *new* careers for women because its look is so new that the woman expecting to while away a few hours a week may be in for a surprise. The residential arena, in a continuing striving for professionalism, is tightening its requirements for practice. More demands are being made on agents by the brokers who allow them office space. There is less and less room for the dabbler.

Only a trickle of women are entering some of these newly opened fields, but their numbers will increase as women in real estate generally become more visible. Those now engaged in their specialized occupations are active proselytizers. All of the dozens of women interviewed for this book were enormously helpful in revealing how they got started, how much they make, how they succeeded and how they fare in the discrimination picture. They are aware that, for a while anyway, they are trailblazers. "Did you talk to any other women who are doing what I'm doing?" was a frequent question.

Educational opportunities are also opening up. In 1964 only 150 colleges and universities offered courses in real estate. Today there are more than 535, and many of them offer degree programs in the subject.

Real estate seems to attract a certain type of woman. She is a self-starter, and something of a free spirit who will not be

confined to a structured nine-to-five role. She is the sort of woman who is ambitious but has not, until hitting on real estate, found just the right outlet for her energy and drive. She is independent and enjoys knowing that her income depends solely on her own ability and not on the fact that she merely shows up at the office each day. Dealing with people is an important part of the job, so she is charming, too.

It is a rare little girl who tells her mother's friends, "I'm going to sell real estate when I grow up." Yet thousands of women are now working in the field, most of them having arrived by a circuitous route. For many, an interest in construction, or planning, or selling homes had long been in their minds, but had not crystallized. The tempo of the times has led them to take action. One woman in these pages tried to become a commercial broker for nearly ten years while traveling around the country with her Navy husband. She was a residential sales agent, but no broker would hire her for commercial leasing because of her sex. Finally she had had enough. She stopped selling houses, organized a battle plan, and got the job she wanted.

Another woman recalls that as a little girl her "greatest treat" was having her uncle take her to see steam shovels at work. As a secretary in an engineering firm, she enjoyed working around engineers. One of them was a woman. She began to think. . . . Today that woman is a construction engineer.

"A woman's greatest challenge," commented one successful real estate woman, "is to open her own closed eyes and look around. She can be whatever she wants to be."

For the women who have entered the field over the years, real estate is attractive for several reasons. For one, there are no age restrictions. Read in these pages about a seventeen-year-old auctioneer in Illinois and an 80-year-old residential sales agent in Connecticut.

Although college and post-graduate training are needed for a few of the occupations—engineering, planning, architecture—most do not require any education beyond a high-school diploma. And yes, a few women have made it without that!

Previous work experience in the field rarely matters, either.

Real estate women have been stewardesses, secretaries, artists, housewives, publicists, actresses—in fact, they have held just about every other job under the sun.

Here then are a dozen or so career choices. They are for the high school or college student to prepare for, for the working woman and the older woman re-entering the job force to tackle now. The bottom line is this: all that is needed for success are brains, ambition, and more than a dollop of moxie. The barriers are down. The doors are open. Step inside.

A Woman's Guide to New Careers in Real Estate

1

The Ever-Growing Residential Sales Arena

IS EVERY OTHER WOMAN SELLING HOUSES THESE DAYS, OR DOES it just seem that way?

Senate wives, says *Womens Wear Daily,* are seeking jobs to boost family income or relieve Potomac ennui. Antoinette Hatfield and Lou Tower are selling real estate. The blonde daughter from "The Beverly Hillbillies," *TV Guide* relates in a full-length profile, has quit show business and is now selling homes to the stars. Television's "Maude" has earned *her* real estate license, stating with steely-eyed determination, "As we in the trade say, *any* house is for sale."

And that is not to mention the realty women in one's own local and social circle. New real estate offices appear to be springing up on alternate street corners—and there is no need for owners to worry about staff, either. Women are at the door, license in hand, and never mind about the recent slowdown in home sales in some areas of the country.

Residential sales is a field that has always been receptive to women, ever since the first real estate licenses were issued early

in this century (California adopted the first license law in 1917). Its universality of appeal has attracted widely disparate types, from distressed gentlewomen whose clients were found by leafing through the Blue Book, to the adventurer willing to work hard at a career that paid only for enterprise—but then paid very well indeed. In between were the thousands of middle-income working women who still make up the bulk of the selling force.

Somewhere along the line from the male-dominated early days, owners of realty offices began to realize they needed saleswomen. Reverse sexism aside, it is agreed by the majority of both sexes that women are a shade better at selling a house than men. They can point out the special features that would frequently elude their male counterparts. They can understand the emotion and trauma that go into moving. And, despite the male househunter's banging on pipes and inquiring about dry rot in the basement, it is his wife who really chooses which house they will buy. So it becomes a matter of women selling to women.

"No man today can say 'I'm going to open up an office and hire only men,' " said one male realty board officer. "He can't, because he wouldn't make money."

Realistically speaking, of course, there is also the income factor. Many women enter residential sales as a part-time occupation; they have the security of a spouse's backup income. Men in the field are usually primary breadwinners and must work full-time. Unless they are first-rate hustlers, they cannot earn a living salary (that is, commissions).

Throughout the country, there are more than one million licensed real estate salespeople and brokers. More than eighty percent of them are engaged in residential sales, the remainder in appraising, property management, commercial brokerage, and other specialties. Close to half of the 500,000 members of the National Association of Realtors, the Chicago-based professional organization, are women.

It is not difficult to understand the appeal of residential sales to women, apart from its part-time income lure. It is, for one, a personal service, working with people to find them the

most important purchase of their life—a home. It is an occupation that does not require a college diploma; and age is not a factor in employment. (The median age of women brokers is fifty, of saleswomen, forty-five. In one Connecticut town there is an eighty-year-old woman who is the community's top producer. She entered the field in her sixties!) Women with little job training; those who cannot or will not be confined to a nine-to-five desk job; older women facing the "empty nest syndrome"—all start thinking, "Maybe I can sell real estate." The women's movement has also boosted membership rosters. "My real estate license says Maude Findlay, not Mrs. Walter Findlay," booms TV's Maude.

If it is not hard to become a saleswoman, it *is* difficult to become a good one. The field is saturated, and all around one are those who fall by the wayside. In some communities the turnover in personnel is as high as seventy percent a year. The woman who earns a good income will find she is always working, and no "part-time" about it. Houses must be shown in the evening and on weekends. And then they must be shown again. Open houses of new listings must be visited with one's fellow salespeople.

"I tell my staff," said one woman agency owner, "if your husband expects you home every night at six to start dinner, it's not going to work out."

A nationwide study conducted in 1975 of salespeople and brokers by the National Association of Realtors ("Profile of the Realtor and the Realtor-Associate"—information on how to obtain a copy is listed at the end of this chapter) revealed that the average work week was fifty hours for brokers and forty-seven hours for salespeople. Over thirty percent of brokers and twenty-five percent of salespeople spend sixty or more hours per week at their profession.

The independence of the field, while a challenge to those self-starters who will ultimately succeed, can take women without direction or discipline and leave them at the starting gate wondering what happened because *nothing* happened.

"About forty percent of the people who enter the field leave it in the first year and twenty percent more have usually left

by the end of two years," reported John Lumbleau, head of a real estate school system in California, about realty people in his state. "At the end of five years there's a professional core left of about twenty-five to thirty percent."

Mr. Lumbleau explained that about nine percent of new sales personnel have never been "on their own" in business. "Even when working with brokers they're still responsible for securing their own clients and listings, and many of them can't quite handle their own destiny. There's a tremendous number of people in business who need someone to tell them what to do."

In all, the field is no place for the dabbler. In fact, some offices will not offer a desk to any salesperson who does not earn $7,000 to $10,000 a year. It is a serious trade and, waking up to the fact that numbers of people are wandering around calling themselves real estate salesmen, its members are working to see it become even more professional and more off-limits to the dilettante. Indeed, these people do not last long anyway, but there is no room for the woman who lists a house at $10,000 over its value or sells a lot for development that does not meet zoning standards and *cannot* be built on, or sells a plot of land where the buyer expects to place a mobile home only to find that mobile homes are not allowed in that locale. All of these errors have happened, plus the most common of all: telling a buyer his real estate taxes will remain the same, only to find out months later they are five times higher. There is no room for unethical salespeople with no knowledge of the business, and every attempt is being made by local realty boards to weed them out.

What Makes a Saleswoman?

A New York broker, seated in a client's living room, was busily negotiating a sales price for a cooperative apartment. During all this, the child of the house was nailing the woman's shoe to the floor. "I pretended not to notice," the unflappable broker explained. "After all, there was a very substantial commission involved."

Now there's a saleswoman!

Besides true grit, the successful saleswoman must be able to work on her own, of course. But she must also enjoy working with people. Her home schedule must be flexible enough to handle the showing of homes at odd hours. She should be community-oriented, not just because joining organizations and attending luncheons could lead to listings, but also because she is generally interested in the area where she lives and knows it well. She knows who is about to move, what companies might be relocating, who is getting married and might need housing. When she reads the newspaper she misses nothing. In a way, she is always "at work."

At the job, successful women have learned, or invented, tricks of the trade. They know varying ways to close a sale. Rather than ask a question requiring a "yes" or "no" answer, which could lead to a very definite "no," the pro gives the client a choice. "Would you prefer to see the house at 6:00 or 8:00 this evening?" One woman carries dog biscuits in her handbag to charm the family pooch. Answer a question with the same question fed back, suggests another top salesperson. Client: "This bedroom is too small." Agent: "This bedroom is too small?" How do clients reply to that? Well, often they forget it. Another woman, on entering a house she is showing, goes in on the first floor and then goes up to the second floor instead of to the basement. "From the second floor it is easy to go down two flights to the basement. But if you go to the basement first, you've got to climb two flights. If you're all stomping up and breathing heavy, the client may think, 'How am I going to manage all these stairs?' "

Those are just a handful of fascinating psychological ploys realty people use to sell houses. Successful women build up their stock sometimes without even noticing.

On the tangible side, women in residential sales *must* have a standard-size car. Of lesser importance, but still necessary, is a professional-looking wardrobe. When thinking of the real estate women one has dealt with, which of them has not appeared beautifully dressed? Successful women do not wear jeans and a tank top or a dowdy skirt and blouse. Their clothes, if not expensive, are well-coordinated and their

grooming impeccable. No frumps—of any age—need apply. This applies to these days, of course. In many towns there is probably an "old gal" who sells up a storm in a housedress and ankle socks and can be found on a folding chair outside her office jawing with the locals.

Salespeople, Brokers, Agents, Realtors

Is each term different or can they be used interchangeably? Contrary to the way they are frequently seen, the words "salespeople," "brokers," and "Realtors" have different meanings. Only "agent" can be used to describe all of them.

Salesperson

The salesperson's license (see pages 18-27 for licensing requirements) allows the beginner to handle the preliminary phases of the selling transaction, but not to close the sale. The broker does that. After one or two years of selling, the novice, sponsored by a broker, can apply for a broker's license.

Broker

Licensed after passing another examination and fulfilling requirements, the broker usually runs his or her own office. A broker must be fully cognizant of, and responsible for, all the ramifications in each home sale. If she owns her own office, there is administrative work, too. Brokers can make appraisals, develop new building projects, rent and manage properties.

Realtor

A Realtor is a broker who has met additional requirements beyond the state licensing examination and who has been accepted into the membership of the local Board of Realtors. (A registered trademark, the word "Realtor" is always capitalized.) Not all brokers are Realtors and very few salespersons are. Founded in Chicago in 1908, the National Association of Realtors is the nation's largest trade and professional group, and is constantly striving to upgrade the trade by tightening licensing requirements, by establishing affiliate societies for new branches of specialization, and by promoting college-level courses in real estate, among other activities.

Because they felt they were being ignored and were power-less, realty women founded in 1935 a special branch of NAR—The Women's Council of Realtors. With more than 12,000 members today, WCR brings women brokers and affiliates (salespeople) together, not only for social introduction, but to afford them opportunities for public speaking, committee work, practice of leadership, and other basically confidence-gaining programs and activities. Many, many women see no need for what they consider a "women's auxiliary." They want to be where the men are. But others enjoy their affiliation with WCR and are eager proselytizers, citing specific sales and gains made through membership. Different strokes . . .

Where Do They Work?

Beginning saleswomen interested in residential sales can work for a broker selling or renting houses or apartments. That may be a small, two-person resale office independently run, or it could be one that is part of a national chain—Gallery of Homes, for example, the nation's largest residential real estate marketing network. Or Homes for Living, which also aids in relocation.

A newly licensed saleswoman can also work for a major developer, selling single-family homes or condominiums. There, work begins when the sales trailer is set up alongside the excavation site and continues often until several months after the last tenant or homeowner has moved in. The sales-woman sells units or houses, frequently helping to pick interiors. She keeps in touch with buyers until they are able to move in, answering their many queries about construction progress, changing the color of the kitchen, etc. Work goes on after the units are up, checking to see that everything meets local standards and buyer requirements.

Apartments are big business. What is probably the greatest impact on real estate in the last few years has been the growth of condominiums and cooperatives as a new housing style. The former has had an especially meteoric rise. In 1974 nearly twenty-five percent of housing starts—probably as much as fifty percent in some metropolitan areas—were planned and sold as condominiums. Cooperative living, while pretty much

indigenous to New York City, also rose dramatically in the sixties and early seventies.

By way of explanation: in a cooperative, buyers purchase shares in a corporation that owns the apartment building. The number they own in the corporation is proportionate to the size and cost of their unit. They become tenant-shareholders and are given a proprietary lease that gives them the right to their unit. A condominium more nearly resembles single-family home ownership. The condo buyer purchases his unit outright and obtains financing for his purchase in the manner of any homeowner. Banks still usually finance cooperatives through personal loans.

The woman selling condominiums is a woman with a lot on her mind. If there is much to learn in selling houses, there is even more to learn in selling condominiums. Projects are sold through offering plans that can run as long as—well, the winner here seems to be a New York offering running to 468 pages! Buyers must be informed of maintenance costs, owners' association duties and rights, recreation leases, and the myriad other details that make up a condominium community.

As stated above, cooperatives are another form of apartment ownership and one that is equally complicated. Confined for the most part to New York City, cooperative selling is extremely competitive and calls for only the most aggressive and skilled brokers. "A cross between a psychology professor and an electronic calculator" is how a good cooperative broker is described.

Think you're up to it? Here are the backgrounds of nine women who comprise the co-op sales staff of a major Manhattan brokerage. Their backgrounds are widely diversified, but the ladies share many of the qualities that go into top-flight selling: they are savvy and tough, and they share a tremendous enthusiasm for selling.

1. Was an editor at a major fashion magazine and then sales promotion director at a cosmetics firm. She speaks Dutch, French, and some Italian and Spanish.

2. Studied to be a statistician and economist. Worked in the economics department of Standard Oil of New Jersey.

3. Sold mini-computers before entering real estate.

4. Not much working experience, but a wealth of social contacts. That sometimes counts more.

5. Public relations work, then nine years of real estate experience. One year recorded a million dollars in sales in the first three months.

6. Helped her husband run a resort motel.

7. Ran her own decorating firm.

8. Photographer's model. Learned the economics of running her own business.

9. Is eighty-two years old and just plain knows everything about the business and everyone in it.

Women new to real estate can also handle apartment rentals. Some enterprising women, for example, see something else besides becoming rental agents when they look at a vacant apartment complex. There was a great deal of overbuilding in the early part of this decade; and that, coupled with a generally tight money situation, has produced apartment projects that just don't seem to move. Or could it be that the developer went about selling the wrong way? To solve his quandary a small number of leasing specialist firms have opened, dealing only with distressed properties. One of these is Special Occupancy Service, Inc. (S. O. S.), owned by Betty Padilla, with offices in Campbell, California. Ms. Padilla has rented thousands of apartment units in nine states by approaching the marketing of the project far differently from the way the developer did.

For one thing, a decorator is brought into the troubled project to redecorate all the model rooms. Completely. The decorator in Ms. Padilla's case is her daughter, Jorja. Ms. Padilla notices other factors in the project's makeup or design that could be hampering sales. Landscaping is improved, or drawn in where there is none. One project was located behind office buildings and the street name was not on the map. The rain that winter had caused a delay on outside lighting and landscaping. The project was dying. Ms. Padilla held a Christmas

patio-decorating contest, giving extra points for decorating early. The place became so well-lighted it could be seen for miles. Her firm rented three apartments a day.

In other developments, Ms. Padilla perks up sales by recommending the elimination of the security deposit. Advertising is strictly controlled by S. O. S.

"We do not do anything that anybody else cannot do," she says. "It's just that we do it better and work harder at it."

The secret to all success, of course. And all those empty apartment units help, too!

Commissions

It is always the seller who pays the broker's commission, and that fee can vary from one locale to another. It may be, say, six percent on the first $50,000, 5 percent on the next $50,000, and two and one half percent on whatever amount goes over $100,000. More often it is a straight percentage, regardless of the amount of the sale. A common commission is six percent, so a $60,000 house sale would earn $3,600. If it's a multiple-listing sale from another office, that office would get twenty-five percent or more. The saleswoman would then split the seventy-five percent remainder with her own office. So she'd make about $1,350 on the sale.

Most saleswomen operate on a commission basis. Some offices offer beginners small salaries for a certain length of time, and many others offer drawing accounts against commissions. Many offer group life insurance programs and other employee benefits.

How much can a beginner be expected to earn?

The "Profile" issued by the National Association of Realtors places the median income of brokers in 1974 at $24,000; of salespersons at $12,000 for full-time workers, $3,000 for part-timers.

Interestingly, when it comes to comparing male-female salaries, it turns out that male brokers earn $25,000 to a woman's $15,000. The NAR has no explanation for this discrepancy, although it allows that there are more men than women in the higher-paying fields of appraising, property-management,

etc. They also speculate that perhaps women are more cautious than men in breaking away to open their own office, which also means a higher income.

How Listings Work

There are two types of real estate listings—exclusive and multiple. In an exclusive listing an agreement is made between the seller and a real estate agent that gives the agent the exclusive right to sell a particular property for a certain period of time. No one else may sell it. The length of time is arrived at by the seller and the realty agent and usually depends on the salability of the property involved. Agreements range from 90 days to six months, with the higher-priced properties listed longer. With an exclusive listing a real estate agent can work toward the sale of that property with no interference from outside salespeople or brokers.

If the property has not been sold at the end of the time period agreed upon, the seller and real estate agent reevaluate their agreement. Sometimes the two disagree about the asking price of the property, or any number of other factors concerned with it, and they agree to go their separate ways. Sometimes they sign up for another six months of an exclusive listing, or they may go for a multiple listing this time, almost always with a lower asking price than the first time around.

Realtors long ago concluded that a single real estate sales office, operating by itself in a limited geographic area, would have to miss out on a certain percentage of sales because it could not hope to have enough listings of homes to satisfy all its customers' needs.

So in the early days of this century came the forerunner of what is today's multiple listings system, when on certain appointed days members of a local realty board would gather to exchange information about their listings. Frequently auctions would be held and real estate salespeople came prepared to purchase certain properties desired by their customers but listed by another broker.

Today the multiple listings service has achieved a high degree of sophistication. Brokers and salespeople view new

homes for sale on certain days of the week. Listings are circulated to all member firms regularly, and new listings are hand-delivered by messenger, usually within forty-eight hours after a property goes up for sale.

Realty men and women join a multiple listings service individually, not with their company. They must belong to the local Board of Realtors.

Multiple listings remain somewhat exclusive in that the real estate agent who gets the original listing remains in on the ultimate sale and continues to handle the advertising. The difference is that information about the property is now systematically disseminated to all other realty people in the area.

Besides the reasons mentioned earlier, exclusive listings can become multiple when the property is unique—say, an unusual architect-designed house that needs wide exposure to find the one buyer who will appreciate it, or when a seller is rigid in his requirements for a sale.

Everyone shares in the commission pie on a multiple-listing sale.

The Million Dollar Club

Salesmen need incentive, right? To foster some competitiveness around the office, and to give salespeople something to brag about, most communities have a Million Dollar Club for those who sell one million dollars' worth of real estate in a single year.

Carol Zins is a top seller, and she is also perhaps typical of most women in real estate: in her thirties, married with two children, and living in a suburban area. What is not typical is that Ms. Zins has been a member of the Million Dollar Club at the Berg Agency in New Jersey for four consecutive years. A tall, attractive blonde woman, she exudes no plastic charm or phony patter. She is, as they sometimes say, "down to earth." She is also one smart lady.

On one sunny Friday morning, Ms. Zins was stopping at her office briefly before heading out to inspect new listings. The Berg Agency, a large national brokerage concern, has eighteen offices scattered throughout New Jersey. Ms. Zins

works in East Brunswick, on a busy main thoroughfare a few feet from the New Jersey Turnpike. There are about a half dozen full- and part-timers attached to the office—a male manager, but a predominantly female sales staff.

On this particular Friday Ms. Zins is elated at the stack of leaflets in the back seat of her car and pulls one out to show a visitor. It's her latest sales idea—a flyer on heavy-stock paper with her picture in the right-hand corner and a text that begins, "Introducing Carol Zins (Member Million Dollar Club)." She will blanket the area with them—company personnel offices, former clients, sales and service people she comes in contact with. The flyer describes her success—she was number-one saleswoman of the Berg Agency in 1975—and closes with her phone number.

Ms. Zins is in a good area to rack up sales. Her section of Middlesex County counts houses in all price ranges and is heavy on transfer traffic. It is only about half an hour from New York City, where almost half of its residents commute to work.

In the year that she was top salesperson, she made $30,000. "But I think I can crack $40,000 with a little more imagination," she says, smiling. Thus the flyers. Second in salary in her office was a male co-worker who drew $25,000.

"I work very hard to stay on top," she says. "It might not be the hours I put in but I can think of different things to do, different ways to generate business. If someone were to walk into that office and top me, I'm sure my nose would be out of joint, no doubt about it. I've always been queen and I want to stay that way. Actually, I'm not sure what it is, but I must be doing something right.

"I have a reputation. They know me here, and that's definitely a plus. I do fifty percent of my business on just name alone. They'll call and say 'you sold my friend's house,' or 'I have a friend who's thinking of selling.'

"I do send small gifts to my clients—maybe flowers when they're moving in or leaving. Maybe it's the little things like that. If there are children involved I might send a gift certificate to McDonald's or Gino's with my Christmas card.

"Everything I do revolves around business in some way or other. I carry cards with me all the time. If I go into Bamberger's to buy a pair of shoes I may give the salesman a card when we get to talking. As a matter of fact, I sold one of my own listings last year in another town to a shoe salesman's sister who works nearby. I usually do my shopping in familiar stores. I don't think I would continue going back if I didn't receive something in return. We're helping each other, really.

"Naturally you lose some sales, but you really never know. A man just called me and said, 'I just put a binder on a house.' I said, 'Wow!' He said, 'I'm sorry, but it came through the friend of a friend.' I said, 'Gee, that's a shame, but if I can ever help you or answer any questions, please give me a call.' He said, 'Well, you never know. If this doesn't go through, you may have a crack at it yet.' Well, he's right, maybe the offer *won't* be accepted. Then I'll be back in business.

"Now tomorrow I have to show houses to a man being transferred into this area. I'll spend a few hours with him. I like to point out the schools, the shopping center, the transportation. He's coming in from Ohio and I've made a reservation for him at the Sheraton down the road. I have an idea of the house I'm going to sell him. Usually I make the house I think they'll buy the third and last one I show, but this man I'll probably show four houses.

"I usually don't take the husband out without the wife because it's the wife who buys the house nine times out of ten—because she's the one who's going to be in it all day. So a married man coming into my office wanting to look at some houses—I have no intention of taking him around. First, he wouldn't be able to buy it without his wife seeing it and also, to be honest, I just don't feel safe. You never know . . ."

Carol Zins' husband, Artie, earns somewhat less than his wife but neither seems to mind. They have two children. Ms Zins' mother lives with them, which pretty much takes care of the baby-sitting problem. Too, Mr. Zins works different shifts so someone is always home.

"I think Artie may get a little lonely at times. But we go out. We go to dinner once or twice a week and then to visi

friends. A *lot* of people come here. I think nothing of it—I'll say to them, 'Oh, I have papers to sign—come over to my house tonight and have a cup of coffee. Artie's home.' "

The next step up for Ms. Zins could be managing one of Berg's offices. But she is not sure she wants that, and in talking about it almost every sentence contradicts the preceding one.

"I made more money than the manager made last year. It's strictly administrative work and if I can only make $20,000-$25,000, I don't need it. I want it just for the fact of saying a woman can do as good a job, if not better, than a man. There are really some chauvinists around here, in plain English. Maybe I'm too dominant, but this is all part of being a salesman. If I were a man I'd probably be a regional manager today. I wouldn't want to relocate—How can you manage an area you don't even know? How can you sit down with a staff and say why didn't we sell this house when you don't even know what the houses should be priced?—but I do know one office I wouldn't mind having that's not far from here. It's one that isn't doing too well. I said, 'Jerry, before you close that office I want a shot at it.' "

Her eyes sparkle with the thought of resurrecting that limping branch. But could this woman give up selling?

In Business for Oneself

The first survey of women-owned businesses conducted by the U.S. Department of Commerce showed there were 402,025 such firms operating in 1972. Grouping them by industry, firms offering personal services led, followed by businesses categorized as "miscellaneous retail." Women operating their own real estate and building firms ran third, with more than 60,000 such firms in operation nationally.

Some women—Carol Zins is one—prefer selling for another broker to setting up their own shop. But many brokers—close to half, in fact—rent office space and hang out their own shingle.

"It happened suddenly to me," recalled one broker. "Just as I was packing for a meeting, my broker called me and said,

'I'm planning to retire from the business in a month, just in case you'd like to do something about it.' "

The soon-to-be-out-of-work broker had been thinking of opening her own office for some time, but that was a plan for one of these days. She had also discussed with four associates the formation of a corporation. But now she was faced with making an immediate decision. After much deliberation, she decided the corporation route was not for her and she began planning a sole venture.

She chose an inexpensive office in a local mall and decorated it. Another expense was mailing 300 personal announcements telling of the venture. She joined the Chamber of Commerce and two multiple listings services and was off.

Going into business need not be an expensive proposition although there is, of course, that panicky feeling of disassociating oneself from the security that comes with letting an employer do all the major business worrying. You're on your own now, kid! A Philadelphia woman reported little financing was required to start her real estate firm. "I was married, too, so I could afford to take a gamble on a new business." She added, "From the first month, though, we've earned enough to stay afloat." The "we" is the two associates to whom the new owner has given desk space.

Many women find it more profitable to combine insurance, and even law, with their real estate offerings. In an age of one-stop shopping, they have discovered that a comprehensive service solving all of the househunter's problems brings in even more business. One broker, for example, offers a tag sales service to her clients, besides the gamut of real estate services. In a small community, and in a quiet real estate market, the more services offered the more valuable the office and, naturally, the higher the broker's profits.

Sexism Lives, But Barely

Residential sales has, of course, been one area of real estate where women have been accepted. There has been no need to fight for equal pay, because a six percent commission is six percent, no matter who sells the house. And, as stated earlier

women are needed in this arena. No male office manager can afford to turn them away.

Of more importance to the future of women in the trade, however, is their increasingly frequent appearances at realty board events—which even a few years ago had the look of an all-male college reunion—and their election to offices on those boards.

To some extent discrimination does still exist, but women agree that this occurs with the old timers, who just cannot get used to women working, period; or it happens with male colleagues who might be jealous of a female co-worker's higher sales. At state and national levels, professional organizations are still heavily weighted in favor of men (after all, that's why the Woman's Council of Realtors was formed), but times are changing there, too.

There is no scientific reason to back up discriminating practices. An in-depth five-year study conducted by the Marketing Survey and Research Corporation of Princeton, New Jersey, in 1974, concerning hiring criteria in the real estate industry, concluded that the sex, age, race, and education of personnel had little to do with their potential for success in the job.

The study was based on a sampling of some 250,000 people, some of them job applicants, others already employed in the field. The personality traits examined included ego drive, empathy, growth potential, leadership ability, assertiveness, reliability, complacency, sociability, cautiousness, personal relations, vigor, rigidity, and the ability to make decisions, handle detail, and delegate responsibility.

Walker & Lee, Inc., an Anaheim, California-based diversified real estate services firm, conducted a somewhat similar study comparing the home sales of seventeen saleswomen and seventeen salesmen in three contiguous resale offices in Orange County to see if men or women are better real estate salespersons.

It was a draw.

"Young homebuyers and former renters showed a definite preference for working with women. On the other hand the older more experienced buyers worked more often with sales-

men, who also sold more larger homes," reported a Walker & Lee vice-president.

Sales prices of the homes varied between sexes by less than $200, with women's sales averaging $34,203 to men's $34,023.

Saleswomen sold to more buyers under thirty years old and to renters (seventy-four percent of their sales). People who move more frequently also tended to gravitate to saleswomen.

In analyzing the data of the study, the Walker & Lee executive commented, "Women may sell better to younger buyers because of their backgrounds as mothers. In most cases this experience gives them the patience and tenacity necessary for dealing with the problems of moving into a first home.

"Men, on the other hand, seem to be more comfortable in working with the slightly older, "move-up" buyer who is not undergoing the emotional experience of buying a home for the first time and is more knowledgeable about real estate."

Education and Job Outlook

All salespeople and brokers must be licensed. Licensing requirements vary from one state to another, but usually call for passing a state-administered written examination and paying a small fee. In some states the applicant must attend thirty hours at a local school or college studying real estate principles, zoning laws, financing, etc. In other states applicants are merely issued a handbook they can study at their own pace prior to the exam. Sometimes a high school diploma is required; in other instances a grade school education is satisfactory.

Another frequent prerequisite for taking the exam is a promised position with a local realty office after licensing.

A license is nice to have and, like typing and swimming, it is something you can be away from for a while and can pick up again with little trouble. Betty Fox, a New Jersey shore saleswoman, earned her real estate license seventeen years ago. In the ensuing years events intervened to keep her from selling. But in 1974 she and her husband retired to the shore. There she was, surrounded by beach houses, stores, boardwalk stands, and seasonal cottages. And a reasonable measure of

time on her hands. Well, why not? Ms. Fox was able to renew her license merely by sending a $15 check to Trenton. In 1975 she racked up more than $50,000 in seasonal rentals for her company.

Besides the courses leading to licensing, there are a growing number of real estate programs being offered in colleges and universities in undergraduate and graduate curricula.

"The demand for real estate education has more than tripled in this country in the past twelve years," said Philip C. Smaby, president of the National Association of Realtors.

Twelve years ago there were only 150 colleges and universities offering courses in real estate, according to a survey conducted by the association's Department of Education. Today there are more than 535 (reported in a 1974 survey) and that number is growing rapidly.

There are some 146 colleges offering associate degrees in real estate, fifty-six offering bachelor's degrees, seventeen offering a master's degree and seven offering a doctorate degree. The remainder offer real estate courses for credit without leading to a degree.

Graduates of those programs enter appraising, property management, management of realty offices more often than sales. They may work for title companies and large brokerages dealing in commercial, investment, farm, and industrial properties.

(Interestingly, graduates may still have to take the thirty-hour real estate course required by many states before obtaining a salesperson's license.)

The job outlook for those in residential sales is good. True, some areas are saturated, but the turnover is high so there is always room for newcomers. And like cream, the good will rise to the top. Women who are willing to continue their education in real estate in the above-mentioned college programs will find even more opportunities—and at a steadier income.

Real estate per se is changing and growing, too. The suburbs are expanding, condominiums and townhouses are a new housing style, and there are a growing number of people moving back into older city houses, providing some intrepid realty

people with a new "townhouse" market. There should be a continual growth in the second-home market, in cluster houses and perhaps "new towns." Some twenty-seven percent of today's population are senior citizens, requiring special housing needs. Look for new housing styles for them as well.

Other Career Guidance Sources

The National Association of Realtors
430 North Michigan Avenue
Chicago, Illinois 60611

Affiliates (at the same address) include:

American Chapter/International Real Estate Federation
American Institute of Real Estate Appraisers
American Society of Real Estate Counselors
Institute of Real Estate Managers
National Institute of Farm and Land Brokers
Real Estate Securities and Syndication Institute
Society of Industrial Realtors
Women's Council of Realtors

The NAR offers career guidance information, listings of accredited colleges and universities offering real estate degree programs, and scholarship information. The booklet "Profile of the Realtor and the Realtor-Associate," is also available from NAR for $4.75.

"Real Estate Career Opportunities, Series C22," available for $1.25 from Catalyst, 14 E. 60 St., New York, New York 10022. Catalyst is a national nonprofit organization that aids college-educated women in achieving career goals. However, since real estate is not just for those with post-high school training, women who have not attended college should feel free to write for the booklet. It's for them, too.

Licensing Requirements

Requirements for obtaining a real estate broker's and/or salesperson's license vary from state to state. Following is the name

and address of the administrating officer in each of the fifty states and the District of Columbia. A list of accredited courses and reading materials may also be obtained upon request from those states requiring educational prerequisites.

ALABAMA	Mary L. Goodwin, Director Alabama Real Estate Commission Room 562, State Office Building Montgomery 36104
ALASKA	J. Ray Roady, Director Division of Occupational Licensing Alaska Department of Commerce Pouch D Juneau 99801
ARIZONA	Victor M. David, Acting Commissioner Arizona Real Estate Department 1645 W. Jefferson Phoenix 85007
ARKANSAS	Kenneth H. Graves Arkansas Real Estate Department 1311 W. Second St. (P. O. Box 3173) Little Rock 72201
CALIFORNIA	Robert W. Karpe Commissioner & Chairman of State Real Estate California Dept. of Real Estate 714 P St. Sacramento 95814
COLORADO	Keith T. Koske, Director Colorado Real Estate Commission 110 State Services Building Denver 80203
CONNECTICUT	James F. Carey, Executive Director Connecticut Real Estate Commission 90 Washington St. Hartford 06115

DELAWARE	Thelma Lewis, Asst. Secretary Delaware Real Estate Commission State House Annex Dover 19901
DISTRICT OF COLUMBIA	William R. Downing, Secretary District of Columbia Real Estate Commission 614 "H" St., N.W. Washington 20001
FLORIDA	C. B. Stafford, Executive Director Florida Real Estate Commission State Office Building West Morse Blvd. Winter Park 32789
GEORGIA	Elmer A. Borgschatz Real Estate Commissioner Georgia Real Estate Commission 166 Pryor St., S.W. Atlanta 30303
HAWAII	Yukio Higuchi, Executive Secretary Real Estate Commission Department of Regulatory Agencies 1010 Richards St. (P.O. Box 3469) Honolulu 96801
IDAHO	Marion J. Voorhees, Executive Secretary Idaho Real Estate Commission State Capitol Boise 83720
ILLINOIS	Melvin M. Landau Commissioner of Real Estate Department of Registration & Education 628 E. Adams Springfield 62706
INDIANA	Carl J. Nicholson, Executive Secretary Indiana Real Estate Commission 1022 State Office Building

100 N. Senate Ave.
Indianapolis 46204

IOWA

C. R. Galvin, Director
Iowa Real Estate Commission
1223 East Court (Executive Hills)
Des Moines 50319

KANSAS

John Ball, Director
Kansas Real Estate Commission
535 Kansas Ave., Room 1212
Topeka 66603

KENTUCKY

George L. Cane, Chairman
Kentucky Real Estate Commission
100 E. Liberty St.
Louisville 40202

LOUISIANA

Alvin J. Unick, Director
Department of Occupational Standards
P. O. Box 44095
Capitol Station
Baton Rouge 70804

MAINE

Paul A. Sawyer, Administrative Officer
Department of Business Regulation &
Real Estate Commission
Capitol Shopping Center
Western Avenue
Augusta 04330

MARYLAND

Charles G. Chambers, Executive Director
Maryland Real Estate Commission
One South Calbert St.
Baltimore 21202

MASSACHUSETTS

John W. McIsaac, Executive Secretary
Board of Registration of Real Estate
Brokers & Salesmen
State Office Bldg.
Government Center
100 Cambridge St.
Boston 02202

MICHIGAN

Richard V. Griesinger, Deputy Commissioner of Real Estate
Department of Licensing & Regulation
1033 S. Washington Ave.
Lansing 48926

MINNESOTA

Edward J. Driscoll, Commissioner of Securities
500 Metro Square Bldg.
7th & Robert St.
St. Paul 55101

MISSISSIPPI

James D. Hobson, Jr.
Administrative Officer
Mississippi Real Estate Commission
505 Woodland Hills Bldg.
300 Old Canton Rd.
Jackson 39216

MISSOURI

Thelma D. Peterson
Acting Secretary
Missouri Real Estate Commission
222 Monroe St.
Jefferson City 65101

MONTANA

Matthew H. Brown
Board Director
Department of Professional & Occupational Licensing Board of R. E.
Montana Real Estate Commission
42½ N. Main
Helena 59601

NEBRASKA

Paul Quinlan, Director
Nebraska Real Estate Commission
600 S. 11th St., Suite 200
Lincoln 68508

NEVADA

Angus McLeod, Administrator
Real Estate Division
Department of Commerce
111 W. Telegraph St., Suite 113
Carson City 89701

NEW HAMPSHIRE	Alice C. Hallenborg Executive Director New Hampshire Real Estate Commission 3 Capitol St. Concord 03301
NEW JERSEY	John J. Regan, Secretary-Director Division of the New Jersey Real Estate Commission Department of Insurance 201 E. State St. Trenton 98625
NEW MEXICO	Kenneth R. Miller, Executive Secretary New Mexico Real Estate Commission Room 1031, 505 Marquette Ave. NW Albuquerque 98101
NEW YORK	Elia J. Malara, Director Division of Licensing Services Department of State 270 Broadway New York 10007
NORTH CAROLINA	Joseph F. Schweidler, Secy-Treasurer North Carolina Real Estate Licensing Board 813 B. B. & T. Bldg. P. O. Box 266 Raleigh 27602
NORTH DAKOTA	Dennis D. Schulz, Secy-Treasurer North Dakota Real Estate Commission 410 E. Thayer Ave. Box 727 Bismarck 58501
OHIO	Robert M. Gippin, Secretary Ohio Real Estate Commission 33 North Grant Ave. Columbus 43215

OKLAHOMA	Charles C. Case, Jr., Secy-Treasurer Oklahoma Real Estate Commission 4040 No. Lincoln Blvd. Oklahoma City 73105
OREGON	M. J. Holbrook, Commissioner Real Estate Division Department of Commerce Commerce Building Salem 97310
PENNSYLVANIA	Pierce L. Clowster, Jr. Room 300, 279 Boas St. Harrisburg 17120
RHODE ISLAND	Reginald D. Whitcomb, Deputy Administrator Real Estate Division Department of Business Regulation 169 Weybosset St. Providence 02903
SOUTH CAROLINA	Ralph H. Baer, Jr., Commissioner South Carolina Real Estate Commission 900 Elmwood Columbia 29201
SOUTH DAKOTA	Jack C. Burchill, Secretary South Dakota Real Estate Commission Box 638 Pierre 57501
TENNESSEE	Ted R. Nelson, Executive Director Tennessee Real Estate Commission 556 Capitol Hill Bldg. Nashville 37219
TEXAS	Andy James, Administrator Texas Real Estate Commission P. O. Box 12188 Capitol Station Austin 78711

UTAH
Stephen J. Francis, Director
Department of Business Regulation, Real Estate Division
330 East Fourth St.
Salt Lake City 84111

VERMONT
Nelda G. Rossi, Executive Secretary
Vermont Real Estate Commission
7 East State St.
Montpelier 05602

VIRGINIA
Ruth J. Herrink, Director
Real Estate Commission
Department of Professional & Occupational Registration
2 So. 9th St.
Richmond 23202

WASHINGTON
George B. Oaks, Administrator
Washington Real Estate Division
P. O. Box 247
Olympia 98504

WEST VIRGINIA
Donald E. Portis, Executive Secy.
West Virginia Real Estate Commission
402 State Office Bldg. #3
1800 E. Washington St.
Charleston 25305

WISCONSIN
Roy E. Hays, Executive Secretary
Wisconsin Real Estate Examining Board
819 North 6th St.
Milwaukee 53202

WYOMING
Glenn Hertzler, Jr., Commissioner
Wyoming Real Estate Commission
2219 Carey Ave.
Cheyenne 82002

2

New Opportunities
in Commercial Leasing

UNTIL ABOUT FIVE YEARS AGO, WOMEN WERE NOT PERMITTED
by real estate companies to sell or lease commercial space.

But that, as events are reckoned these days, was a lifetime
ago. Today we have Celeste Yarnall in Los Angeles breaking
sales records, earning a six-figure income, and saying she
wouldn't mind at all becoming the Mary Wells of real estate.
In Manhattan, Lynn Goddess, another relative newcomer to
the field, received an in-trade award in 1975 for bringing about
"the most ingenious deal of the year," a complicated morass
of negotiations that lasted more than a year and resulted in
the sale of a prestigious high-rise office building to a foreign
government. For the amount of that single commission, read
on.

Actually it would be hard to find a real estate commercial
brokerage office of any size today without at least one female
broker. She may not be taken seriously yet, and she may have
been hired as needed window dressing, but she is there. And
women in commercial leasing being no back numbers, it
won't be long before she is noticed.

"I had to be approved by an executive committee as recently as 1973 when I was hired," explained Lynn Goddess, who is vice-president of Cross & Brown Company, one of New York City's largest firms. "All the men went in like that," she added with a snap of her fingers. "With me it was a matter of five months."

What makes this particular area of real estate so special? It is where the money is. Brokers earn varying commissions on long-term leases usually starting at 6 percent. That's a sizable commission. In home sales the agent is dealing in sums of money that run from $20,000 or so to, say, $250,000. In commercial leasing the amount in question frequently *starts* at $250,000.

In fact, office leasing is such a new ball game that its differences should be especially noted by the woman hoping to cross over from home sales to the business side of real estate to increase her earnings. It will not be that easy.

How Office Leasing Works

There is no textbook. It is on-the-job training. Commercial brokerage is for self-starters, but the field takes enterprise even one step further. The broker must truly possess the instincts and stamina of the riverboat gambler. She must appear super-confident without crossing the line into obnoxious. She must be aggressive—yes, an aggressive woman—imaginative, and extremely resourceful in keeping both client and buyer (or tenant) happy. Deals sometimes take months to close, and the broker is almost always operating on a commission basis—so she cannot have serious money worries. A fairly solid bank account or a regularly employed spouse is a must for the beginner. It can be a long time between checks.

If residential sales is competitive, the commercial arena is more so. One woman took up smoking after having been without the weed for three years. Another looks down, frowning, at her "problem" nails.

Kenneth Patton, president of the Real Estate Board of New York, says of real estate in that city: "It's a tough eccentric business, with a lot of raw individualism and brutal competi-

tion. There is so much in-fighting that the women never complain about being discriminated against; they just take it for granted that, for everybody, it's dog-eat-dog."

Some women would disagree with Mr. Patton about discrimination. None would argue it is indeed dog-eat-dog.

Commercial brokerage includes sale or rental of office, store, or industrial (warehouse and factory) space, and sometimes land zoned for commercial use. Available space is measured in square feet, not number of rooms or floors. Costs are "aggregate rent," the total amount of rent a tenant will pay for the number of years specified in the lease. For example, an advertising agency takes 20,000 square feet of space in a building for ten years at an aggregate rent of one million dollars. That would work out to $100,000 rent a year, or $5 per square foot a year. (In actuality, though, the $5 is usually a base figure and is inflated over the course of the lease, through an escalation clause, to take in taxes on the building, electricity, and the tenant's pro-rated share of the operating expenses on the structure. Sometimes that $5 figure can almost double.)

Interestingly, all that work and pressure on brokers does not usually spill into off hours. There is little to take home except the ideas fomenting in one's head. Occasionally a client may have to be shown space on a weekend if his schedule precludes a weekday call, but for the most part the job is, if not a nine-to-five one, not all-consuming either.

That is not to say the successful broker is not always aware somewhere in the recesses of her mind just what she does for a living. Brenda Rediker, a Manhattan broker who runs her own commercial leasing office, spent some time on a vacation in Italy seeing if stores and boutiques along Rome's fashionable avenues could be persuaded to open small shops in Manhattan. Of course Ms. Rediker stood ready to help them find locations.

Deals, and the people involved in them, can be picky, picky, picky. Landlord and tenant can haggle for months over the rent, or renovation of the space, or any number of niggling details that keep signatures from the lease and the commission

from the finger-tapping broker. "If you're pressured for next month's rent, it's hard not to press too hard," remarked Ms. Rediker. "New brokers *must* have a cushion." She recalled she once had a client who wanted a certain basement and second floor space, but needed a conveyor to run between the two floors. The lease was held up until the landlord got a permit to make the building fit for a conveyor. Then the architect had to get a permit and so on and so on. "Some deals can take a year," she concluded, "and some take forever and still fall through.

"But I was in home sales, and looking into somebody else's closet and bathroom wasn't the daily routine I wanted. I wanted a challenge and I like a man's world."

Brenda Rediker is doing well. Let's take a look at two other women who are very much a success in that "man's world." *Very* much a success.

In Los Angeles

Century City's gleaming skyscrapers rise from 180 acres of land that used to house the 20th Century-Fox movie studios. Now fourteen years old, the new "city" houses several high-rise condominium buildings, a theatre complex, the huge Century Plaza hotel, plus dozens of stores and restaurants. But more than half of the total acreage is office buildings. In fact, Century City, which is adjacent to Beverly Hills, is pretty much on a par now with the downtown financial section of the city for prestigious office quarters. Several million square feet of space are available, led by the sparkling new forty-four-story twin Century Plaza towers, which contain one million square feet apiece.

Into this sprawl of opportunity stepped Celeste Yarnall, a porcelain-pretty blonde woman resembling somewhat the Mary Wells whose path she wouldn't mind following. A television actress in the mid-sixties, Ms. Yarnall was finding roles for women increasingly "disgusting" and, even worse, more and more scarce, as film actresses, finding fewer movie roles available, moved into television, bumping actresses like Ms. Yarnall. A new career was clearly called for. The former Miss

Rheingold (1965) hit upon real estate. "I didn't want residential work. I really work better with men, they're more decisive."

After obtaining a real estate license, Ms. Yarnall went to work in 1972 for the second largest commercial agency in town, becoming the first woman in commercial brokerage on the important West Side of the city.

"I had $20,000 in the bank to finance myself for my first year," she recalled. "I never touched it. I made $10,000 in my first six months, and $30,000 the first year."

Ms. Yarnall next moved to Greenwood & Co., a new brokerage concern setting up shop in blossoming Century City. She is there now as vice-president. Although primarily working with the new buildings in Century City, her work overlaps into other sections of the city's West Side. In 1975 her commissions topped $100,000.

How has she done so well in just three years?

She agrees that the availability of so much new space in Century City has been a plus.

"But I really learned the hard way. I called the heads of major corporations to see if they needed office space. I called the court trustees for Equity Funding Corporation. Since they were bankrupt they had something like one million dollars in office space to get rid of. I always try to get to the top man, too, and let *him* filter me down to his lower executives.

"I've been successful because I'm extremely persistent. I stay with something until it is completed. And I'm in business for just one thing—to get paid. Not to make a deal—there are brokers who are professional presenters and never close a deal. Not me.

"Problems with men? Absolutely. My background as an actress and the way I look, well, it isn't possible for me to be intelligent, right? They say 'why aren't you married to some nice Beverly Hills lawyer?'

"On the job, when I take clients around to show them space and I sense they aren't serious or are interested only in flirting, I have one of my partners sit in on the next conversation.

"I must say you can't appear to be too intelligent with

them, though. They just hate it. A woman's advantage is being feminine and not coming on too strong. I see the chauvinism all around me, but in a way I find it kind of fun. It's such a game."

Ms. Yarnall lives in an impressive home in Pacific Palisades with her six-year-old daughter (she is divorced) and a live-in governess. She is in the office between 8:00 and 8:30 in the morning, staying until early evening.

As the commissions have rolled in, Ms. Yarnall's standard of living rose accordingly. The home in Pacific Palisades followed a house at the beach. It goes without saying she dresses to the nines, as all female commercial brokers do—interestingly, preferring dresses to pants outfits. And again, as is the norm, her automobile also makes a statement.

"I own as expensive a car as I can because I want to intimidate my clients. It makes me look as if I'm not desperate for their business. Also, I think they'd rather go around with me in my Mercedes than some sixty-year-old broker in another type of car." A recent addition is a phone in the car "so I can negotiate on the drive in."

Ms. Yarnall admits that until very recently she "used to run constantly" and for years took no time off. But by mid-1976 there was a sign of change. "I've calmed down a little bit," she says. "I'm pretty secure with what I'm doing now. I've even taken a vacation."

And in New York

When the Real Estate Board of New York awarded Lynn Goddess and her associate Richard Seeler the Most Ingenious Deal of the Year Award in 1975, the young broker considered it recognition—finally—of women in other than residential areas of real estate. She was the first woman to be honored in the thirty-two-year history of the award, and it was the first time her company had won since 1949.

Said Ms. Goddess: "If people could pay for this award they'd pay a lot for it; it means that much in this business."

Then with a smile: "It's very encouraging to women that we're no longer considered dilettantes. Really! It was a sort of

'we can't show discrimination so we'll have our token woman' thing. But now with this award male brokers will think 'there may be some really talented women around so we'd better start looking for them.' "

The transaction for which Ms. Goddess and Mr. Seeler, who is executive vice-president of Cross & Brown, won their distinction was the sale of the sixteen-story 2 Dag Hammarskjold Plaza office building, which is located near the East River in the area of the United Nations.

What could almost be considered a diary of the negotiations, frequently delicate and time-consuming, appeared in *Real Estate Forum,* a local trade publication:

In early December 1973 the Cross & Brown Company brokers learned that the Government of Jamaica might be interested in purchasing a Manhattan office building which it could partially occupy and which would carry its name. Additional criteria called for a well-located prestigious property convenient to the United Nations that could be purchased outright and in which space could be made available on contiguous floors for consolidation of five existing facilities. On April 1, 1975, 16 months later, the Jamaican Government took title to the 16-story, 100,000 square foot Medcom Building at 2 Hammarskjold Plaza from a partnership headed by Harry Macklowe in one of the largest sales transactions in Manhattan last year (1975).

At the outset, Mr. Seeler and Ms. Goddess took independent surveys and produced 2 Hammarskjold Plaza as the most qualified prospect. When Mr. Macklowe was first approached, he did not want to sell, it having been his first and only development enterprise in which he felt a strong, personal attachment. However, broker persistence finally paid off and an offering price was established.

In January 1974, Jamaican Government representatives visited the property and expressed enthusiastic interest. The brokers then devoted more than two months to preparing and verifying a 30-page comprehensive presentation to the buyer which stressed the building's unique advantages, including: proximity to the UN; lower cost of occupancy

through ownership versus renting (the portion of the building occupied by the government would be exempt from real estate taxes and future escalation of such taxes); the building was operating at a profit which could be applied against occupancy costs; the structure itself is unusually beautiful and could serve as an effective vehicle for projecting the image of Jamaica as a newly independent country and a leader in the Caribbean; and it is large enough to provide room for growth yet small enough so that its purchase price would not be a hardship.

Among negative factors: consent of the mortgagee was required for any sale and in the absence of such consent the mortgage could be called. In addition, the building was fully rented but the principal tenant, occupying 28,000 square feet on contiguous floors, needed expansion space and had already shown interest in either purchase or terminating its lease.

Their presentation was forwarded in April and the brokers flew to Jamaica on June 12, 1974 for a crucial meeting to discuss all aspects of the deal. New questions were raised: "Was the asking price firm? Could the buyer put apartments in the building? Could a penthouse be erected on the roof?" The brokers could immediately answer that the price was indeed firm; the other questions required extensive research and the answers were positive. The brokers were also able to clarify purchase of the leasehold interest in a small, one story taxpayer which adjoined the building on the north side of the block, on which the air rights had been retained by Mr. Macklowe to increase the size of the main building. Also included in the transaction was a sculpture garden, controlled by a Parks Department permit for 125 years, which whoever owns the building is obligated to clean and maintain.

In the following month there were many discussions and telephone calls between the brokers and the Government of Jamaica and meetings between the brokers and the seller. Suddenly, in July, the buyer withdrew from the deal. In August, however, the Cross & Brown executives learned that

the Deputy Prime Minister, who also was the Minister of Finance, was in New York City on other business. A meeting and an inspection of the building were hastily arranged since, although he had been aware of some discussions about the building, he had never seen the original presentation. Keenly impressed with the property, he told the brokers his government would review the matter again.

Meanwhile, the brokers learned that another building had been offered the Jamaicans and was under consideration. The seller was also becoming ambivalent and threatened to take the property off the market, but the brokers kept him involved and prevailed upon him to be flexible on price. In October they told the Jamaican government they were confident that a lower offer would be accepted if it were received within the next 48 hours. Some 24 hours later the brokers were authorized to make the offer. A 60-day sales contract was signed November 19, 1974, subject to obtaining the mortgagees' consent and a written cancellation and possession agreement between seller and principal tenant, thereby guaranteeing availability of four contiguous floors within 18 months after closing of title and the right to recapture the name of the building.

When approached for consent, the mortgagee asked that a very substantial consideration be paid since the mortgage was carrying a below-market interest rate. Neither seller nor buyer was willing to pay the consideration or even to contribute to it. Lengthy negotiations ensued and the transaction went through repeated critical stages. The pressure was continually on the brokers to keep the deal alive. Compromise was urged on all sides. By this time it became apparent that the principal tenant was interested in moving, but could not be advised of the sale lest he take advantage of his crucial position and demand payment for cancellation of the lease. Complete secrecy was more critical than ever.

While this scenario was being played out, the date of the re-scheduled closing, March 14, 1975, was nearing. Suddenly and unexpectedly, the brokers received a call from the seller requesting an extension of time to obtain the cancellation

and possession agreement from the principal tenant, which would run beyond the passing of title. Fortunately, the Jamaican government agreed to an extension. Of course, the government had only the brokers' word that the seller would obtain the cancellation and possession agreement. There was no guarantee. After the closing, a Jamaican official explained it was his government's confidence in the brokers, built up over almost 16 months of negotiation and conferences, that enabled Mr. Seeler and Ms. Goddess to obtain the extension and the risk it entailed.

On the appointed closing date, April 1, 1975, the seller produced a consent agreement from the mortgagee and the sale was closed at the agreed price with the buyer assuming the existing mortgage. On June 30, 1975 the principal tenant signed an agreement to vacate its space between January 31 and June 30, 1976. Except for a brief period immediately after the buyer called the deal off, there had not been a single business day for 16 months, including five trips to Jamaica, when the brokers were not involved to some degree in the negotiation of this sale.

Admittedly, the above transaction does not come along often, even for the New York City broker. A description of the details involved in such a large building sale is included here to provide the reader with an idea of the complexities of a sizable and sophisticated property exchange. Incidentally, for her work on the "ingenious deal," Ms. Goddess received a not-so-incidental commission "in excess of $350,000." (The largest number of commercial brokers in Manhattan earned $25,000-$40,000 in 1973.)

Cross & Brown has been named rental agent for the building now owned by the Jamaican government, which will bring Ms. Goddess another, much smaller commission annually. She points out there are really two kinds of office brokers—management and promotional. The promotional acts as salesman in the promotion of business, primarily seeking new customers to buy or lease space. The management broker, on the other hand, functions as the owner's representative and acts as his renting agent. (See Chapter 9: Property Management—Help Wanted.)

Lynn Goddess, who is in her early thirties, came to real estate in 1971. After college, she spent six years in fund raising and public relations work, spearheading several major successful national fund-raising campaigns.

"I figured if I sold intangibles, I should be able to sell tangibles, like office buildings," she says of that time. After obtaining a real estate license she joined a medium-sized firm in Manhattan doing commercial leasing and sales. Married at the time, she and her husband separated soon afterward. "Then my financial picture took a total reversal. I'll just have to be a little hungrier, I thought. I'll just have to close my deals a little faster." In the first four months she closed three deals, again more the exception for the newcomer than the rule.

In 1973 Ms. Goddess joined Cross & Brown. Her ascent there has already been noted.

And what of the future?

"The problem is that competition becomes fierce and your chance of getting any decent-size deals becomes less likely," she explains. "What I try to do is assess the market—what *aren't* the others looking at because they're so busy with their office space? Often in this business everybody is so occupied with the day-to-day they don't stop to say hey, what's a little different or more rewarding?

"Right now I have a plan in the works here—and I'm convinced it's viable—that will blow the minds of the real estate industry. It'll take months to work out, but it'll blow their minds. It blows *my* mind!"

You read it here first.

Small or Large Firm?

In the traditional order one begins with the small company, learns the ropes and then moves on to a larger organization. But not always. Lynn Goddess agrees with other brokers that the small vs. large firm is an individual decision, bringing into play such variables as the broker's personality to the size of the city in which she is working. But as Ms. Goddess told a career seminar at New York University of her own experiences:

"I began my own career as a broker with a smaller size firm. I found a smaller firm was an easy place to get started, espe-

cially for a woman. It offered me constant close communication with my associates. Another advantage was that any leads of potential customers would be funnelled to fewer people.

"Fifteen months later I found I had certain basic requirements and needs which were not being satisfied, and thus moved on to join a larger, more established company.

"I had need to consult with a number of more experienced and seasoned brokers. This can be vital when you are confronted with problems in a deal and you aren't quite sure as to the best way to handle them. In smaller firms there may be 1 or 2 senior brokers and you are limited and guided by their experience. There is nothing like being able to call upon the experience of 50 or 60 seasoned real estate people when the need arises.

"I had a need for a more comprehensive understanding of the current real estate market, knowing where and at what price deals could be made. It is obvious that this is only possible in a larger firm where you have a free exchange amongst many brokers and exposure to the many kinds of deals they have worked on. How comprehensive an understanding can you get in a discussion with only a small sales force?

"I had a need for more efficient means of compilation of available property listings. Since listings are one of the two basics of our business—the other being clients and customers—it is essential that a broker's listings be as updated and complete as possible. Since smaller firms don't have the money or staff for a separate listing department, brokers are forced to devote several hours daily bringing their listings up-to-date. This comes to approximately ten hours weekly, or 520 hours a year. A larger firm, such as the one with which I am now associated, not only has its own listings department, but also has these listings computerized. Updated computer read-out sheets are available weekly. To a broker, time is money; and anything which reduces his effective productive time—time working with clients or negotiating on deals—is money out of his pocket.

"I had a need for a firm with total service capabilities, containing a brokerage department with experts in office leasing,

site assemblage, sales and investment services, and industrial real estate. How does this affect me? For one thing, you don't have to throw away leads you may have outside your own area of concentration, since you may refer them to a specialist. This in turn can be an additional source of income. For example, if I am working with a client looking for office space and he also happens to require 10,000 square feet of industrial space, I merely contact a broker in our industrial department and he takes it from there. Naturally, you would participate in any commission if and when it's earned.

"A larger firm would have a management department in addition to special supporting services, such as appraisals, mortgages, and consulting specialists. This can be a valuable aid to a broker. When, for example, a customer needs estimates of construction costs on some unit which he is considering renovating, all that a broker would have to do is contact a member of his in-house construction department. Sometimes a broker may receive this information within a matter of minutes or hours.

"I had a need to get some expertise in management brokerage. This can also be a source of renewal income certainly welcome in bad times. Many owners only choose large firms as their rental agents.

"I had a need to be associated with a firm which manages many buildings and controls a great deal of space. This becomes more important as the plethora of space on the market becomes absorbed and the demand becomes greater than the supply.

"I had a need of being associated with a firm of stature whose name was readily recognizable. This is a wonderful aid in gaining entree with many major corporations, especially for a woman, who still is considered somewhat of a novelty in commercial brokerage.

"I say to you that whenever the opportunity arises where a seasoned broker is willing to take you under his wing and train you, grab it. Your training and education, especially in the early stages, is essential for making you a competitive and informed broker. Remember you can always change firms."

How To Get Started

It has been mentioned elsewhere in this book, but it will bear repeating throughout, that real estate is a field open to the newcomer with no previous experience. Since it is basically selling, with the salesperson operating on a commission basis, a realty office will usually be willing to take on a beginner with plenty of moxie and assorted work experience, from Avon lady to aviator. That applies to the small firm, but also to the larger or more prestigious company, too, which sometimes has an in-house training program.

Another point to bear in mind is the office leasing picture in the city you're in or heading for. Overbuilding during the boom years of the late sixties and early seventies has left a surplus of space in some cities. Celeste Yarnall concedes that Century City's building days are just about ended. Granted, there will still be opportunity for re-leasing all the existing space, but the excitement, challenge, and bustle in dealing with a new "city" is pretty much over. The Manhattan office picture has been a partly cloudy one. Lynn Goddess considers herself fortunate to be covering the midtown area, which is still crackling, and not downtown, which is—well—not. Naturally there will always be office buildings in cities and there will always be brokers leasing and selling space. But some times are better than others; some places better. Do some thinking and talk to a few in the business before quitting that regular paycheck and taking the plunge.

Does a successful commercial broker have to work in a *large* city? No, but the *area* must have something going for it. What follows is the experience of a young beginner in a small town with a difference.

Patricia Levy is a commercial broker with Alexander Summer and Co. in Teaneck, New Jersey, one bedroom community among many close by the Hudson River across from Manhattan. It has been the scene of much office construction within the last few years, along with other communities in Bergen County. Alexander Summer and Co. is prominent in the area. It offers appraising; property management; commercial, land, and industrial sales and leasing; and mortgage and investment services.

But back to Pat Levy. She is from North Carolina, in her early thirties, married and with one daughter age twelve. Ms. Levy did not attend college and spent several years of her early married life traveling with her Navy husband. Although everyone's story is different, Pat Levy is typical in many ways— age, educational and work background—of women who enter real estate.

While living in Rhode Island where her husband was stationed, Ms. Levy got her real estate license. She sold houses and did well. "I was the first woman in that company," she recalled. "All the men were patting me on the head until I started to infringe on their territory. I got to the newspaper first and checked the ads and practically took over the rental market. I was making over $500 a month and this was seven years ago."

A tall, attractive woman, Ms. Levy continued her story over lunch in a suburban restaurant not far from Teaneck.

"Then one morning I was driving to work past a vacant lot on a corner. The sign said '23 acres for sale, zoned commercial.' I called the phone number on the sign and tried to get an exclusive listing from the owner. I couldn't, but he did give me an open listing, which, when I sold it, brought me ten percent commission, or $1,200. I said to myself, wait a minute. That was so easy, maybe I ought to look further into this commercial business.

"A few months later I was at a convention of real estate people. All the men were chatting with one another or drinking. I was talking to a man who asked me if I knew of any land available in the area suitable for a shopping center. I said I'd find some. So I spent the next week searching out records in the town hall trying to find spots I thought would be suitable. I contacted a few owners of land and was able to come up with one owner who agreed to sell his property. It was the best lot, too. Everyone in the office was curious by this time. Then one morning this fellow drove up in a large black Cadillac. *Mafia,* they screamed at the office, and they really put me down. We left to look at the land. Well, for various complicated reasons that deal fell through, but I still had commercial leasing in my mind. I went back to selling houses, but I was

still thinking *I* can add and subtract the big numbers, too."

The Levys moved to California and Ms. Levy went to work for another residential firm. She didn't do well. But in nine months the family was back in New York. After a few "boring" months as a housewife, the young saleswoman went back to work for a local broker, again selling homes.

"I don't mean to put down residential real estate, but I've always had this commercial and retail thing in the back of my mind. Again, the men in the office didn't let me do it. My boss said, 'If you want to do that, go someplace else, because that's no place for a woman.' He had ten women in the office and he used to call us his little 'stable.'

"Someone my husband knew wanted to buy an apartment building. I asked my boss what would be in it for me if I brought him to you? He said 'Nothing. Stick to selling houses.' When someone walked into the office one day and wanted to rent a store, he told me the same thing. So I finally left.

"I made up a list of commercial brokers. I went to three firms—in person; I never write letters. In the first I couldn't get past the receptionist. In the second they were laying off people. The third was Summer. I talked to the secretary to the vice-president and then the vice-president called me. He said he had been considering taking someone on to go into the central business districts of the county, part of a training program. We both thought about it and had some meetings. He told me I would not do as well as I had done in residential in the beginning.

"When he finally offered me the job I said yes and we began contract negotiations. To protect the employer—I have access to their files—I can't go to another company in Bergen County for a period of one year, although I could go back to residential sales. Commissions would be six percent of the aggregate rent for the term of the lease. On a sale the commission would be six percent of the price of the building and ten percent on the sale price of vacant land.

"When I started working I first went through the files on the five towns I would be covering to read up on them. Then I

went to each downtown to become familiar with it. I visited the stores, talked to the merchants and if it was an attractive store I'd ask if they'd be interested in another location, either to expand or to open a branch store. I'd always leave my card.

"I drove all around the state looking at shopping centers. Summer, after all, handled the leasing for two of the largest malls in the state. I'd look for a pattern. What stores rented in centers? I also looked at New York stores to see if they'd consider opening a branch in New Jersey."

The digging and walking around lasted several months. Since she was part of a training program, Ms. Levy received a small salary (under $5,000) while waiting for the commissions to come through. "Naturally I couldn't have lived on it if I didn't have my husband's salary. Some people could perhaps live on that little. *I* couldn't.

"There's a lot of pressure, tension in this field," she continued. "But the people in the office, the other brokers and the secretaries, were all very helpful."

The work day began with Ms. Levy reading all the local papers, the trade publications, and *Womens Wear Daily* ("They carry a lot of information about retail chains and where they're moving"). Then it was out of the office. Finally it happened. A sale! Ms. Levy brought to Teaneck a small gift and card shop, one of thirty in a chain. The commission was in the neighborhood of $8,000. Not a bad neighborhood, as they say.

Shortly after negotiating her first retail deal Ms. Levy moved—at last—into commercial leasing. Within two months she had closed two deals.

"I still have a way to go before I can say I can really make it on my own. If I couldn't depend on my husband's salary I would be nervous, but it's exciting and I have great hopes. I'm working very hard and doing a lot of scrambling around, but somehow you're dealing with a different element here. It's a little more sophisticated than home sales. I love it."

3

The Urban Planner

PLANNERS. PLANNING. IF YOU THINK YOU'VE SEEN THOSE words with increasing frequency over the last few years, you're right. They have cropped up in news stories ranging from the battle to preserve the wilderness of the Pacific shore to the equally intense stand to save New York City landmarks. And that's not mentioning Master Plan, zoning, and new town stories from the heartland.

Planning is an important and in-demand profession these days. Jobs could be considered plentiful and, unlike numerous other occupations, the outlook is good for an even greater number of openings in the next few years.

Best of all, women in planning are far more visible than in any of the professions. Women comprise fewer than ten percent of the enrollment in architecture and engineering schools. In medicine and law the figures are close to twenty percent. But thirty to thirty-five percent of planning students these days are women.

That's a good number of women—and a great deal of work for them to do.

Urban planning was an important part of city government in Europe for centuries. In this country it took its place around the turn of the century. Remember the movie *Chinatown*, set in Los Angeles in the 1930s, with its almost incomprehensible plot about diverting the Los Angeles water supply to the then-barren San Fernando Valley? Well, that city's planning department, which was organized in the 1920s, figured in the movie somewhere.

In those days, and in fact until perhaps the last fifteen years or so, planners were concerned with new sewer lines, traffic patterns, widening streets, and the general appearance of a city. Necessary work, but hardly visionary.

In the 1950s, imagination made its appearance at the planning table. "It was a romantic era of belief that the cities could change," recalls Connie Lieder, a Baltimore planner, of her college days. "New towns and urban renewal were going to change the world."

Of course the 1960s shattered that filmy vision with its pragmatic ugliness. In the cities there was poverty, inadequate housing, problems with schools. The suburbs were coping with postwar sprawl. Should growth continue? In what direction? What about pollution? And preservation? Tying the two together were questions about public transit, job opportunities, and accessibility to jobs and to cultural and social facilities. Existing planning departments began bulging both with new staff people and with charts, maps, computer printouts, and theories about growth. Even smaller communities frequently hired one lone planner.

Today, the planner's role can range from judging the long-range social implications of a new senior citizens housing complex—How is transportation in the area? Will it be moving a low-income group to a middle-income area? What about crime at the new location? Would the new building disturb the ecology of the area?—to laying out a complete new town. Because of the scope of the field today, many planners dig into a specific part of the planning process. They are specializing in transportation, urban renewal, design, and the social services (education, health services, environmental health, crimi-

nal justice), to name a few areas of interest. The field draws its personnel from a wide cast of the net. Architects can be planners. Engineers are sometimes transportation planners. And students with majors from geography to economics are entering the profession.

The Good Planner

Many qualities go into making a good planner, but the American Institute of Planners considers these the most important: 1. a capacity to analyze difficult problems and come up with imaginative ways of dealing with them; 2. a commitment to social and environmental change—not holding on to the old order; 3. a desire to work with people to help them in developing *their* preferred solutions to the problems that concern them, for planners do not know automatically what people want; and 4. plenty of initiative.

To the above could be added some words from women already active in the field. Be able to write a good sentence, says one. Written reports, surveys, Master Plans, etc., are a good part of a planner's responsibilities. Be able to present yourself well, says another. Of equal importance is in-person presentations of your, or your department's, recommendations, not only to your immediate superiors but to outside agencies, public interest groups, the City Council, the Mayor, the media. The process of effective communication and of treading the delicate political tightwire of the governmental bureaucracy are skills that must be developed by the woman who seeks to get ahead.

Popular books can whet one's interest in the profession. Suggested best sellers that are not textbook-heavy and yet can convey an overall idea of the problems of today's environment are the books of Lewis Mumford and Jane Jacobs; *The Greening of America*, by Charles Reich; *How to Save Urban America*, by the Regional Plan Association; and *The Power Broker*, the Pulitzer Prize-winning biography of Robert Moses by Robert Caro.

It is also possible to watch planners at work. Attend public hearings and meetings of the local Planning Commission.

Volunteer jobs at some public agencies are sometimes availa-
ble, especially for enterprising high school students. Actually,
anyone who has done community volunteer work in fighting a
zoning variance, say, or lobbying for park improvements or a
day care center or whatever, has had a taste of the work of the
planner and, in fact, has probably run into one or two while
being the activist.

One City Planner

There are no Frank Lloyd Wrights or Christiaan Barnards in
planning—at least none has yet come to national prominence.
So let's take a look at one typical planner whose office is City
Hall.

Peggy Sheehan, at twenty-seven, is principal planner (high-
est level of planner on the Civil Service ladder) for Jersey City,
New Jersey. Late in 1975 a federally financed study depicted
Jersey City as the worst large American city in which to live.
A nice challenge for a young planner, that. Jersey City is per-
haps typical of today's urban blight, as the phrase goes. It is
an old waterfront city, directly across the Hudson River from
downtown Manhattan. The middle class has largely fled, leav-
ing behind the unemployed, the pensioners, and those making
a marginal living wage.

The city has plans for an elaborate waterfront renewal pro-
gram. And there are still blocks of attractive housing—a few
brownstone revival neighborhoods have sprung to life.

But there are whole chunks of the city that resemble East
London after the war. Skeletal, burned-out hulks of buildings,
vacant lots, abandonment.

The planning department consists of nine men and two
women, plus a clerical staff. It is divided into transportation,
zoning, regional planning, housing, and environmental plan-
ning. Ms. Sheehan is in housing. She develops housing pro-
grams for different neighborhoods, prepares funding applica-
tions and does housing research. She is also responsible for all
environmental reviews. Right now she is updating fair-market
rentals.

With just one large map of the city on the wall her office is

spare. Her desk is not. From the look of Peggy Sheehan's desk, she will never catch up. But she smiles as she looks down at the mass of papers, books, documents, charts. "You can get by doing just what is required," she says, stirring her early morning container of coffee. "But I always have to do more." Again the smile.

The biggest satisfaction in her job, she explained, has been preparing the federal revenue program for Jersey City—the city has received a six-year commitment for six and one half million dollars a year—and her biggest challenge has been how "to get the community to work with us on where and how the money should be spent.

"I started by contacting every church and civic group and block association I could think of to get a representative from each to attend the meetings. There were more than twenty-five people and the meetings were held over a three-month period. A lot of people were dissatisfied at the way it was done. But it *was* a good attempt at involving the community, and many people who complained did admit later they had no idea how complicated it was to see programs like this through.

"Now there are eighteen people from each of our six wards meeting once a month. They're given a report on where the program is."

And where it is is that there are some twenty projects under way. Among them:

 • a neighborhood preservation program to aid three historic areas in the city in housing upgrading, vest pocket park improvement, etc.

 • a new architectural team that will work on the downtown

 • completion of forty of the last units in a public housing project

 • continuation of eleven projects originally funded under the Model Cities Program, but which had since the expiration of the Model Cities Program been discontinued

 • increasing a tenant service to provide an additional five staff people to advise and counsel apartment dwellers.

Ms. Sheehan developed an interest in planning in the late sixties while doing voter registration work. But she thought the profession was too architecture-oriented, so she chose a graduate program (following a B. A. degree in history) at the University of Wisconsin in urban studies. And ended up a planner after all. She secured the position of senior planner (a notch below the principal title) in 1970. She has since completed a half dozen courses at the New York University Real Estate Institute and is now studying computer programming. Add to that a rigorous commuting schedule. Ms. Sheehan travels from Long Island every day, across Manhattan and into New Jersey. It's fair, she says. Her husband travels the same distance to his job at the other end of Long Island.

About her job she is pragmatic: "If you look at long-range planning you never get anything done. I realize the limitations of government agency work. I know, for example, that we can't use most of what's being offered us because it's mostly for homeowners. I know there's very little private-sector rental housing right now and that any programs would basically be a continuation of housing within the public housing framework.

"I remember a planning teacher at school who wanted to impart ethics. He said, 'Don't ever agree to do a survey or research for a group whose goals you don't subscribe to.' Everyone laughed because we were all doing things like that— working on a questionnaire for groups that would ultimately throw people out of their homes. There's lots of theory in school, not all of it applicable to real life."

She cautions against high expectations. "I sometimes tell interns here, 'Don't think you'll have seen a new building or a new park while you're here. It won't be a wonderfully fulfilling experience. In fact it's downright drudgery.' Right now there's a student downstairs earning six credits going through tax records to find out how many senior citizens live in a preservation area."

Then, of course, there are always the funding problems that go along with working with a city agency, not to mention, as she puts it "the political reality of dealing with politicians." The smile has become rueful.

Schooling . . . and Then?

A growing number of junior colleges and community colleges are offering two-year programs leading to an associate degree in planning or urban affairs. Graduates of these schools usually work in planning agencies as technicians or assistants to professional planners.

There are only a few schools—the University of Illinois and Rutgers University, to name the better-known ones—offering programs leading to an undergraduate degree in planning. A spokesman for Rutgers' undergraduate planning program said he had no trouble placing a young man in an entry-level agency position similar to one the holder of a master's degree would enter. And a young woman he described as "exceptional" was placed with a private consultant, considered quite a coup for a beginner.

But he agrees with almost everyone with a perspective of the field that a graduate degree is pretty much mandatory for a move-up-the-ladder career in planning, although it depends, of course, on one's level of ambition. There is a minority voice that asserts a graduate with a bachelor's degree should begin work in the field and then perhaps continue her education in the evening. Work experience sometimes can substitute for the advanced degree.

There are more than fifty colleges and universities offering graduate programs leading to Master of City or Regional Planning degrees. Which are best? "There are no heroes these days and that seems to apply to schools, too," remarked an administrative officer at AIP. High marks have, however, gone to the University of North Carolina and the University of California at Berkeley.

Any undergraduate degree will usually suffice for admission, although those in the field suggest majors in economics, geography, and the environmental sciences. Some math courses, statistics, and a basic computer course are also helpful.

Admission is competitive. Any outside work the applicant has done in planning or allied areas can count in her favor. Volunteer work counts, too. Have you, for example, tracked over your locale to contribute data or sketches to your community land map? Have you worked with an environmental

group? How about your downtown area—a project to preserve or upgrade the commercial district?

This type of effort: A second campus of the local community college opened in Marin County, California. No big news story to most papers in the Bay Area, but the editor of the *Pacific Sun*, an "alternative weekly," took a somewhat cooler look at the sleek new institution of higher learning. He mobilized a volunteer squad, almost all of them housewives, to look into the school's raison d'etre. Among other findings, the squad discovered that since Marin was moving toward a no-growth state, the new campus, which was built on the basis of a population projection of the early sixties, could become a "ghost town." The school wasn't necessary at all. The woman who had worked on the *Sun*'s task force could well put her experience on an application blank, stressing the planning aspect of her research and findings.

Where the Jobs Are

The planner can work for city, county, state, or federal agencies, for the private consulting firm—the Rand Corporation "think tank," for one—or the regional agencies: the California Coastal Commission is an example. Some of the larger developers hire planners. Positions in the public sector are more plentiful, consulting work usually pays better. Frequently, too, planning means relocation. In fact, in the public sector challenges must come from transfer to an even larger city where the planning problems are more complex than those in the city left behind.

Here is a sampling of entry and mid-level positions taken from TAB—a job-openings bulletin issued twice a month by the American Society of Planning Officials (ASPO). In this particular issue there were twenty-eight positions listed, the highest paying one with the city of Fort Wayne, Indiana, at $30,000.

Pennsylvania—(Huntingdon) Huntingdon County Assistant Planner ($10,000-12,000. Rural, mountainous county needs assistance in preserving an irreplaceable natural and cultur-

al environment. An opportunity to meet planning challenges before the impact of major growth is felt, to start with a small, newly formed planning staff, and to face the full range of planning concerns. Master's degree in city or regional planning. No experience necessary, but writing and research skills and a flexible mind are required. Apply. . . .

(St. Petersburg, Florida) Economic Development Division Assistant Economic Development Economist Salary $14,000 to $18,500, depending on qualifications. Bachelor's degree or master's degree in economics, planning, business administration or related fields with three to five years' increasingly responsible experience in economic development planning. Strong background in urban economics analysis and experience in input/output or cost-revenue analysis preferred. Apply. . . .

Chicago, Illinois. Northeastern Illinois Planning Commission. Rural Affairs Specialist $14,628-20,676. Will provide liaison between NIPC's central office and the rural communities. Applicants should have knowledge and experience in rural and regional planning, local government and community development. Graduation from a college or university supplemented by a master's degree in agricultural economics, community development, or planning and three years' professional experience or any equivalent combination of education and experience required. Apply. . . .

At the placement office of the University of California at Berkeley, the following openings were among the many planning vacancies during one two-month period:

Planner—Torrance, California—$1,030 per month

Planner—Chino, California—$1,250

Senior Planner—Eugene, Oregon (six years experience plus B. A.)—$17,000

Community Development Director in Bay Area—$1,636

Land use planner—Oregon—$1,129

Associate Planner—Richmond, California—$1,437 (college

degree plus four years' experience or master's degree plus two years' experience)

Job openings, according to Jane Adams of the university's placement office, are posted nearby for architects and land-scape architects, but there are few of them compared to the rather extensive planning listings.

Jobs in the public sector differ, of course, from one community to another, and so does the make-up of the planning department or other agency. But let's look at the structure of one city's planning department—Los Angeles, with its 200 souls coping with the sprawl of "a hundred suburbs in search of a city."

The Director of Planning, according to the brochure about the department, has the responsibilities of administering the staff, setting out the department's work program (formulation of programs and projects) and making recommendations to the City Planning Commission, the Mayor, and the City Council on planning matters. (The City Planning Commission is a five-member part-time board appointed by the Mayor with the approval of the City Council. Its function is to review the recommendations of the Planning Director in order to advise the Mayor and the City Council. In some instances—zoning changes, for instance—it is empowered by the City Charter to make final decisions.)

Then there is the department. Under the director there are the following categories of planner, as defined by the Civil Service examination job descriptions. There is talk of revising job descriptions and/or qualifications in one way or another, but the listings do, for now, offer an insight into how a City Hall planning department is structured. Los Angeles is atypical because of its size, but in smaller cities the set-up is pretty much the same—just on a smaller scale.

Principal City Planner (starting salary $2,456 per month).

The duties: A Principal City Planner serves as Assistant Director of the Community Analysis Bureau, or directs the work of a major division of the City Planning Department. The requirements: Two years of full-time paid experience as

a Senior City Planner or in a class which is at least at that level and provides experience in urban planning or zoning. A master's degree in city and regional planning is desired, but not required.

Senior City Planner ($2,027 per month)

The duties: A Senior City Planner supervises a specialized unit engaged in professional city planning activities.

The requirements: Four years' experience as City Planning Associate. A master's degree in urban planning is desired but not required.

City Planner ($1,700 per month)

The duties: A City Planner plans, supervises, coordinates and reviews the work of a unit engaged in professional city planning activities in community and city-wide planning, environmental planning, and city zoning laws.

The requirements: Two years' experience as City Planning Associate. Master's degree in Urban Planning or closely related field may be substituted for one year of experience.

City Planning Associate ($1,450 per month)

The duties: A City Planning Associate prepares or assists in the preparation of studies and reports in the areas of Community Planning, Environmental Planning, and the City Zoning Laws.

The requirements: 1. Graduation from a registered four-year college or university and two years of full-time paid professional planning experience as a Planning Assistant, or in a class which is at least at that level and which provides professional experience in Urban Planning.

2. A master's degree in Planning, City or Urban Planning, Community Planning, Regional Planning, Transportation Planning, Redevelopment Planning, Urban Economics, Geography, Urban Sociology, Urban Studies, Urban Design, or Environmental Studies may be substituted for *one year* of the required professional planning experience.

3. A master's degree in Environmental Engineering, Political Science, Public Administration, Architecture, Landscape

Architecture, Civil Engineering, or Law may be substituted for *six months* of the required experience.

Planning Assistant ($1,230 per month)

The duties: This is the professional entry-level position. A Planning Assistant does planning work at a professional level by researching, studying, surveying, and reporting on city urban and community planning problems.

The requirements: A four-year degree in Urban Planning *or* (2) a four-year degree in Architecture, Landscape Architecture, Mathematics, Engineering, Public Administration, Geography, Economics, Sociology, Political Science, or Urban Studies *and* one year professional experience in Urban Planning *or* (3) a four-year degree in any field and two years' professional experience in Urban Planning *or* (4) ten years of professional experience at the level of Cartographer.

Hethie Parmesano is moving through the labyrinthine Department of City Planning of the city of Los Angeles. An exceptionally qualified woman in her late twenties, Ms. Parmesano brought a Ph.D. in Economics from Cornell University to her entry-level position of planning assistant. Unsure at first whether to continue in planning—she and her husband were new to California and had several career choices under consideration—she is now plunging ahead and aiming for a planning associate slot. "My job right now is rather specialized," she explained. "I do quite a bit of research—population and employment projections—and working with computers to predict housing and unemployment statistics." She also attends meetings as liaison between the planning department and other city agencies—and in the evening teaches research techniques at California State Polytechnic University at Pomona.

Her office—or rather her desk—is typical of City Hall; i.e., several desks in one overcrowded room, no decor save the ubiquitous plants and colorful gewgaws on or around each desk, cartons of printed material piled high in the hallway outside the office door. The air is busy, as opposed to studiously quiet.

"Under civil service you need to be a self-starter," Ms. Parmesano cautions, a frequently heard qualification for government service. "There's lots of dead wood around. If you want a nice, quiet job you can have it, maybe spending a whole day processing zoning change applications." But if you want more, she concludes, you must do more.

Then there is the private consulting firm.

Raymond, Parish & Pine, Inc. is based in Tarrytown, New York with offices in Camden, New Jersey, Harrisburg, Pennsylvania, Hamden, Connecticut, Philadelphia, Pennsylvania, and Washington, D. C. The firm provides services in land planning, environmental studies, site engineering, market studies, traffic planning, zoning, and historic preservation/restoration. Its president, George Raymond, until recently was chairman of the planning department at Pratt Institute in Brooklyn, which offers a graduate degree in the field. One of his students in January 1974 was Deborah Parriott, a young woman from the Denver-Boulder area who was a recent history graduate. But in her senior year at college she took a course in urban history and became, as she explained later, more interested in the future than in the past. Now she is a planner.

While at Pratt, Ms. Parriott turned in a paper to Mr. Raymond. It was on new towns, as she recalls. It was also an exceptionally fine work, so good Mr. Raymond hired her as an intern for RP&P. "It doesn't matter to me, man or woman," he said in explaining his decision—incidentally, quite a break for any student. "How you perform, what your interest is, that's what's important."

Ms. Parriott was salaried as an intern, besides earning credits. She is now working full time for the firm and continuing her schooling in the evening.

She was hired specifically to work on the Master Plan for Brookhaven, Long Island. Master Plans show, step by step, the direction a town should take in future years in its land use, schools, types of housing, etc. Plans, some of which are enormous documents with charts and maps, have become pop-

ular since the overall rise in interest in planning concerns.

The project director for the Brookhaven plan was Edith Litt, vice-president of Raymond, Parish & Pine and, along with Ms. Parriott, one of only three women on a staff of thirty to forty planners. Brookhaven, Ms. Litt explained, had specific problems. It was growing like Topsy—the population had tripled, to 320,000, in the last fifteen years—and was feeling the pressures of that explosion. How should it continue to develop? Or was "no-growth" in order? The four staff people who worked full time on the project—at times there were as many as twelve assigned to the job—took a year and a half to complete the Master Plan. The most far-reaching single recommendation made, says Ms. Litt, was that Brookhaven develop a lower-density zoning category because the water supply was sandy and the town absorbed water quickly. However, the report also said the town could support a population of up to 750,000, and that some 2,300 units of housing were needed for the elderly.

(A footnote to the plan: late in 1975 the Brookhaven zoning law was attacked in a class-action suit charging that the town's zoning law was exclusionary and that low-income and minority families were "systematically restricted to enclaves" within the town. Never mind the elderly, who were predominantly white and middle-class. The suit was modeled after the historic Mt. Laurel, New Jersey, decision earlier in the year, in which the New Jersey Supreme Court declared that the zoning ordinances in that community were economically and racially exclusionary. The Mt. Laurel decision was expected to upset quite a few housing and zoning apple carts nationally).

Ms. Parriott recalls of her work on Brookhaven's Master Plan: "The town board approved it. Sometimes you do a plan and nobody will adopt it." Sometimes, too, a Master Plan—or huge portions of it—becomes outdated almost on publication, as change in the community has been going on throughout its preparation. Such books are relegated to a shelf in some planning director's office and that's the last of them.

The young planner prefers consulting work: "You don't get some of the continuity you get with city work, sometimes the consultant isn't retained for a continuing period of time, but

you get more latitude and more freedom." Ms. Parriott works on housing studies, some Master Plans, and occasionally helps municipalities with Community Development applications—how much money they should ask for under the federal funding program and what they will do with it when they get it. There are also commissions from private developers: site plans, economic feasibility studies. And in the area of historic preservation: preservation or restoration of a main street, alternative uses for a building.

"A generalist can put the pieces together. I'd much rather do this than specialize."

She offers a word of advice: "Watch the school you choose. Harvard, for example, is more scholastic. At Pratt you have a working faculty and that could be more practical."

Women in the Profession

As mentioned at the beginning of this chapter, women are faring better in planning than in other professions. A survey by the American Society of Planning Officials in 1968 showed that women were granted thirteen percent of all B. A., M. A., and Ph. D. degrees in planning and related fields. In 1974 that number had risen to thirty-five percent. In 1973 the joint AIP-ASPO Women's Rights Committee set a two-year target for the following achievements: 1. women should comprise at least twenty percent of the students enrolled in planning schools; 2. women should comprise a minimum of twenty percent of the professional staff of each planning organization. They were then between ten and twenty percent of the staff. The group also aimed to advance women within the profession to managerial and supervisory positions within all planning organizations.

The 1975 target date found most of their ambitions realized—if not totally, at least the percentage points are coming up nicely. Women are doing well in planning, according to Connie Lieder, the Baltimore planner and chairwoman of the group, although she adds that in another area they still comprise only six percent of planning faculties at colleges and universities.

The attitude of male co-workers and employers is generally

good. One woman planner said, "The men in planning tend to be liberal politically anyway. And if there are a few chauvinists around it's only because their consciousness hasn't been raised. Once you straighten them out on a point or two they're all right, too."

Another factor working in favor of women is that planning depends in great part on the professional with imagination along with the set skills. And imagination, unlike weight lifting, does not favor one sex over another.

Job Outlook

It looks good. The American Society of Planning Officials estimated that in 1972 over ten percent of all jobs in the city, county, and metropolitan (city and suburbs) areas were vacant. Listings in TAB, the job-openings publication of ASPO, appeared plentiful in 1975, as did those reaching college campuses, although the latter are almost always positions in the public sector.

On the federal front, Department of Labor statistics issued in 1975 estimate average annual openings for planners to 1980 at 750. Planning should remain strong, the report said, as long as there are urban renewal programs, land improvement programs, beautification and construction of new towns and cities, and preservation of existing buildings.

Public vs. Private Practice

Which to choose—public service or the private consulting firm? In many respects it's six of one and a half dozen of the other, with the private sector usually taking the lead for better pay in the long run.

A civil service position is, of course, secure from the vagaries of the economy and the labor market (although municipal cutbacks sometimes see planners furloughed right along with other civil servants). A successful planner—one who is also skillful in politics and knowledgeable in budgeting—can rise to prominent city or state positions. John E. Zuccotti, chairman of the New York City Planning Commission ($45,000) was named Deputy Mayor in the heat of that city's fiscal crisis

in 1975. Described as "a brilliant planner," Zuccotti is credited with broadening the planning process of the commission by introducing local boards (there are now sixty-two such boards) into the process, redefining the process as something continuing and fluid rather than as a search for an absolute embodied in the somewhat static goals of a Master Plan. He has also succeeded in utilizing a number of special zoning mechanisms to blunt community opposition to development, while persuading builders to provide certain design amenities sought by communities.

A glowing record, and an even more glowing future in the political arena, according to those in and around City Hall.

But being a good politician means dealing with the political realities, and this can aggravate and discourage planners. There is the constant attempt to please all sides. There is money—or rather the lack of it. "Right now housing is in a slump," said Peggy Sheehan, the Jersey City planner. "It's so hard to be working on plans for certain types of housing when you know you can't see them through."

Money is no problem with a private firm, at least not for the individual planner. Usually a contract is arranged before a project is begun. Also, there is a certain variety to the assignments a consultant undertakes, allowing her to dip into, and acquire experience in, a number of planning specialties.

Professional Organizations and
Other Career Guidance Sources

The American Institute of Planners is the national organization of professional planners, regional and urban. Its close to 12,000 members must pass an oral examination to be approved for membership. "For someone to put AIP after his or her name—that's as much of a qualified planner as exists," said one on the field. The AIP publishes a raft of printed material to aid the woman interested in the profession.

Brochures for newcomers and those who have not yet made a career choice include "The Social Responsibility of the Planner," "The Challenge of Urban Planning," suggested reading lists, and a directory of colleges and universities offer-

ing planning and related degree programs (a joint publication of AIP and the American Society of Planning Officials). There is no charge for any of these publications.

Affiliate membership in AIP for those in fields related to planning, such as law or the social sciences, is available at a cost of $50 a year and offers many of the benefits of full membership.

The institute publishes a quarterly Journal, a bi-monthly magazine, "The Practicing Planner," and several newsletters. All of these, plus periodic reports and notices of conferences, etc. are available under the Full Publication Subscription program, which costs $30 a year. It is open, of course, to non-members. Separate subscriptions to the bi-monthly magazine, a lively publication, are $15 a year.

For those in college or working in a planning agency and considering planning as a profession, there is an Intern Membership in AIP, which introduces the beginner. Annual dues are $10.

The American Institute of Planners is at 1776 Massachusetts Avenue, N. W., Washington, D. C. 20036.

Then there is the American Society of Planning Officials. It is the layman's organization and anyone interested in planning can join. ASPO has about 11,000 members, many of whom also belong to AIP. Membership dues are $25 a year, which includes copies of the monthly magazine, "Planning," plus TAB, a list of job openings that is issued twice a month. ASPO will be happy to send a complimentary copy of "Planning" to interested women at no charge. Their address is 1313 E. 60th Street, Chicago, Illinois 60637. Again, some of their career material might be a duplication of the AIP—the two have brought out joint publications.

Would-be planners in the San Francisco Bay Area (and those in the profession who haven't heard about the group) might contact *Bay Area Women Planners Association* for a bit of sorority. The organization is quite active, with more than 200 members. Write Spring Ruth Friedlander at 434 66th Street, Oakland, California 94609. Printed material available here, too.

4

Running Auctions and Tag Sales for (Fun and) Profit

REMEMBER THE AUCTIONS OF TWENTY—EVEN TEN—YEARS AGO? Something vaguely fly-by-night about them, wasn't there? The cold barn or boardwalk shack, the questionable goods, the sleazy, frequently snoozing, audience. Then there was the auctioneer. Color him the same hue as rainmaker. A mesmerizer, to be sure. But . . .

Well, times have changed. And in this instance for the better. Auctioneering is a respectable business these days, not to mention a growing and profitable one. Along with social acceptance has come a difference in how the profession presents itself. The chanting auctioneer today is sometimes a woman. And—although certainly entitled—she's no Ma Kettle in white ankle socks, either.

The first woman auctioneer was licensed in 1946, and for many years she had little company. In 1963 there were just six women out of 2,000 auctioneers nationwide. Ten years later, the National Association of Auctioneers reported the number had risen to forty women out of 4,000 members. Now the leap. In 1976 there were close to eighty women in the same general membership.

"Women are just not very successful as auctioneers," remarked Bernard Hart, executive director of the association in 1973. "Most of them have voices that are too high-pitched and they don't have the stamina."

And how did Mr. Hart feel about that statement in 1976?

He replied with a chuckle, obviously chastised somewhere along the line, "I guess I've had to change my mind about women. Look how many there are. That says something."

How important is voice? Some women agree with him that it takes a certain pitch to conduct auctions without grating on the audience or fading in an hour's time when some events run considerably longer.

But, says one woman auctioneer, "Voice doesn't matter. They'll wait a few seconds to get used to your pitch. And the mikes help." So a Jackie Onassis whisper, no. Every other range should make it.

Today, women are selling just about everything that can be put on the block—tobacco, art, home furnishings, houses and condominiums, even cattle.

In New York City, Regina Hayes, who took over her late husband's auction business in 1968, has sold confiscated, abandoned, and stolen automobiles for the city's Police Department. They've gone for from $5-10 up to $2,000 and more. She has also auctioned unclaimed trunks and baggage for hotels, the YMCAs and the Port Authority of New York and New Jersey. (The latter bring especially large crowds. Bidders dream of finding riches in the abandoned suitcases.)

In Steamboat Springs, Colorado, L. L. "Cookie" Lockhart sells both livestock and farm and factory equipment at auction.

Ms. Lockhart, who is in her mid-thirties, is the daughter of an auctioneer and her own daughter is now attending auction college. She and her partner, Mr. Lee Van Otterloo, and their staff of fifteen handle about thirty auctions a year as Lockhart-Lee Auctions.

She also announces parades and cutter races (two teams of horses pulling a sled or buggy), occasionally models, *and* manages her own real estate brokerage business.

(Surprised at almost nothing in the auction business, Ms. Lockhart's resonant contralto voice still expresses a touch of amazement at how much supposedly worthless items are going for these days in the name of nostalgia.

"They're buying wagon wheels for living rooms or decoration outside and I recently sold a worn-out brown wood toilet seat for $37.00. *$37.00.*" A tribute to nostalgia—and to one sharp auctioneer.)

Some women enter the business via antique shops, accepting goods on consignment for resale. But an even greater number, like Cookie Lockhart and Regina Hayes, come into the field through contacts closer to home. Auctioneering is a family business.

Duke Rath's Auction Center in Elgin, Illinois, has produced perhaps the youngest auctioneer in the country, Mr. Rath's seventeen-year-old daughter, Mari Kaye. Ms. Rath has been helping out around her family's business since she was twelve. She recently completed a course at one of the country's auction colleges and now spends weekends and summers up there on the podium chanting. Her father says, "She'll say anything up there to keep things going." Mari Kaye agrees. "If it's going slowly I'll stop and give a little sales pitch, tell jokes, try to keep the ball rolling."

Agreeing with other auctioneers that the toughest items to sell are the miscellaneous "junk," Ms. Rath has also found cattle rough, at least initially. "It was the first time I had to auction something in cents per pound. That's hard to keep track of in bidding."

The most difficult part of the task, the women have found, is that first session, or those first few sessions, at the microphone. Doing the chant in front of a hundred or so customers, all the while mindful of the item on the block, how to describe it, how to get a good price for it, and what's coming up next. Please the crowd, please the seller, please your own company. Pressure.

Said Mari Kaye Rath: "The first time I got up was at auction school in Mason City, Iowa. It wasn't too bad because I didn't know anyone there. But the second time, my parents

came up to hear me and that sort of scared me a little, my father being an auctioneer and all. But once you get started you get caught up in what's happening."

Marge Kennelly, a Ridgewood, New Jersey, real estate broker and auctioneer, has never forgotten the initial "crowd fright" of *her* first auction nearly ten years ago.

"I was scared to death. I had a speech impediment, a lisp. The mike scared me. I absolutely didn't know what I was doing, and when I say that I mean it. I had no background in the auction business. I just went out and did it."

Ms. Kennelly is one of a growing number of brokers who are offering one-stop real estate service: sales, appraisals, auctions, and estate, or tag, sales.

Unlike most women, she does not use the chant. "I don't like it," she says. "It sounds like cattle calling. I figure if you can't understand me you're not apt to bid."

Auctioneering is a business, but the women who conduct auctions know the day's event is also entertainment. There is a responsibility to make it lively and interesting.

"Take a good auction out of doors in good weather and it can be more fun than going to a show," said Ms. Kennelly. "It's a ball.

"I finally dragged my cleaning lady to one of my auctions after years of trying. She turned out to be one of my biggest buyers. My boys had to help her carry everything home."

The Job Outlook

Said one man: "They taught us in auction school that when times are good you can make a living and when times are bad you can get rich!"

Times have indeed been rough lately, and auctioneers are reaping the few rewards of a downturn economy. Personal and corporate bankruptcies have increased. (Involuntary liquidations arranged through the federal or state courts take control of a debtor's assets and dispose of them for the creditors. Auctioneers are paid a percentage of the gross set by the court— usually around seven to eight percent.)

Too, buyers in general are shopping around these days and

the auction method affords a glimpse of what is being offered in the marketplace at what price.

Some states require the licensing of auctioneers; others do not. Members of the twenty-seven-year-old National Auctioneers Association must be licensed.

The turnover rate among auctioneers is high. But the times, while bad for many, are ideal for the auction business. They always are.

How to Get Started

It helps to be born into the business. Otherwise, hitch your wagon to a star is the advice of women now in the business. Work for a reputable auction firm, even if it's as the resident "gofer." There is no better way to learn the business than by observing and doing. There is no textbook.

The National Association of Auctioneers (their address is at the end of this chapter) will put any interested woman in touch with the member auction firms in her state. She can contact them directly for additional career guidance and, with a little bit of luck, a job.

That is local. Should a would-be auctioneer come to New York, say, along with the would-be writers, advertising people, etc.? Why not? A stay at Sotheby Parke Bernet Inc. would be invaluable instruction in the handling of art and furnishings. So would work at Sotheby's or Christie's in London. But in New York, bear in mind that the Parke Bernet gallery is British-owned now, with about half the staff coming in from abroad. Competition for jobs is intense. Alternatively, turnover is high, providing a revolving number of openings.

Early in 1976 Sotheby's named its first woman auctioneer at its Madison Avenue Galleries. Lorna Clare Kelly, a thirty-year-old Briton who came up through the ranks at the gallery, finds crowd fright no problem. "All you have to remember is that bidders are more nervous about buying than you are about selling and you're home free."

What *does* threaten her equanimity is the house code and the speed at which she will be required to translate those code letters into dollars.

Ms. Kelly explained that everything—the amount of the reserve (that's the price below which an object will not be sold), the advance bids, and the estimates at which the pieces are expected to sell—is written down in code in the auctioneer's book. He or she must refer to it frequently, at the same time juggling dollar translations with the bids from the floor and lacing the chant with descriptions of the art objects up for sale.

Generally, both men and women put in a few years at the larger and/or prestigious galleries learning all they can, then head off in other directions (unless they rise like Ms. Kelly), usually into business for themselves.

At some point in the learning process, a course at auction college should be included. No woman, even those who grew up in the business, has found the course without merit.

A listing of auction colleges appears at the end of this chapter. The schools usually run a two-week course at a tuition charge of $200-$300. Students are taught the auctioneer's chant, how to handle oneself at an auction, how to develop an eye for the goods, and the business end of auctioneering. Some schools have specialities. The one in Montana, for example, is known for cattle auction instruction. Invaluable experience to the beginner is the requirement that each student run two auctions herself before satisfactory completion of the course.

The schools offer no placement service.

As with most careers in this book, auctioneering is for self-starters. It requires determination, nerve, and a terrific will to succeed. At the start it can be "enormously scary," as one woman expressed it. Since women in the field are still relatively few, there is little opportunity for the we're-all-in-this-together camaraderie that can be so comforting.

"You have to really want to do it," says Mari Kaye Rath, "or you'll chicken out again and again and again."

The Tag Sale

You have to appreciate our free enterprise system. Take a new do-it-yourself fad and sure enough there'll be someone along who will, for a fee, do it all for you. Tag sales, for example.

It was 9 A.M. and the no-nonsense bargain hunters had already begun gathering at the house on Holloway Lane, calling hello to familiar faces while heading determinedly for the open front door.

The sun had risen on still another professionally run tag sale in Westchester County, an expensive suburb north of New York City. But then, with so many held there these days, the sun can hardly miss.

Tag sales, also known as household liquidations and estate sales, are a growing phenomenon nationwide. They were a natural outgrowth of garage sales. Why bother ticketing hundreds of odds and ends, worrying whether you've picked the right price to get the item moving while still profiting? Why face the trauma of seeing friends and neighbors poring over—and walking away with—familiar possessions, even unwanted ones? Why bother setting the whole thing up? For a fee—usually twenty-five percent of the day's proceeds—you can hire someone to do it for you.

Contributing to the popularity of the sales is a highly mobile society with a tendency these days to sell unwanted goods rather than throw them out or cart them along in the moving van. And, at a certain income level, homeowners get sensitive about setting out their history in a driveway. Unlike the garage sale, tag sales move everything indoors for privacy.

They can be held in city apartments, but the sales flourish in suburban communities because houses mean a good supply of merchandise. In Westchester County, much of which is a string of bedroom communities, some ten to twenty women have set up shop in just one recent year.

But most of them fold down quickly. For one thing, competition is intense. One businesswoman laid down her loose-leaf notebook containing leads, addresses, and the like for a moment during one of her sales. When she picked it up again the filler sheets had all been removed. Competition is *very* intense.

Also, say the few who have succeeded, the business is far more complex than it appears to the housewife who may see it as a pleasant part-time job. True, no special skills or education—or even much cash outlay—are needed to get started. But a knowledge of antiques is mandatory. So is nerve

and, perhaps equally important, an outside income. Few tag sale operators can make a living conducting sales. Many are women who need their husband's income to give them that necessary nerve, and quite frankly are middle- or upper-middle income women who could not live on the low four-figure income most operators pull down.

One tag sale operator who has been successful is Linda Glick of Larchmont, N.Y., in Westchester County. Having been in the business close to five years, she is considered one of the county's three or four enduring tag sale operators. It is Ms. Glick who conducted the sale on Holloway Lane. An attractive woman in her late thirties, she bustled around the house greeting many of the early birds by name and helping her assistants in opening up the sale. The house itself was a split level situated on a quiet winding street already clogged with the parked cars of customers. It was a neighborhood of perhaps $60-70,000 homes.

Inside the rather prosaic furnishings were neatly priced with gummed labels and ready to go—literally. Everything from the pictures on the walls to food in the cupboards was for sale. "Everyone has a 10-cent measuring cup and a copy of *Ship of Fools*," remarked one tag sale operator. So did the Margolins.

Why were Bea and Albert Margolin selling all their worldly goods?

Ms. Glick sat on the edge of a bed, extricated herself from a few folded blankets being pulled out from under her by eager shoppers and explained.

With the exception of some clothing and a few treasured possessions, tag sale companies liquidate the entire contents of a house, unlike a garage sale where just miscellaneous odds and ends are sold. Ms. Glick said most clients, including the Margolins, are couples whose children have grown and left home and who are moving to smaller quarters, frequently in another part of the country. Other clients are leaving for nursing homes or are dismantling a household after a divorce. Sales are sometimes ordered by the estate of a deceased homeowner.

In Milwaukee, Wisconsin, a four-woman liquidation team

known as The Settlers was asked to handle an apartment where a murder had been committed. Everything was just as the police had left it, including the blood stained mattress. They were also asked to handle the home of a suicide, complete with bullet holes in the sofa. They turned both jobs down.

Transferred executives bring little business. They may get rid of a few items at a garage sale, but most of their belongings go with them.

Ms. Glick added that the Margolins were staying at a nearby hotel. "I don't want them here during the sale," she said. "It's too traumatic for them, even though these are the things they really want to leave behind."

Added another woman who runs tag sales: "I remember having a sale of my own things and I overheard someone saying, 'What terrible taste. How could she live with junk like that?'" The woman added with a chuckle, "*I* think I have exquisite taste. But that goes to show you these sales can be a pang to the homeowner. Very few people can go through one without some tremors."

As most estate companies do, Ms. Glick sets the prices on the items to be sold, although she allows homeowners to tag a sentimental favorite. Just one. In this case it was a pair of pseudo-Oriental lamps that were ticketed at $350. "If they bring $50 a pair, that's good," Ms. Glick said with a smile.

Clients are given an estimate of what the day (or weekend) should bring. The tag sale operators then charge twenty to twenty-five percent of the proceeds. Gross receipts range from about $2,000 to $20,000. Above that the sale is generally closed to the public and only antique dealers are invited to buy. Few companies will turn down even the smallest sale, though: it's good publicity. Ms. Glick says, "Under $3,000, I have the women who work for me run the sale. I make an appearance to show them I do exist, but I don't work the sale."

Ms. Glick employs seven women who are paid three dollars an hour to assist her in setting up a sale, which can take from a few hours to several days. The women earn thirty dollars for the day of a sale. Where very expensive merchandise will be

sold, Ms. Glick will hire a guard or two. The women are not allowed to buy at a sale they're working, and Ms. Glick buys nothing either. "If I want to buy I go to a competitor's sale."

As for her own compensation, she said it is fortunate that hers is a two-income family (she has a husband and a teenage son). "If I really hustled I could make a living at this," she explained. "It wouldn't be inconceivable to make $20,000 a year." As it is, she averages fifteen to twenty sales a year.

"I've always been interested in antiques. I used to go to liquidation sales in Minnesota when we lived there. When we moved to New York from Connecticut I had a knowledge of antiques and a very good eye. I'm still always taking antiques courses.

"I spent some time as a sales manager for Macy's and tried a new paper in Westchester. Then one day I heard of a couple who wanted to sell the contents of their house. I called them, they said go ahead, and it was very successful. Then a friend started helping me with the sales and it soon got to the point where I had to hire other women.

"The first sale, I priced things by what I would pay for them. Then you get excited when they buy and you raise the prices. But you find out soon enough they won't pay.

"There's a lot of competition here, but I don't know about some of the newer companies. They don't have an eye for the goods. They don't have a background. For one thing, you can never show a client you're insecure about anything and don't have an answer. If they say, 'How much is that tapestry worth,' I have to have an answer right there even if the answer is, 'I'll have my expert come in and look at it.' I know glass and porcelain; all my workers know something in different areas. Any of the dealers will come in for me because the next time I run into a house with a $4,000 dining room set that won't be sold, I'll go to that dealer and tell him about it. Just hanging around dealers you learn a lot. A dealer will call me aside and say, 'I want to show you this so you'll never forget it.'"

Ms. Glick added that it would be possible for the newcomer to get started on a cash outlay of under $1,000—to be spent on

advertising, some posters that are attached to utility poles directing customers to the sale, name cards, bulk postcard mailings announcing sales to prospective customers. Some companies go in for dressing up, which can be another initial expense. Marge Kennelly, the New Jersey auctioneer who also runs tag sales, decks out her workers in straw hats so customers can find them in the thick of a sale. Another company's uniform is a denim apron over plaid pants. The women working for Ms. Glick wear no uniforms.

Besides the relative ease of getting started, another attraction of the business to the neophyte is that there is almost no regulation of the sales beyond what goes with any business. There is the occasional part-time employee who puts some of the choicer merchandise into his or her pocket, but the most common gripe against the companies appears to be that grandmother's eyesore vase was sold for a lowly $3.50. In Westchester County, for example, no complaints against tag sale operators have reached governmental agencies.

The women use various approaches to find customers. They keep up on local gossip about who's moving, who's redecorating, who died (frequently the tag sale brings more people than the funeral). They pay a commission to bankers, attorneys, and especially real estate brokers for tips. And they advertise in local realty publications. Supposedly it is against a broker's ethics to give out names of customers, especially where a commission to them from the tag sale operator is involved. But members of realty boards say they release the names only if the seller of the house asks for assistance in disposing of his or her household effects.

Marge Kennelly says that even with the appearance of ease, "it's not a snap to make a success of this business. You've got to know household effects. You've got to know antiques and you also have to know current prices on new items—a refrigerator they want to sell, for example."

Yet errors in judgment do occur, even among the pros. Ms. Glick recalled that in one of her earliest sales, a pair of dirty black candlesticks was let go for $35. Buried under the grime was $800 worth of silver.

In a sale run by another company, a doctor's wife offered $2.50 for a round terra cotta object with a hole big enough for a bird's head. It was dangling from a tree (outdoor effects are sold, too).

"I sold that old birdhouse in the backyard," the tag sale operator told the owner.

"But, my dear," said the owner, "I have no birdhouse."

What was sold was a piece of pre-Columbian sculpture worth thousands of dollars.

"Every single one of us has let good things go by," Ms. Glick remarked. "You have to be so careful. Mistakes look bad for all of us." She glanced around the bedroom, by now looking emptier. Would everything be sold by the end of the sale the next day?

"The last day I'll sell at almost any price. And a woman from the 'Y' who has tag sales there takes batches of what's left. There's even a little old lady who comes in and buys half-empty bottles of Windex, things like that. Believe me, it'll all go."

It all went. The sale grossed $3,800. The two lamps were not sold and Ms. Margolin took them with her to Florida.

Additional Information

The auctioneer's professional organization is the National Auctioneers Association, located at 135 Lakewood Drive, Lincoln, Nebraska 68510. Besides answering career inquiries, the association will send interested women a copy of the monthly magazine *The Auctioneer* for a charge of fifty cents.

There are ten auction colleges recognized by the National Auctioneers Association. They are:

> Ruppert School of Auctioneering
> Box 189
> Decatur, Indiana 46733

> Mendenhall School of Auctioneering
> High Point, North Carolina 27263

> Missouri Auctioneering School
> 1600 Genesee
> Kansas City, Missouri 64102

Britten Auctioneering Academy
P. O. Drawer B
Bryan, Texas 77801

Nashville Auctioneering School
1921 West End Ave.
Nashville, Tennessee 37203

Knotts School of Auctioneering
1163 Second Ave.
Gallipolis, Ohio 45631

Superior School of Auctioneering
P. O. Box 1281
Decatur, Illinois 62525

American Academy of Auctioneers
3820 So. Cincinnati
Tulsa, Oklahoma 74105

World-Wide College of Auctioneering
Mason City, Iowa 50401

Western College of Auctioneering
P. O. Box 1458
Billings, Montana 59103

There are 115 members in the National Auto Auction Association. It is located in the Hilltop Professional Building, 144 No. 44th Street, Suite D, Lincoln, Nebraska 68503. Bernard Hart is the executive secretary—a knowledgeable man, helpful on any phase of the auction business.

5

Women in Construction

THE ARCHITECT DESIGNS THE BUILDING; THE ENGINEER SEES that it is structurally sound; those in the building trades erect it. Happily, these days, women are represented in all phases of the construction process. By lawsuit, by grudging tokenism, and in a very few instances by sailing in, women have begun to take hold in jobs that, whether requiring the formal schooling of the architect or the brawn of the construction crew, once had been another of those men-only strongholds.

The times are not propitious for a career in any of the job descriptions within this chapter, construction being just barely out of its mid-seventies slump. On the other hand, for a woman, the times can be pretty good for just such careers. It balances out. And new construction *is* on the upswing, however mild the activity.

The Architect

Women in architecture = women in ferment. Perhaps in no other profession is there the discrimination against women as there has been—and in many instance still is—in architecture.

Sadly, perhaps in no other profession is there as much unem-
ployment, too. The economic recession of the mid-seventies
has resulted in a building slowdown that has seen layoffs of as
many as sixty percent of the architects in some sections of the
country.

Construction is slowly picking up. In any event, there will
always be new buildings and there will always be the call for
architects to design them. Women in the profession have no
control over economic waves, but they can tackle the other
half of the gloomy news in today's architecture pictures: dis-
crimination. For, in fact, women comprise only about three
and seven-tenths percent of the nation's 42,000 architects, ac-
cording to 1970 census figures. They are eager to change that
picture.

In February 1975 the Task Force on Women in Architecture,
under the aegis of the American Institute of Architects, issued
a thirty-eight-page report entitled "Status of Women in the
Architectural Profession." The report urged AIA members to
recognize the following problems: under-representation of
women in the profession; inequality in employment oppor-
tunities; inequality in pay; and discrimination by omission
(women have rarely been represented among officers, directors,
committee chairpersons, or even committee members in AIA
and other professional societies).

Female architects responding to the task force's inquiries
told varying tales of discriminatory practices, from college
placement offices unwilling to "bother" with female graduates
to the inability of women to move above the lower entry-level
jobs in architectural firms to the still deeply ingrained think-
ing of many male superiors and co-workers that women do
not really need their jobs and are, in fact, taking them away
from deserving males. True, many architectural offices are
scurrying around to hire a woman, but those inside complain
that their attempts to move upward are hampered or ignored.
Hopefully, women feel, the AIA is directing itself to the find-
ings of the task force and raising the consciousness of more
than a few of its members.

Women say they have special talent for the profession. Al-
though conceding that some men think that way, too, one

woman architect feels that women have an aptitude for such areas of the profession as urban design—in planning community facilities and the plazas framing office buildings. Bobbie Sue Hood, a San Francisco urban designer, told a session of the special Women's School of Planning and Architecture meeting in 1975 at a college in Maine that women give thought to where the bench should be placed so it is out of the sun, how children will react, what access there is to refreshments and to rest. "It's part of what women historically have been educated to understand and they are often better equipped to solve such needs," Ms. Hood said.

Another speaker, architect Leslie Weisman, who lectures at a school in New Jersey, joined with Noel Phyllis Birkby of Brooklyn in exploring the value of fantasy in devising innovative solutions in architecture. "That sort of approach comes naturally to women once they put their minds to it," Ms. Birkby said.

Added Ms. Weisman: "Women have a major advantage over men in architecture. We may be highly visible in the profession because there are so few of us. But we've never been part of the establishment so we're not committed to it and can devise solutions men may be too restricted to consider."

The day-to-day workings of the profession are slowly changing, too, to keep up with today's demands for "more relative" buildings, for multi-use buildings to save both space and expense, and for esthetic structures that add to, rather than detract from, the remaining land and landscape of the country. Ugly buildings, those not in harmony with their surroundings and those that just plain waste space, are being looked on with new derision these days, not only by architecture critics but also by community planning boards, neighborhood organizations, and even prospective tenants in proposed apartment projects who are no longer willing to accept blindly what the architect hands down.

What does go into the rolled-up plans an architect passes on to his or her client? And who are the clients?

What Is an Architect?

Architects first meet with clients to discuss the purposes, costs,

and preferences for style of the structure to be built—home, office building, church, or school. Sometimes the project is the restoration or renovation of an existing, frequently architecturally significant, structure. Sometimes it is an entire "new town."

Architects must consider the local building and zoning laws, the fire regulations and other ordinances, and then submit preliminary drawings to the client. The final design will include plumbing, electrical, and heating systems in detail. The architect will also specify the building materials to be used and sometimes even interior furnishings. Next, he or she will assist the client in selecting a building contractor and will continue to represent the client, visiting the job site frequently to check on construction progress until the structure is satisfactorily completed and the required tests passed.

An architect can specialize in one phase of the total picture, such as designing, drafting, administering construction contracts, or specification writing. She must be something of an artist, she must be community-minded, if not an activist, a bit of an urban planner, and a researcher. She must be interested in the public good—better housing, better use of open spaces, etc. Add to the above more than a dash of idealism, and that's an architect.

Where Are the Architects?

The architect may practice in a small firm or a large one. She may work for an architectural firm or own one (close to forty percent of all architects are self-employed). She can work for a builder, a real estate firm, or a business that has large construction programs. In the federal government she can be employed by the Departments of Defense, Interior, Housing and Urban Development, or the General Services Administration. Federal and local government agencies are increasingly hiring architects for community planning and urban development projects, so that takes up some of the slack left by the slump in private practice. Interestingly, most architects can be found in California, New York, Illinois, Texas, Pennsylvania, and Ohio.

Education and Job Outlook

All fifty states and the District of Columbia require a license before the architect can practice, mainly to insure that work that may affect the health and safety or property of clients is done by qualified professionals. Requirements for admission to the two-day licensing examination generally include graduation from an accredited architectural school, plus three years' experience in an architect's office for those with a bachelor's degree (two years of experience with a master's degree). Sometimes work experience and completion of an equivalency test will substitute for formal education in applying for the examination.

Most architectural schools offer a five-year curriculum leading to a Bachelor of Architecture degree. It is also possible to attend junior or community colleges with two-year programs that will enable students to transfer to a professional degree program. At present, only eight percent of the nation's 2,000 architectural students are women.

The high school student should concentrate on mathematics, science, and social sciences. Women of any age considering the profession should be able to work independently, but conversely, should also be able to work with a team, since assignments can differ from one project to another. They must have a capacity to solve technical problems and be somewhat artistically inclined (but no artist necessarily) since esthetics plays no small part in building design.

New graduates usually begin as junior draftsmen in architectural firms. There they will make drawings and models of structures under the direction of a registered architect, and may advance to senior draftsman. Other novices work as designers, construction contract administrators, or specification writers who prepare directions explaining the architect's plan to the builder.

Salary-wise, the range is wide in the profession. Established architects can earn $25,000 a year or more. Beginners start at about $11,000 (somewhat higher with the federal government), and draftsmen with two or more years' experience will earn still more. But back to the old discrimination bugaboo,

women's median income is $16,000 vs. $24,000 for men.

The U.S. Department of Labor sees the job outlook for architects as favorable through the mid-1980s, principally because of new areas of government work. A slower growth is expected in private practice. Women should fare well as a result of positive action following the Task Force report.

Professional Organizations and
Other Career Guidance Sources

> The American Institute of Architects
> 1735 New York Avenue NW
> Washington, D.C. 20036

Offers a raft of printed career information, including the 1975 report "Status of Women in the Architecture Profession."

> The Association of Collegiate Schools
> of Architecture, Inc.
> 1735 New York Avenue NW
> Washington, D.C. 20036

Information about schools of architecture and a list of junior colleges offering courses in architecture.

The following are local organizations of women architects, which are extremely helpful with career guidance to women of any age (and sometimes scholarship assistance):

> Association of Women Architects
> Room 800
> 541 South Spring St.
> Los Angeles, California 90013

> Alliance of Women in Architecture
> 41 East 65th St.
> New York, New York 10021

> Organization of Women Architects
> P.O. Box 26570
> San Francisco, California 94126

Sisters for a Human Environment
11035 14th Ave. N. E.
Seattle, Washington 98125

Women Architects, Landscape Architects
 and Planners
c/o Boston Architectural Center
Newbury St.
Boston, Massachusetts 02115

Women in Architecture
c/o Patricia F. Richards
927 Fairway N. W.
Albuquerque, New Mexico 87107

Chicago Women in Architecture
1800 S. Prairie
Chicago, Illinois 60618

The Engineer

Kathryn Anner is a structural engineer specializing in build-
ing construction. She works out of the clean, air-conditioned
offices of Weidlinger Associates in midtown Manhattan, with
only occasional forays into "the field." Right now Ms. Anner
is completing—indeed she has been working on the project on
and off for the past three years—the new Tropical Asia Ex-
hibit at the city's Bronx Zoo. The principal building now
under construction will house animals from Asiatic countries,
some of them exotic species. Ms. Anner designed the facility,
working with the architect. The exhibit, which will feature
other specialized buildings, will be on a fifty-acre site. There
will be a connecting two-mile monorail system. That is not a
Weidlinger project, but Ms. Anner will design the platforms
leading to the monorail. She will also draw up several small
outdoor theaters, footpaths, and kiosks around the exhibit—
which will have an Indonesian motif and many additional
auxiliary and related facilities.

Barbara Bakst, also an engineer, is employed by Turner
Construction Company, a major national builder. At present
she is assistant superintendent on the site of a forty-story office
building going up in Chicago. She coordinates activities with

the numerous subcontractors ("for example, before the ceiling goes in you have to make sure all duct work for heating and ventilation is in"). The building is nearly completed and some early tenants have already moved in. At the height of construction there were five on-site assistants to the superintendent, plus an office staff back at headquarters with some engineers there, too.

When her work there is finished, Ms. Bakst will probably move indoors to the estimating department, or to cost engineering—which could be another assignment on the construction site. As part of her all-round education at Turner she will be sent where there is need. "I've no experience in purchasing," she says. "Maybe there'll be a position there."

Although the only woman "in the field" on this project, Ms. Bakst, who is twenty-four, has had only the most minor and what would nowadays be considered the most innocuous remarks made. "At first it was more of a novelty than a problem," she recalled. "They wanted to get me a pink hard hat and all that nonsense. And they'd give me a hand if I jumped off a high platform. I won't say I didn't get a little bit of a hard time, but no worse than any smart kid from college would have gotten. But if you know what you're doing, they've got to listen."

Kathryn Anner and Barbara Bakst are structural engineers. There are many other engineering specialties—more than twenty-five are recognized by professional societies. There are, in fact, eighty-five subdivisions in the major branches of the profession. But for the purposes of this book only civil engineering will be considered, and even there subdivisions can be found in structural, sanitary, hydraulic, and highway engineering.

What Is an Engineer?

What does an engineer do? Well, she sees to it that the, um, walls are sound and that . . . well, the plumbing works. And let's see. . . .

The best way to explain what an engineer does is to let an engineer explain what an engineer does. Kathryn Anner described her job recently in a symposium at an Engineering Foundation Conference at New England College in New Hampshire. Ms. Anner, who is in her mid-thirties, called her speech "From Katharine Gibbs to Paul Weidlinger." Besides detailing the work of a structural engineer, she tells the story of how a secretary—one Kathryn Anner—developed an interest in engineering, which she pursued through a college degree and a prime slot (she earns about $20,000 a year) at the firm where she began as secretary to the president. Secretaries in engineering with interest, curiosity, and ambition, listen. Ms. Anner's tale makes a fine textbook.

"The first time I was sent out on my own to visit a job site, I was nervous and worried about what questions I would be asked and what problems I would have to solve 'on the spot' without the security blanket of the office and the other more experienced engineers. The major problem that day was a sidewalk outside the building. It was cracking. The architect, contractor, owner's representative, and myself were standing around. I asked if the soil had been properly compacted before the concrete had been poured. The contractor turned around, looked at me, and said, 'Who are you?' The architect introduced me as 'the structural engineer from Paul Weidlinger's office.'

"Well, I'm still the 'structural engineer from Paul Weidlinger's office,' but what does that mean? As a structural engineer I am a graduate civil engineer specializing in the structural design of buildings and bridges rather than the design of roads, dams, or sewers. In school you receive training in all of these specialties in addition to getting fundamental courses in electrical and mechanical engineering. The structural engineer's job is to make the building stand up. He also has an obligation to the owner to design the building as economically as possible, to the architect to help him make it as esthetically pleasing as possible, and to the contractor to make it as easy to build as possible. As you can gather from this, the engineer's job is not just one of designing beams and col-

umns; it encompasses a great deal more than that. The experienced engineer, both mechanical and structural, is consulted by the architect usually at the very earliest stages of the design. That is why it is important to have some understanding of the problems and aims of the architect and mechanical engineer.

"During the construction phase of the project, we are called on by the contractor to interpret what is on the drawings, to offer alternate solutions to expedite the work in the field, and to help remedy mistakes that might be made in the field. It is also necessary to be familiar with the local building codes, and when called upon we must be ready to go to the Buildings Department to answer questions and explain our calculations and drawings. In building a building you start at the foundation and end at the roof. In designing a building you start at the roof and work your way down. This is a big problem for today's engineer. Because of rapidly rising construction costs, the contractor usually wants to start building the foundation while you're still designing the roof. A designer is involved from the preliminary planning of a building through the construction phase of the project.

"I wish I could talk more about the jobs I work on rather than about myself, but as a 'role model' I hope it will be helpful to you to know how I got here.

"After graduation from high school, I went to Katharine Gibbs Secretarial School. Before deciding on becoming a secretary, I had considered going to college, but I really didn't know what I wanted to study. I knew I didn't want to be a teacher or a nurse. I had always liked math, but I didn't at that time know what I could use it for, and besides, I really was anxious to earn some money and have some sense of independence. When I finished the year at secretarial school, I got a job through the placement office of the school with Drilled-In Caisson Corporation, a heavy foundation contractor. At Drilled-In Caisson I was exposed to the below-ground part of engineering—caissons, piles, and borings—and also to the hectic, tense period when a job was being bid on. I remember on one occasion working till late on a bid and then delivering it by hand to the general contractors. It was very exciting, but

also very disappointing when we didn't get the job. Even though I had this attraction to engineering, and as a child my greatest treat was when my uncle would take me to see steam-shovels at work, the idea never occurred to me that I could become an engineer. I didn't select the job at Drilled-In Caisson because it was an engineering firm, but rather because it was a small, one-girl office, and one thing I was very sure of was that I did not want to work for a large company. I also wanted a job that was diversified. This was the beginning of the direction my life would take.

"In a couple of years that company went out of business, and I had to look for another job. To my original requirements of a small office with diversified work was added a third: that it should be an engineering office. Once again I went back to Katharine Gibbs' placement office, and through them I got a job as secretary to Paul Weidlinger.

"Working in a design office was somewhat different from working in a construction office. In construction the engineers were very seldom in the office except when things were slow; whereas in a design office they were very seldom out except on periodic inspection visits.

"After working a year or two in my first job, I had begun to get the urge to go back to school, but I still did not know what I wanted to be. I attended Fordham University evening session, taking courses such as philosophy, English, and history without any particular direction.

"During this time my 'role model,' Alva Matthews, started to work for Paul Weidlinger. I don't remember Alva proselytizing or trying to sell me the idea of becoming an engineer, but just the fact that *she* was an engineer put the idea in my mind, and I was sure that was what I wanted to do. When I told Alva, she was delighted and, of course, gave me tremendous encouragement.

"I enrolled in the pre-engineering course in the first evening session given by Bronx Community College. Despite Alva's encouragement, I was still doubtful as to whether I would be able to do it. It had been several years since I had graduated from high school, and the first year of math and physics

courses was very tough. Once I got through the first year, I knew I would be able to continue, and that I wanted to continue.

"Mr. Weidlinger was not aware at first that I was planning on becoming an engineer, but one day he caught me getting some help on a math problem. From then on he helped me and encouraged me, often giving me statistics problems in between dictation. He is an excellent teacher, and his ambition for me now is that I get my Ph. D. and go back to being his secretary.

"I spent six years at Bronx Community College, and when halfway through I switched from secretarial work to drafting. As the time drew near when I would be completing my pre-engineering course I had to start thinking of transferring to a four-year school to complete my studies.

"Taking a leave of absence from work, I registered at New York University as a full-time day student, and in 1968 was graduated as a civil engineer. Fortunately I had a job and lots of help and encouragement waiting for me at Paul Weidlinger's office.

"Why did I become an engineer? To me it was, I think, a natural progression from one thing to the next. I enjoyed my secretarial work. My job brought me in contact with many intelligent and important people. The days went by quickly as I was constantly moving from one thing to the next. I was surrounded by engineers and scientists, but I didn't speak the language, and I was anxious to learn and be a part of their world. There was nothing more I could learn about being secretary.

"I didn't enjoy being a draftsman as much as being a secretary because I was very dependent on the engineer, and I also missed the contacts with the outside world and the perpetual motion of secretarial work. Now, as an engineer, I probably am a much better draftsman than I was at that time. As long as engineering is a challenge I will be happy as an engineer.

"Discrimination? I have to say honestly that I have never felt discriminated against because I was a woman. During my years of work, I have had contact with, in addition to Alva, a

structural engineer who now has her own office, a draftsman who is now an engineering professor, a former secretary who through her hobby of photography became interested in the construction end of engineering, went to New York University evenings and now is construction manager for a large contracting firm. In addition I have worked with women architects.

"Perhaps because of my contacts with these women, or perhaps because of the attitude of my teachers, fellow students, and co-workers, once the decision to be an engineer was made I lost any self-consciousness I might have had about being a *woman* engineer and settled down to trying to be a *good* engineer."

Ms. Anner added to the above that she did not at all regret her convoluted path to engineering. But now, at last, she's there.

Where Are the Engineers?

Like Kathryn Anner, they are in private practice and they are also employed by the federal, state, and local governments. At the federal level that may be the Departments of Defense, Agriculture, Interior, Transportation, HUD, or the National Aeronautics and Space Agency. At state and local government agencies, engineers work in highway and public works departments.

About one million people worked as engineers in 1972, the U.S. Department of Labor found. About one percent were women. More than half the total number worked in manufacturing. Over 325,000 were in non-manufacturing industries, primarily construction, public utilities, engineering and architectural services, and business and management consulting services. All levels of government employed more than 150,000 engineers. Another 45,000 were affiliated with colleges and universities in teaching and research jobs. A small number worked for nonprofit research organizations.

Education and Job Outlook

Engineering is the profession most receptive to women these

days and is one of the few professions that do not require a graduate degree. It is also one of the dozen or so college majors gaining in popularity in the mid-1970s, as students become increasingly job-oriented, spurning the more theoretical college courses. Part of those increasing numbers can be attributed to the greater number of women entering the profession—at some schools close to one out of three engineering students is female. They are doing well at graduation time, too, to the vexation of their fellow students of the male persuasion. To comply with federal Affirmative Action programs, many companies working on projects funded by the government are actively seeking women engineers. One result of this scurrying is the graduating class at a large university in a metropolitan area where the women graduates had three or four job offerings from which to choose. The only male to get a job—this is in the tight-right-now structural field—was a fellow going to work in his father's company!

Before college, however, young women must get the required mathematics and physics courses in high school to qualify for a major in engineering.

It should be noted here that physical strength is *not* needed for a career in engineering; witness Kathryn Anner's desk job. But other qualities are. Women in engineering, whatever their age of entry into the field may be, need an analytical mind, the ability to make decisions, and the ability to work with a team. No loners here, please. Engineering is an ongoing learning process, too, and engineers must be willing to continue their education throughout their careers.

All fifty states and the District of Columbia require licensing for engineers whose work may affect life, health, or property, or who offer their services to the public. Generally, registration requirements include graduation from an accredited engineering school plus four years of experience plus passing a state examination.

Engineering school graduates usually work closely with licensed engineers at first. But college graduates trained in the natural sciences or mathematics, or women with work expe-

rience in those fields, may also qualify for some beginning jobs.

There is a wide variation in salaries. Beginners average about $11,000. The median salary for women engineers is a little over $14,000, according to the Labor Department, which is not exceptional for the professions. Barbara Bakst, the on-site assistant superintendent in Chicago, says women in her capacity—i.e., perhaps a step above beginner—earn about $12,000.

But the figures can be misleading. Some include all branches of the profession, some are narrowed to civil engineering. In 1972 the National Science Foundation found that women were earning $12,000 a year to a male engineer's $16,900. But now, five years later, there are some reports that women are being offered more than male newcomers to lure them to the field. The salary picture could use a little clarification.

How does civil engineering rank in the overall job outlook of the profession? The U.S. Department of Labor expects engineering to remain open with plentiful job openings through the 1980s. Growth in the civil field is expected to continue relative to population growth, industrial expansion, and defense spending (although naturally this will fall somewhat lower than the peak Vietnam level). Federal programs and emphasis on urban redevelopment and environmental pollution control should also aid growth.

In the structural engineering field, however, the economic recession of the mid-1970s has seen the construction of single-family homes, office buildings, shopping centers, and apartment complexes at record lows. Many engineers are joining their fellow architects on the unemployment lines. Some cities have as high as a sixty percent unemployment figure for engineers. At this writing, construction is beginning to pick up and the long-range outlook is not nearly so gloomy as things have been lately. It would be unfortunate to base a career choice on the economy of the moment. But the structural engineer *is* dependent to some extent on the ebb and flow of the national, if not local, economy.

Engineering is also a lifetime career. Although more than half of women in the profession do marry and close to that number have children, they, like women in medicine, are usually back on the job within five years after interrupting their career. Once back they stay employed for the duration of their working life.

Professional Organizations and
Other Career Guidance Sources

> Society of Women Engineers
> Room 305
> 345 East 47 St.
> New York, New York 10017

(SWE, with 3,200 members nationally, offers a newsletter, scholarships and career guidance information at no charge.)

> Engineers' Council for Professional
> Development
> 345 East 47 St.
> New York, New York 10017

(Offers information on schools, training, and other qualifications for entry to the profession.)

The Builder

Betty Harley is a Florida homebuilder. She has her own company that erects about twenty single-family houses a year in the wide $40,000-to-$250,000 price range, and some small multifamily dwellings as well. She did not inherit the business from her husband. In fact, her husband is a public relations executive. Harley Builders is all Betty Harley's.

There is also Shirley McVay in Lexington, Kentucky, Ouida Regan in Pensacola, Florida, Gracia Whitlock in Monroe, Louisiana, and Arline Signore in Stuart, Florida—all homebuilders.

The National Association of Home Builders says there are a few more women among its 76,000 members. A handful really, but at least they're there.

Commercial developers are another story.

Cecelia Benattar has been a New York-based builder. Ten years ago she razed the old, prestigious Savoy Plaza Hotel on Fifth Avenue opposite the Plaza Hotel and replaced it with the towering, thirty-million-dollar General Motors building, her most prominent project in the city. But Ms. Benattar is British, chief executive officer for a British conglomerate. And she is now building in Toronto, finding the New York City climate for building unprofitable these days. So she is hardly an *American* success story.

There is Marion Knott Anderson, who is behind the development program of Knott's Berry Farm, the California amusement park. Yes, she is the daughter of the park's founders, Walter and Cordelia Knott, so perhaps her position is unique, too. When it was pointed out that she is the only woman in the country to play such a major role in development, she responded, "It only takes one white bird to show that all blackbirds are not. In other words, it only takes one person to show all the others. My advice to other women is to set goals at a young age. You can't accomplish anything if you don't know what you want."

In Tallahassee, Betty Harley wasn't sure at first just what she wanted, career-wise. She is somewhat typical of women in homebuilding—in her forties (many women are older) and has held jobs in a number of different areas. She holds a B.A. degree in art, worked in advertising for a while and obtained a real estate license she hasn't used.

But somewhere along the way an interest in building houses was sparked. In her enthusiasm, and because of a lack of knowledge in the field, Ms. Harley became something of a groupie—talking with builders, hanging around construction sites, even working two years for builders for no pay just to learn the business. She would supervise subcontractors and do some decorating of model homes. Finally, she felt she was ready to start on her own or—"fly by the seat of my pants," as she put it.

She makes it all sound easy. "You take a test, for example, and if you pass you become a licensed general contractor.

Then you go to the bank and say 'This is my financial statement, I'm going to build houses and I'm a licensed contractor.' Then you get your financing and you go to work on your first house."

From her art background, with a few courses in architecture, Ms. Harley learned how to draw plans. Her first house was built on speculation. Today, she builds about half on spec, half by commission. She has just completed the first solar-heated house in north Florida.

"I'm a prime example of the builders in this country. We put up only about twenty houses a year. I wouldn't want to get any bigger. Every house is individual."

Although on firm footing now, Ms. Harley admits she would do it all differently if she could start over. "I'd tell any woman now to get to a university and get some courses in construction. You have to know how to figure concrete, how to figure brick count, you have to know about load limits of lumber. And courses in business management. If you don't know how to manage money, you're in trouble. Then go to a bank and find out what they consider a good financial statement and how you stand loan-wise."

Was Ms. Harley aware that Southern women appear to predominate in the homebuilding scene?

"We moved into an area where there were Florida and Georgia crackers," she replied cheerfully. "I thought I might have a problem, being a woman and all. It was quite a shock to see how it *really* was. Maybe in the long run the gentlemen in the south are really more convinced that a woman can do her thing. In going around the country working with builders in NAHB [she is a director of the association] I see a slight difference. But here they put you on the same level, but they don't put you on the same level. I know that sounds like doubletalk, but for example my subcontractors would never think of cussin' with me around, or they'll say, 'No, no, Miss Betty, I'll do that,' and yet I'm the boss. The southern men want to make it easy for you. They're not going to fight you on anything, even on a bank loan."

The Contractor

Norma Mann (Mann Steel Co. in Dallas) heads the largest ironworker company in the southwest. The number of ironworkers on her payroll averages 125. Mann Steel has placed reinforcing steel in many of the Dallas area's major projects, including the fifty-story Republic National Bank tower.

Women across the country are operating similar contracting firms, supplying goods and services to builders. While some set out to do just that, a goodly number inherited the business after the death of their husbands. They came out from behind bookkeeper's desks in the company, took a deep breath, and plunged in.

Of perhaps more interest and importance than the number of women contractors is the fact that a growing number of them are holding offices in trade associations, where they can work to see more women admitted to apprenticeship programs. A Nebraska woman who owns her own plumbing and heating company is president of the Nebraska Plumbing-Heating-Cooling Contractors Association. A woman was elected executive vice-president of the Mechanical Contractors Association of Central New York in Syracuse. And Eva Poling, who is executive vice-president of the Mechanical Contractors District of Columbia Association, is also past president (1974) of the National Association of Women in Construction, which is working to open up non-traditional jobs to women, "to get them beyond the position of secretary," Ms. Poling says.

The Building Trades

Women in the trades have (almost) always been with us. They did not always toil only in shirt factories or as "typewriters." The Bureau of the Census found that in 1900 there were 545 women listing their occupations as carpenters and joiners. There were 167 brick and stone masons, forty-five plasterers, 126 plumbers and steamfitters, and two roofers. Imagine those two women roofers at the turn of the century. . . .

Under the umbrella of "construction worker" there is a variety of career choices: site superintendent, carpenter, equipment operator, bricklayer, laborer, iron worker, elevator installer, cement finisher, electrician, plumber, elevator installer, roofer, and painter.

Opportunities, on the whole, are good. And the pay is excellent for the female high school graduate with no postgraduate training. Women say they like the chance to work outdoors and with their hands. But probably the biggest attraction of construction work to them is the money. Same as the men there. And women are as adept as the opposite sex in figuring that a $9.91-an-hour plumber's pay envelope is heftier than that of a $3.00-an-hour receptionist or sales clerk.

Today, according to the Bureau of Labor Statistics, there are 33,900 women in plumbing, heating, and air-conditioning trades (eight percent of the total), 8,200 women in painting (seven percent), 16,900 in electrical (five percent), 8,700 in masonry (four percent), and 7,400 in roofing (six percent). The percentages are low when it is remembered that women comprise forty-seven percent of the nation's work force.

Women are turning up in the unskilled labor force. In Rock Springs, Wyoming, twenty women, working mainly as day laborers, are helping build the $400-million Jim Bridger power project for Idaho Power Co. and Pacific Power & Light. They are employed by Bechtel Corporation of San Francisco. A foreman on the project is one Patty Campbell.

At the other end of the climate spectrum there are the broiling roads and streets of southern Florida. In Palm Beach five women were hired as ditchdiggers. "I started it all," said Anna Johnson, who wields the jackhammer. "I got a job as a flag girl—you know, flagging the traffic into one lane—and I asked the boss why I couldn't work the same as the fellas do." The boss told Ms. Johnson he didn't want to mix crews, but if she brought in an all-girl crew, he'd hire them. So Anna Johnson rounded up four friends, all of whom are in their early twenties. Three are single, the fourth is married to a man already on a crew. The women would earn $110 a week, same as the men.

Their male supervisor remarked, "They really work hard.

Of course, they can't actually put out the top production that a man can because men are stronger, but they come in on time every day—ahead of time actually—and when they work they put their hearts into it."

The work is nothing they can't handle, the women say. The jackhammer presents some problems when it gets stuck, Ms. Johnson claims. "There's asphalt down underneath and I have to get the foreman to remove it."

The advantage of work as a laborer is that it is possible to look around at other jobs on the site to see what appeals, how the work is done, and, hopefully, how to get started in the better-paying skilled trades. More than splinters can be picked up by hanging around a construction site!

Those in the building trades (translation: men) expect women to represent little more than tokenism in most construction areas. Not because of discrimination, they hasten to add, but because of a lack of interest on the part of women themselves. Some men also feel the work is too dirty and strenuous for women and they are convinced that women apply for the jobs in a moment of whimsy and are taking them from deserving male breadwinners. These remarks are the more polite of the lot.

But there is a law now, and women across the country have been testing it in a variety of landmark cases. On July 2, 1965 the Civil Rights Act of 1964 went into effect. Title VII of that act, "Equal Employment Opportunity," prohibits discrimination because of race, color, religion, sex, or national origin in hiring, upgrading and all other conditions of employment. It also states that jobs may not be restricted to members of one sex even if the work involves "heavy, physical labor, manual dexterity, late night hours, overtime, work in isolated locations or unpleasant surroundings." The interior of a construction site shack—dirty, low on heat, plastered with girlie pictures—may not be the most pleasant of surroundings, but any woman who wants to be there, and is qualified for the job, has the law and a brace of new court decisions on her side.

Wages for some of the better-paying *union* jobs, as reported by the U.S. Department of Labor, look like this:

Average Hourly Earnings

Plumbers	$9.91
Electricians	9.69
Bricklayers	9.50
Carpenters	9.22
Plasterers	8.86
Painters	8.79
Laborers	7.01

Or, as one young woman put it wryly, "It beats being an unemployed English teacher."

In 1970 all of fourteen skilled trades reported at least one woman worker. In 1960 nine trades reported having no women working.

Jobs in many of the above-mentioned trades require fulfillment of an apprenticeship program, generally conducted by both labor and management and lasting from two to four years. Apprenticeship combines on-the-job training and pay. After the program is completed, the worker becomes a "journeyman," or full-fledged member of the trade.

Women are still finding it difficult breaking into the unions, despite court cases having been won by a few of them. The unions have traditionally been closed to all but the white male. Now there is a sizeable number of minority men lined up outside guild halls. There is legal pressure to hire minorities; there is none to hire women.

Several groups around the country have sprung up to assist women interested in non-traditional occupations, some of them outreach programs supported by the Department of Manpower Administration funded under the Comprehensive Employment and Training Act (CETA) of 1973. One such program is Better Jobs for Women in Denver, Colorado, which reports placing approximately 250 women from 1971-75 in dozens of skilled trades, including bricklaying, welding, and machinery. The average starting salary was $4.00 an hour. The National Urban League, Inc. is also assisting women, as in Recruitment and Training Program, Inc. (RTP Inc.), which has offices around the country and is based at 162 Fifth Avenue, New York, New York 10010. In Los Angeles there is

the Mexican-American Opportunities Foundation.

Then there is the Lady Carpenter Institute in New York; Advocates for Women is in San Francisco.

Joyce Hardwell embarked on a carpentry career in 1963, and a few years later founded the Lady Carpenter Institute at 20 St. Marks Place, a school to teach women how to find their way around a workshop.

An offshoot of Lady Carpenter is the All-Craft Foundation, a non-profit corporation to assist women in getting into the building trades. "Companies are now contacting us looking for women in non-traditional trades," Ms. Hardwell explained. "About ninety-five percent of the people we help to find jobs are female, the remainder minority males. The jobs are in large corporations with government contracts or in apprenticeship programs—carpenter, plumber, electrician, steam fitter. We've worked with DuPont, the Atomic Energy Commission. And even the Metropolitan Museum of Art here in New York got in touch with us. They're looking for a maintenance person."

The lady carpenter is now turning her attention to hardware sales and sales jobs in lumberyards. "They're just beginning to hire women and the pay is good in those areas."

In San Francisco, Dorothea Hernandez is director of an apprenticeship outreach program for Advocates for Women, a non-profit organization also attempting to aid women who have chosen the wrench over the typewriter. In 1975 Ms. Hernandez placed fifty women in apprenticeship programs. Since the AFW program began, more than 500 women have applied. "We've had to cut out advertising because we had hundreds coming in," Ms. Hernandez related. "We had to cut back recruitment from five days to two days of three hours each." Most women have been interested in carpentry, surveying, and electrical work. Ms. Hernandez, like heads of similar outreach programs, admits the going is rough.

"Since women are not considered a minority in the construction industry," she told an *Engineering News-Record* survey on women in construction, "there are no quotas to fill. It boils down to this: until there is a mandate from the Labor Department or the Human Rights Commission that so many

women must be placed, we won't have much progress." The unions, contractors, and government all agree, she says, that more women should be admitted to the trades, but she describes the situation as a "merry-go-round" because each side argues that the other is responsible for making it happen.

Ms. Hernandez added in an interview that most of the women coming into the AFW offices at 256 Sutter Street have lived in collectives in the Bay Area and have been involved in building of one type or another. Many have built their own homes. Other applicants have parents who were tradespeople. And a few are women who consider themselves rebels from the traditional white-collar routine.

If the hiring of women can be stepped up, the outlook for jobs in the next few years is good, far more promising than in some already overcrowded occupations.

Again, from the Department of Labor:

Average annual openings to 1980

Electrician (construction)	12,000
Operating engineer (construction machinery operator)	15,000
Plumber and pipefitter	20,000

To put those figures into some sort of perspective, there will also be these openings:

Dental Hygienist	3,100
Personnel Officer	9,000
Registered Nurse	69,000
State Police Officer	2,900
Veterinarian	1,500

To join a union or to work independently—which is best?

Almost half of the total volume of construction in 1975 in this country was "open shop." Most of those are small, somewhat unsophisticated firms, however, and frequently unable to attract the kind of skilled tradespeople that head for union hiring halls. But, as with most things in life, there are excep-

tions. The Houston-based firm of Brown & Root, Inc., in 1974 ranked second among all U.S. construction firms in value of new contracts: $4.9 billion. It hires nonunion workers almost exclusively. Residential building is mostly union. Nonunion workers are usually found in commercial construction. But again there are exceptions, particularly in different areas of the country where unions are either influential or weak.

Unemployment in the construction trades at this writing is high, thanks to the recession and its accompanying slump in building. In Florida the unemployment figure is close to forty percent. Wage hikes are smaller these days and there is an increasing use of nonunion workers on construction sites. The recession has seen many open-shop contractors winning building jobs that once went to employers of union craftspeople. But union pay *is* better than outside jobs and growing numbers of determined women are being issued union cards, albeit begrudgingly.

Women interested in learning more about non-traditional occupations in construction can turn to several sources besides the ones mentioned earlier in this chapter. The Women's Bureau of the U.S. Department of Labor is a clearinghouse of career information, including the address of the nearest outreach or other apprenticeship program. Their address in Washington is 200 Constitution Avenue, N.W., Washington, D.C. 20210. The bureau has regional offices in Boston, New York City, Philadelphia, Atlanta, Chicago, Dallas, Kansas City (Missouri), Denver, San Francisco, and Seattle.

There is also the National Organization for Women (NOW) Task Force on Labor Unions at 5 S. Wabash, Suite 1615, Chicago, Illinois 60603.

The recently organized Coalition of Labor Union Women (CLUW) offers printed material and career guidance to women belonging to any union or bargaining unit, including, of course, the construction trades. They are at 8731 East Jefferson, Detroit, Michigan 48214. With 5,000 members, CLUW will put interested women in touch with one of its twelve regional vice-presidents for more grass-roots reporting on the labor union situation.

Other Careers in Construction

Besides the architect, engineer, builder, contractor, and trades-people, there are other jobs "in construction" for women with different skills and interests. A microcosm of those positions can be found, for example, at one large company.

Make it the Bechtel Corporation of San Francisco, fourth largest construction firm in the country and builders of dams, power plants, and numerous other projects.

These women are at work at two nuclear power jobsites in Pennsylvania. Their quarters are not fancy, it is frequently dirty work, and, yes, some of them do wear hard hats, jeans, parkas, and other accoutrements of the working man's ward-robe. Ages: Early twenties to mid-thirties.

> Anne Kimball—senior buyer in subcontracts (preparing bidder lists to awarding contracts to successful bidders).
> Qualifications: Came to Bechtel ten years earlier as a clerk-typist. Business course at Hunter College in New York City; a procurement management class at the New York Institute of Technology; studied Law of Contracts at Baruch College—all supplemented by courses provided by Bechtel.

> Sushila Shah—planning and scheduling engineer.
> Qualifications: B.S. degree in civil engineering from a university in India. She was the first woman engineer in the state of Gujrat.

> Cathy Seesholtz—assistant field engineer in charge of seven subcontracts in the office and field.
> Qualifications: B.A. degree in psychology and English. Joined Bechtel as an administrative assistant in subcontracts. Now studying Law of Contracts and Business Administration through Bechtel. Also completed a Construction Assistant course and took a technical writing class, both at the jobsite.

> Valerie Renninger—construction assistant in Quality Control.
> Qualifications: Worked in a bank before joining Bechtel as a clerk.

Cora Brown—Receiving Coordinator (assures that materials are received and processed to jobsite).
Qualifications: Worked fifteen years as a secretary before joining Bechtel as an intermediate clerk.

Gloria Sorber—paymaster at jobsite.
Qualifications: payroll clerk in area factories before Bechtel as an intermediate clerk in payroll. Advanced to senior clerk, chief clerk, and finally paymaster.

Jane Stephens—cost engineer (handles cash flow forecasts and cost studies).
Qualifications: B. S. degree and master's degree in civil engineering.

Theresa Tarasek—accountant.
Qualifications: 1975 college graduate, now studying for graduate degree.

Kathy Semanski—quantity tracking technician (identifies plant components, reporting on their status and quality).
Qualifications: 1974 graduate in business administration, joined Bechtel as an intermediate clerk.

Stephanie Zazo—document control coordinator (handles paperwork related to engineering aspect of project). Supervises eleven people in the department.
Qualifications: High school graduate in 1972, signed on with Bechtel at the jobsite as a clerk.

Some of the women planned careers in construction, others have ended up there. "I didn't know what to expect in the construction field," Kathy Semanski told the Bechtel newsletter. "I'd never done work like this before. The biggest challenge was terminology. Experience was my teacher. I just listened to my supervisor, asked questions, and worked as hard as I could."
Valerie Renninger is now so fascinated with construction, "I'd like to stay with it all my life. I'm enjoying working on a project such as this [the nucleur power site at Limerick, Penn-

sylvania]. What's especially satisfying is seeing the project de-
velop . . . to know that you contributed to its progress."

Ten women, ten new looks at construction.

At the Vocational School Level

The picture is not so bright at the high school level for the
young woman who prefers carpentry over home economics
and, unfortunately, it is at that level that an interest in, and
an aptitude for, the trades should be encouraged. According to
Women in Vocational Education, a report prepared by Dr.
Marilyn Steele for Project Baseline, a massive study of voca-
tional education funded by the National Center for Education
Statistics and published late in 1974, 40.2 percent of all young
women enrolled in federally authorized vocational education
are in home economics. Another twenty-nine percent are in
female intensive clerical fields. The remainder are studying
cosmetology, interior design, and similar programs. Those in
various shop courses are an insignificant percentage.

In Dallas, Texas, the Skyline Center, a cluster of three sec-
ondary schools, made news in 1975 by reporting that its voca-
tional school (the other two are a regular high school and an
adult evening school) had completed construction of a single-
family house, which was being sold on the open market for
$40,000. Three more houses were planned.

The Skyline Career Development Center, as the school is
known, offers an excellent variety of courses. The bulk of stu-
dents are in building trades programs: construction, electrical,
refrigeration, bricklaying, cabinetry. There are also sheet metal
and plastics courses; in all the school, twenty-eight clusters of
subjects comprised of ten courses each.

The carpentry course teaches, along the lines of other trade
schools in the country, a preparation for a four-year appren-
ticeship. The student learns elementary structural design; sys-
tems of frame and concrete form construction; and the use,
care, and safety of tools. He or she is also taught to do rough
framing as well as inside and outside finish work, and to hang
doors, set windows, and fit hardwood flooring.

The electrical program teaches the care, use, and safety of equipment and the installation and maintenance of electrical layout; blueprint reading; and electronics.

For the would-be plumber there is a course leading to a five-year apprenticeship that instructs in welding, soldering, and the installation and maintenance of radiators, pumps, boilers, oil burners and gas furnaces, air conditioning and hot water, steam and radiant heating systems.

At Skyline, there were indeed a few girls involved in building the house, which, incidentally, took eighteen school months to complete. But where are they? In interior design courses and in plastics courses.

"We would have a girl or two occasionally in one of the other courses," remarked Gene Brandenberger, assistant manager of Skyline Center. "There's nothing to keep them out. And they'd stay for the semester and they'd love it. Then they'd drop it. It was too strenuous for them, or they'd just lose interest. But our top student in the aeronautics program is a girl, so the courses are there if they want them."

Perhaps a shop course is still a curiosity to the young woman who, even these days, is frequently not thinking beyond stereotypical roles. Perhaps girls are still made to feel uncomfortable in those courses, not only by their "fellow" students, but also by vocational school teachers. And perhaps—make that *definitely*—there is greater difficulty placing them in apprenticeship programs than there is with young men.

Vocational training for women with non-traditional interests, say those working at the administrative level nationally, has a long way to go.

Professional Organizations and Other Career Guidance Sources

The National Association of Women in Construction is comprised of more than 7,000 women in all phases of the building industry—builders, engineers, bookkeepers, trade association officers, paymasters, etc. There are chapters in forty-five

states, including Hawaii and Alaska, and in Canada. For membership information write Jerome Gladysz, (yes, that's *Mr.*—they're an equal opportunity employer), Executive Director of NAWIC, 2800 W. Lancaster Avenue, Fort Worth, Texas 76107.

The National Association of Home Builders' membership of 76,000 includes builders, marketing and advertising people—anyone connected with homebuilding. It is located in Washington, D. C. The headquarters has no printed material to offer non-members, but suggests interested women get in touch with their local NAHB chapter. There are 650 of them nationally, operating on the state or local level: e. g., Florida Home Builders in Tallahassee, Home Builders Institute of Long Island (New York) in East Meadow. The local chapters usually have career material.

International Brotherhood of Electrical Workers, 1125 15th Street, N. W., Washington, D. C. 20005.

United Brotherhood of Carpenters & Joiners, 101 Constitution Avenue, N. W., Washington, D. C. 20001.

United Association of Journeymen and Apprentices of the Plumbing and Pipe Fitting Industries of the U. S. and Canada, 901 Massachusetts Avenue, N. W., Washington, D. C. 20001.

6

To Washington for a Housing Career

"Washington's like San Francisco. Every-
one wants to be here. It gives us one hell
of a selection."
— Personnel officer

IT IS A VENERABLE CLICHÉ—THE THOUSANDS OF YOUNG PEOPLE
streaming into Washington each year to find challenging ca-
reers in public service, smart Georgetown apartments, and,
perhaps even more important to some, an exciting after-hours
life. The Capitol, after all, is a company town where a fre-
quently dry-as-dust product can be made to appear quite
glamorous.

In the post-Watergate era probably the district's hottest job
ticket is a journalism career, with its hope of toppling still
more miscreants through the typewriter. Law, too, is fashion-
able.

HUD

But there is another area where job applicants far outnumber
vacancies, a field that was popular a few years before our
imaginations toyed with deleted expletives. It is the national
housing arena.

That's right, housing is glamorous. Consider: A small, non-
profit organization plows through more than 2,000 applica-

tions annually from highly qualified individuals, most with a mini-alphabet of degree letters following their names. The office has a staff of forty.

Then there is the district's prime hirer of housing specialists. At the U. S. Department of Housing and Urban Development, some 24,000 career inquiries and job applications are processed each year. "Most of them are young people who say, 'I want to work in housing,'" remarked a HUD personnel officer. "Unfortunately, they don't always say what they want to *do* for us, but housing appears to be 'in' right now."

Why the seemingly sudden popularity? And just what constitutes a housing career, anyway?

Interest in the roof over our heads dramatically accelerated in the mid-sixties. There were riots in Watts and other long hot ghetto summers, which forced a look at growing urban decay and abandonment, remnants of the flight from the cities in the preceding decade. Of course, "housing" also means single-family homes in suburbia, and there is no lack of applicants for jobs in those related fields. But the ones most people coming to Washington seem to want are in the public sector—finding and improving housing for low-income residents of the inner cities, with the aid of the federal government.

HUD is a young agency. It was created in 1965 to bring various programs for cities under one roof where they could function more effectively and where new programs could be added to solve what were becoming increasingly complex problems.

Under its umbrella HUD drew the Public Housing Administration, the Federal Housing Administration (FHA), and the Model Cities program, among others. Besides its 4,000-member headquarters operation (situated, fittingly, in a gleaming white building in an urban renewal area of the city), it maintains ten regional offices—in Boston, New York, Philadelphia, Atlanta, Chicago, Dallas, Kansas City, Denver, San Francisco, and Seattle. They range in size from 425 to more than 2,000 employees and, with the exception of the Denver regional office, they are further broken down to area offices in cities within the region. In other words, you're never far from a HUD office.

So HUD's birth helped spur interest in housing careers. And so did the increasing number of courses offered in colleges and universities at both the undergraduate and graduate levels—degrees in "urban studies," "urban community development," and, of course, programs in planning.

But what does a housing specialist do? Well, besides clerical workers, HUD hires attorneys, community planners, engineers, appraisers, and analysts in the areas of construction; housing; economics; computer and budget analysis; equal opportunity; housing management; and finance and mortgage credit.

"It's all administrative—program formulation, policy making, management and the like," Doris Johnson hastens to point out. "I have applicants, men and women, who say to me, 'I want to work with people.' I feel like telling them, 'Go become a sales clerk, because you won't work with people here. Out in our field offices you're more likely to "work with people," but not at headquarters.'"

Ms. Johnson is head of the Federal Women's Program at HUD. Her quarters in the personnel department are appropriately decorated—feminist posters, ashtrays, mugs, and other bric-a-brac, much of it humorous. A good thing there's a laugh every once in a while. The women can use one.

Women at HUD

The Federal Women's Program was established in 1967 by the Civil Service Commission in response to an executive order to assure equal opportunity for women in government. This came some 100 years after the Treasury Department hired "lady clerks" at $600 a year while male clerks drew from $1,200 to $1,800 for the same job. Today the FWP operates at every agency and, as might be assumed, at varying degrees of success despite the rhetoric. The Civil Service Commission released a report for the year ending October 31, 1974 that showed women held seventy-one percent (419,066) of all white-collar jobs (exclusive of the postal service) at the GS-1 through GS-6 grade levels, which presently pay $5,559 to $12,934; twenty-five percent (158,430) of the positions in the middle grades, GS-7 through 12, now at $11,046 to $25,200. Women

hold only four percent (9,317) of the positions at the GS-13 level and above, now $22,906 to $37,800.

A HUD fact sheet, headed "We've got a long way to go, baby," shows that the median grade level for white males is GS-12, for white females GS-7, for minority males GS-8, and for minority females between GS-5 and 6.

Blitzes of workshops and meetings, and even an appearance by Gloria Steinem have been held at HUD. What it all boils down to is one percent—that's the size of the increase in positions held by women, FWP workers say, during the years 1967-75.

"There is a commitment from the top," Ms. Johnson conceded. "They *are* giving women jobs, but at too slow a pace." Part of the problem, she explained, is the old gripe of the need for consciousness-raising among the male higher-ups. (One male director, when asked if he would speak to a woman reporter about the work of his bureau, replied "Can't she talk to one of the women?"). The other stumbling block to female advancement is peculiar to government service. Almost every federal employee must pass a Civil Service examination to be appointed to his or her job, and veterans are moved immediately to the head of the list. Since many women are trying to enter previously male-dominated fields, they are frequently bumped by men with service records. And that impediment would take a law to change.

Job Vacancies

The employment situation at HUD is generally tight for both men and women—only about 400 new staffers are hired annually, and half of them are secretaries. But there are always openings in some areas. While planners and attorneys are lined up outside the front door, there are never enough accountants or auditors. "We could use 100 right now," said one personnel officer. Since the job requires about seventy percent travel, there are few takers, male or female. Computer science is another relatively open field. And engineering. In some areas, too, it helps to be from a sparsely populated state, since certain positions must be distributed geographically and a disproportionate number of applicants come from the Northeast-

ern corridor. If you're from, say, Utah or Nebraska, you might sail in.

And guess where help is so desperately needed that HUD has prepared a recruitment brochure announcing, among other lagniappes, that the department will pay moving expenses for anyone taking the jobs? Secretaries. No one can get enough good secretaries. For holders of positions ranging from a GS-2 typist to a GS-5 stenographer, HUD will even help find appropriate housing in the Washington area.

To upgrade the position of secretaries in the department, Ms. Johnson, a bright, humorous woman with a streak of the maverick, has hired a male secretary. Now six or so others have taken on men or are looking for male secretarial help. After all, wasn't a male secretary once a status symbol? Realizing the irony, Ms. Johnson said with a wry smile, "It's pathetic, but that's the way it works. If you get men in it raises the level of the job."

The typewriter, it is pointed out, can be a springboard to a better position at HUD if the secretary keeps her eye on the next rung—and pushes hard. There are no merit promotions in government work. Aside from secretarial jobs there are higher-entry-level professional slots that range from GS-5 to GS-7.

"Since HUD is a relatively new department, it's flexible," said Ms. Johnson. "Women can kind of make the job what they want it to be. It's not a stagnant agency, it's dynamic and constantly changing heads of offices, so it gives someone an opportunity to be creative. Anyone who comes to a federal job and does only what is required will never get anywhere."

HUD is also a department where job-related volunteer work can count as experience on an application form. Did the applicant, for instance, organize a block association or work with an environmental group or to preserve a landmark? It should all be put down. Ms. Johnson also suggests that applicants go into detail about what they *did* on their previous jobs, not skimming over them by just giving them a title and a one-sentence description. And, she adds, presentation counts. Translation: appear confident.

Deborah DuSault more or less lucked into her first job at

HUD, having been hired during its early days when competition was not so keen. Since then she has moved ahead nicely. A native of Washington, Ms. DuSault graduated from college in the late sixties with a nice, general degree in medieval history. And what does one do with that? "Urban development, I thought, sounded good and seemed like a wholesome thing to do," Ms. DuSault recalled of her immediate post-college thinking. She headed for HUD and began work at a GS-5 entry-level job in the personnel department. Today she is a supervisory personnel officer with a staff of twenty-nine. She has a GS-14 rating and an income of more than $24,000 a year.

Such happy endings still occur, of course, but as Ms. Johnson points out, today there are far more Phi Beta Kappa women still sitting behind typewriters waiting for their chance.

Special Programs

One small step HUD has taken to open up a few more jobs is the Intern Program (GS 5-7). The agency (and a few other federal departments as well) takes on some twenty-four new people, half of them women, each year. There are some 850 applicants for the slots. Candidates are recent college graduates as well as promising employees. In fact, there are a certain number of intern positions that must be filled from within the department. Work assignments are rotated for special orientation to the department. Frequently interns spend time in one or more of the regional or area offices to get the feel of "the field." By the end of the year they have a broad base of knowledge and are usually kept on in a permanent position in program and management areas.

Trish Ganley spent the fiscal year 1974 as an intern in the equal-opportunity area of the department. She was not involved in a team project, nor was she given "make work" assignments. Her specific job was to work with groups as diverse as planning associations in Las Vegas and the Miami Valley, the National Association of Realtors, and the U.S. Catholic Conference to pass fair housing ordinances and then to work with them on implementing programs. After her year of in-

ternship, Ms. Ganley was retained in the same area of HUD.

Like a surprising number of women working in housing at the national level, Ms. Ganley hopscotched around, career-wise, before landing at the white building on 7th Street SW. She taught school briefly, sold real estate in the Virginia area in the late sixties, then went to work for the U. S. Catholic Conference in Washington, where she helped formulate "social action-type" programs for three years. She came to HUD as a secretary to get the proverbial foot in the door, and a few months later applied for an intern assignment. "Because of my background in real estate and my interest in housing I felt this was the organization I wanted to be with," she explained, adding that her experience with the U. S. Catholic Conference probably also helped in winning the internship. "I'm working to fight discrimination in housing, yes, but I also want to make a contribution right here for women in HUD. I'm afraid there's discrimination here, too."

Besides the Urban Intern Program, HUD also has set up a part-time program for men and women with college degrees or considerable work experience. The jobs run from twenty to about thirty-nine hours a week, although there is a move underway to lower the ceiling to thirty-two hours a week. Employees hold a regular Civil Service rating and qualify for all benefits of a federal career. The positions are professional, not clerical, starting at a GS-9. There are fifty part-timers in the headquarters office; sixty-five in the regional offices.

For Pat Warren the part-time program was a godsend. She can take and pick up her toddler from nursery school without dashing around madly at either end of the day. Her hours are 9:30 A.M. to 4:30 P.M. And, as a personnel staffing assistant, she holds a nice GS-12 rating. Ms. Warren, who is black, works with a team of eight to try to bring more women and minorities into HUD at the higher-level jobs. To supplement her associate degree from a business college, and her considerable government working experience, she is taking in-house continuing-education courses, workshops on making speeches and writing reports, and seminars on personnel procedures. If she chose to return to college in the evening, HUD would pay all tuition for a work-related program.

"This is a perfect program for working mothers," Ms. Warren remarked. "And we seem to have quite a few students—the hours are great for them, too."

Other Opportunities in Washington

Although the bulk of national housing jobs in Washington are with HUD, there are a few other employers, although on a much smaller scale. It is possible, although extremely difficult, to get a job "on the hill" as a legislative assistant on one of the housing committees. "I don't know about that, though," remarked one observer. "There're *really* against taking women on in those jobs. And they seem to want lawyers." And there are several non-profit housing groups with small staffs—the National Rural Housing Alliance has a staff of three or four, the Housing Assistance Council, funded by HUD, has about a half dozen. The National Housing Conference, a major housing lobby, also has a small staff.

Aside from HUD the largest employer on the national level is the National Association of Housing and Redevelopment Officials (NAHRO), and here we're talking about a staff of forty. NAHRO is an association of local redevelopment agencies, public housing authorities, and local housing and rehabilitation officials. It is supported in part by fees paid by its 10,000 members. Besides disseminating housing information and explaining laws and proposed legislation, it does some low-key lobbying.

Small as it is, Mary Ninno, associate director for policy development, says applications for positions at NAHRO run more than 2,000 a year. Only highly qualified specialists are hired. NAHRO can afford to be choosy. An advertisement in the Washington *Post* for a data analyst, a position that could not be filled from within the organization, drew, in a couple of hours after the paper appeared on the newsstands, ten letters (hand-delivered), twenty phone calls, and five applicants who stopped by in person.

Another well-received ad that appeared in the *Journal of Housing*, the monthly publication of NAHRO:

Housing Management Analyst—NAHRO is

seeking an individual to assist its project director for housing management services in the development of policy and the implementation of NAHRO services programs in the area of housing management in accordance with current NAHRO contractual obligations. Candidate should possess a working knowledge of the property management aspects of low- and moderate-income housing programs; strong analytical and written and oral communications skills; one to three years' experience with a local housing authority, preferably involved in the HMIP and/or TPP programs; familiarity with the management by objectives process; or a combination of lha and research experience. Graduate work in public administration, sociology, business administration, or related field desirable. Work experience may be substituted for education.

Salary range: $15,000 to $17,000.

Mary Ninno echoes the reservations of Doris Johnson at HUD. "The young people are drawn here because it's typical of young people to want to work in a field where they think they're doing some good. They can go to the National Association of Home Builders, for example, and of course some of them do. But mostly they want to work in public housing.

"But I have to tell them this is not a face-to-face kind of thing. You aren't going to see the people you're helping. What you *will* get to do is meet a lot of people who are active in the field and you'll get an idea of how the legislative process works and of our relationship with federal agencies."

Judy Morris, thirty years old, has a bit of both worlds. As assistant director of information at NAHRO, Ms. Morris travels a great deal setting up seminars and other programs and doing some speech-making on federal programs and new legislation at the local level with NAHRO members and chapters. She gets to see quite a bit of "the field."

"You get perspective," she says, "but you can still stay at

the national level. I don't know if I'd like to be permanently at the local level and I don't know if I'd like the private sector. I like public service. It has a great appeal to me, the whole subject of cities, local government, housing. And Washington has had a lot to do with my thinking.

"There's more leverage for women at the national level, I think, although the financial gain is better in government service than with private groups like this."

Ms. Morris's background: a master's degree in library science, a stint as a researcher in the HUD library, then what she considers the job that brought all her theory about housing together: running the housing program for the national League of Women Voters, specifically formulating and helping local chapters to implement integrated housing programs in the suburbs. All of her work was in Washington.

In the opinion of Eugene Schneider, a thirty-one-year-old project director for housing management at NAHRO, the neophyte has no place in Washington as her first step in a housing career. "The public sector, rather than the corporate structure, has so much opportunity for young people," he says. "Where else would I have had the chance to be director of a local redevelopment and housing authority [in Virginia] at the age of twenty-six?

"But you must start at the grass-roots level these days—city, county, or state—and stay there for at least five years. A major criticism of people at the national level is that they do not have the day-to-day experience in the field. And they realize, these people, that one of the gaps in their own background is not having worked with people and taken the raps. If you have that experience, if you've paid your dues, if you've worked in the trenches, you're that much more valuable."

(Mr. Schneider adds somewhat ruefully that in his years with the housing authority in Fairfax County, Virginia, there were an average of 180 responses for every vacancy. So much for the ease of obtaining even local experience.)

"Besides three years in Virginia I spent the two before that in Rochester, New York. But now I want to do something at the national level and to work with people in the emerging profession of housing management. I'd like to try to prevent

disasters such as the ones that have already occurred in public housing projects in the past. Pruitt-Igoe, for example. But I wouldn't be effective in this job if I hadn't spent those years in the field."

Trish Ganley, the HUD intern, agrees with the importance of front-line experience. "I'd love to be out in the field. Many of us would. But there's no chance, or very little chance, once you get a Washington job."

Mr. Schneider suggests that a woman hoping to make the trek from local housing to a post in Washington might do well to take courses in municipal finance and/or municipal administration. That catch-all, urban studies, he said, might be a popular major for those interested in the field, but there are too many graduates in that area these days, he feels, and they are not trained for the special, in-demand positions.

"There is a tremendous need for young professionals who understand the principles of good management," he concludes, "but first the entry, or local, level."

All of which is not to say every woman interested in any phase of housing *must* start her career at City Hall or with the local housing authority. Her very *first* step, however, should be to her local Civil Service Commission or HUD office to see what's what. Then, armed with the necessary Civil Service rating and/or work experience, Ms. Smith can go to Washington.

Other Career Guidance Sources

The following booklets are available at area Civil Service Commission and/or HUD offices:

"Working for the USA—How to Apply for a Civil Service Job." Or write Superintendent of Documents, U.S. Government Printing Office, Washington, D.C. 20402. Charge is 50¢ for the forty-page booklet.

"HUD—What It Is, What It Does"—Information Center, U.S. Department of Housing and Urban Development, 451 7th St. SW, Washington, D.C. 20410.

"Shopping for a Future" (strictly for secretaries). Or write U.S. Department of Housing and Urban Development, Office of Personnel, Secretarial Staffing Branch, Room 2270, 451 7th St. SW, Washington, D.C. 20410.

"Careers with HUD," "Urban Intern Fact Sheet," "Fact Sheet—Part-Time Professional Program"—Office of Personnel, U. S. Department of Housing and Urban Development, 451 7th St. SW, Washington, D. C. 20410.

HUD Challenge is the glossy monthly publication of the U. S. Department of Housing and Urban Development. Subscriptions are $15.90 yearly, available from the Superintendent of Documents, Government Printing Office, Washington, D. C. 20402. Limited copies are available of the special September, 1975 issue of *HUD Challenge* devoted to women—either with HUD or in allied areas. Back copies are $1.40, available from the Superintendent of Documents.

The *Journal of Housing* is published eleven times a year by the National Association of Housing and Redevelopment Officials. Subscriptions are $12 annually. Write NAHRO at the Watergate Building, 2600 Virginia Avenue NW, Washington, D. C. 20037.

NAHRO also publishes an *Urban Careers Guide,* which is a 140-page directory of educational opportunities in the fields of housing, housing management, urban renewal, community development, and housing code enforcement. The book costs $5.00 to nonmembers, available at the above address.

"Tenant Services Personnel—48 Job Descriptions From Large Housing Authorities" is also available from NAHRO at a charge of $2.50. An interesting look at positions in public housing.

7

Restoring and Renovating Older Properties

IT WAS ONLY TEN OR SO YEARS AGO THAT THE CRY HEARD throughout the land was "tear it down." Reduced to rubble were Greek Revival courthouses, Moorish movie palaces, rows of Victorian brownstones, and other relics of our early days, the likes of which we will certainly not see again. In their place rose the new—the shopping center, the gleaming office tower, the suburban tract development, the ubiquitous parking lot.

But we tired quickly of most of our new buildings. If they were not merely bland, they were poorly constructed or inconveniently located or . . . something. Look at the handsome older construction next door. They don't make them like that anymore. Why, a little fixing up and. . . .

Slowly the nation's collective consciousness has been raised to the need for protecting some of our older treasures. Naturally not every structure more than fifty years old can or should be saved. But older buildings do provide a line of continuity from the days when our earlier countrymen walked these very streets, the reasoning goes, and they must be al-

lowed to co-exist with present-day structures—or where is our history except in books? On the less altruistic side, as economic changes made for tighter purse strings, the idea of restoring or renovating old buildings made more fiscal sense than new construction.

Thus was preservation born.

As interest in this relatively new field grows, so do the number of jobs (although, we must warn, there are still few of them). The stories of four women now at work preserving or restoring older buildings, principally in the nation's cities, follows. Two of them are self-employed, two are salaried.

The Speculator

Mary Weir might wince at the word "speculator." She is truly interested in the heritage of our older housing stock. But the fact is she and her husband, Sam, do make their living gambling with houses, depending on a number of variables in the economy and in the real estate market to increase the profit of their holdings. Sort of like Monopoly—with the game board a chunk of the state of New Jersey along the Atlantic Coast.

In the past ten years the Weirs, who are in their thirties, have purchased and renovated twenty-two homes on or near the New Jersey shore, living in six of them along the way. Some are run-of-the-mill beach cottages; others are estates of historical and architectural note. It is a full-time job for both of them.

For the Weirs, renovating houses, as with so many occupations in this book, was not a planned career. They fell into it. About eleven years ago Samuel Weir, a research chemist from Philadelphia, met and married Mary Patterson, an interior designer from Pittsburgh. Within six months after they had both finished graduate school, they moved to Sea Bright, New Jersey, an ocean community that, while still attractive, had seen more glorious days. Their house cost $4,000 and was the sort of bargain that is usually advertised as a "starter home." Some bargain. The house was condemned. But the couple worked on it, so much so that when they eventually moved they kidded that the only original parts left were the roof beams. They turned the house into two separate apartment units, and

they also managed to pay off its mortgage within six months. He worked for a chemical firm at the time; she was a housewife and new mother.

But here is where their fortunes took an unusual turn. They took the road less traveled, so to speak. Rather than sell the house and move to a better one in a typical upwardly mobile fashion, the Weirs held onto the house and rented the two apartments. They bought another, larger, house into which they moved. That one cost $17,000. It took some scouring around for short-term loans to make the down payment and trips to eight or nine banks to secure a mortgage.

"After that it became easier and easier," Mary Weir recalled. "We could use equity in the houses for a down payment and only occasionally had to cough up cash. When we did, it came from rentals."

Casually clad in jeans and a T-shirt, a few strands of her dark upswept hair escaping from their clips, the modern Mary Weir looked slightly anachronistic in the oak-paneled library of house number twenty-three, which she and her husband are now in the process of restoring. It is a thirty-five-room estate in Rumson, an attractive year-round community a mile in from the ocean. Known as "The White House," the mansion, which was built in 1904, boasts eleven-foot ceilings, a large entrance hall, a billiard room, sun room, library, and what could only be a ballroom, a huge space ringed with windows, now filled with miscellaneous furniture, a piano, and a small boy reading on the rug. And these are just a few of the rooms on the first floor.

The couple claims the work is forty percent complete. When it is finished—and that will include furnishing all the rooms—they will sell it or rent it. Rental for the next summer season would be $12,000. If they do rent, they will move out until fall. "When we leave we just take along a brown paper bag with a bottle of sun-tan lotion in it," Ms. Weir jokes. They paid $100,000 for the house. If they sell it they will ask for $250,000.

But we are ahead of ourselves with house number 23. Back to the early days and that second house.

While living in house number two—and counting the nice

little pile of change from rentals on the beach cottage, which had year-round tenants—the Weirs saw themselves becoming more and more committed to the idea of acquiring houses, fixing them up, and selling or renting them. They were, in fact, already turning house number two into two apartments. So Mr. Weir quit his job to concentrate on the couple's new occupation. And Ms. Weir turned *her* sights outside the home. He now does the plumbing and electrical work, and has become an expert on the heating problems of large old homes. Ms. Weir does most of the painting, papering, furniture repairing, and furnishing. She also handles the books. But the jobs overlap, no score is kept, and Ms. Weir points out that *she* knows her way around the cellar, too. "At first I left things up to Sam to do and then I'd wait. But you can't spend your whole life waiting; I'd rather be busy."

They stayed in house number two for three years and rented both apartments when they left. During those years they purchased three smaller houses.

Slowly a routine has emerged, and so has a system of handling that much property. For one thing, the couple prefers renting their houses to selling them, principally to escape capital-gains taxes, but also because property values in the region, they reason, are rising an impressive eight to twelve percent a year, making houses worth holding.

"Sure, there's aggravation in renting," Ms. Weir admits. "But tenants rarely call you if you fix things right the first time. It's nothing compared to the aggravation of a nine-to-five job."

Every Saturday, rain or shine, the two "house recyclers," as they call themselves, leave home at 3:45 A.M. for the Englishtown flea market, one of the largest in the country, where the good stuff is snapped up by 7 A.M. They shop for furniture and bric-a-brac for the houses. They also haunt local estate sales.

"I know what to buy. I don't buy chairs that are going to take three days to re-upholster, for instance." Furniture stripping is, for the most part, also too time-consuming.

"We like to restore, but we're not fanatical about it. But if

you *can* restore you're so much better off. It's much cheaper. Take this paneling," she continued, gesturing around the room in which she was curled up on one of her $5 bargain-buy chairs. "Back in 1904 they used to pay carpenters $1.50 a day. That's why they could afford paneling. Today it's out of the question to install oak panels, but if you already have it and it just needs to be fixed up, great. Go ahead."

While agreeing that buyers of older homes like period details, Ms. Weir also points out that kitchen and bathroom must be very up-to-date indeed. Much of the Weirs' renovation expense goes into installing modern kitchens and baths and in making the heating system the most economical for large, drafty houses. There is more to renovating old houses than cosmetic changes, they and other remodelers point out. In addition to the above expenses, frequently the house must be rewired, or the plumbing is out of date, or there is not enough closet space and some must be built. In other words, you have to spend a little to make a little.

Another touch the couple likes to add is a special spiral staircase they purchase from a New York firm for $350. They put it together like an erector set with a five-foot hole on the top floor. Voila! The attic is converted into a master bedroom.

About her success in house recycling, Ms. Weir is modest but clearly pleased that it is going well. "A large part of the work is getting organized," she says. "And then just using common sense. After all, we've been around walls all our lives. So you make your best friends the paint store and the hardware store.

"What it really is is making yourself go up that ladder every morning at 8 A.M., not putting it off. You can't diddle around all morning. Forget the ironing. Forget everything."

The Weirs have pared domestic chores to the bone. The couple has two sons, ages five and eleven. "They're with us constantly, of course, but they can take care of themselves, too. The younger one knows how to make himself oatmeal in the morning.

"Every two weeks we go roaring through the house and clean it. We don't have the time or inclination to watch televi-

sion. When we're working on another house we come home at seven and we all make dinner and we all clean it up. We eat off paper plates. You've got to."

The Weirs have lived in The White House for two years, and it may, in fact, become their permanent home. It succeeds their most recent completed project, "Golden Crest," another Rumson stately home. That one had forty-six rooms, fourteen bathrooms, and hallways fifteen feet wide and sixty feet long. It had once been a summer hotel, then a college fraternity house. It is being rented now at $1,000 a month until it is sold. Another house has just been sold for $180,000, including furnishings with an estimated value of $30,000.

The two have no trouble finding buyers for these behemoths, because of the high transfer traffic in the area. "Those people sometimes prefer furnished homes," Ms. Weir contends.

"But I think twenty-three houses is a bit much," she finally allows, with a smile. "We want to do other things now, so we're trying to simplify things by selling some of the houses. I'm more interested right now in doing terrific big mansions. Maybe buying them and turning them into condominiums. We're working on gazebos, too, designing them and putting them on the market.

"I'm sure I'll find something to do worthy of my talents." The smile broadens to a laugh.

The Renovator

On Washington Circle in the District of Columbia stands a block of ten Victorian townhouses. Of red brick with turreted towers, several of them are badly deteriorated. There was a fire in one or two of them. Marilyn Taylor has recently purchased them all. She reasons that the houses are near the State Department, they are architecturally impressive, and Washington certainly needs more middle-income housing. She plans to sell the townhouses for about $175,000 each.

Who is Marilyn Taylor and where is she getting all this money?

Marilyn Taylor hails from the Midwest. She started her career in housing rehabilitation in 1966, when one of the men

who is now her business partner ran for Governor of Wisconsin. She worked as a secretary in the campaign. He lost, but Ms. Taylor immediately went to work for the development group he soon formed. That group eventually merged with Inland Steel Development Corporation and Marilyn Taylor became director of housing for Inland. In that capacity she was given a budget of $10 million a year to find housing properties that would be profitable for Inland.

She came to Washington, a city ripe for housing renovators, and her husband, a graphics designer, left his Wisconsin office to join her.

First Ms. Taylor found the Cairo Hotel, the tallest nongovernmental building in the district. It had been an elegant apartment hotel but, as has been the way with so many city hotels, had now been reduced to little more than a flophouse. Today it has been restored to its former prominence as an apartment building. It was a challenge selling the Cairo to Inland, Ms. Taylor acknowledges, but she liked the "kooky" look of the hotel, its location, and the entire neighborhood, which, in fact, is on the upgrade. A confirmed city person, Ms. Taylor keeps an eager eye on the latest Washington revival neighborhoods.

The Cairo—costing $575,000, with a renovation price tag of $3 million—was a success, but somewhere in the midst of the renovation Ms. Taylor decided she really did not want to stay with a large company, no matter how much spending money was allocated to her. She wanted something more . . . independence.

So she went into business more or less for herself. She does have several partners who usually vary from one project to another. She has remodeled several other Washington apartment buildings under her new regime, and after the Washington Circle townhouses are completed she will turn to the Brighton Hotel, which she hopes to turn into a condominium, a complex undertaking but one that she—and just about every other developer in the District—finds infinitely preferable to owning rental units with their attendant problems of rent control, which translates into lower income. With the con-

dominium (and with the townhouses, too, for that matter) it's buy it, sell it, and you're out.

Her partners are, for the most part, silent. It is Ms. Taylor who arranges the financing for each project, hires the contractors, works with the architects, spends time on the construction site, and does the usual yelling and screaming.

Ms. Taylor considers herself a preservationist, preferring to work with existing handsome old buildings to building new ones. "I try to keep as much as we can of the old building," she says. "On the Washington Circle houses, for example, we'll clean the brick facade, but frankly the interior will be contemporary. They weren't built as grandiose, so the material inside isn't all that terrific."

She also prefers working in the city to the suburbs, citing the enormous supply of basically sound housing in the district awaiting rehabilitation.

Her education as a political science major did not prepare her for a career as a housing rehabilitator. "I simply learned by doing," she says. "Construction is difficult in any renovation project because you never really know until you start dealing things out what it's going to cost. That's what's tricky. You have to give people a certain price and if you're wrong you're stuck.

"People always have these great ideas about getting rich by renovating houses," she concludes. "The only way you can become wealthy is if you're a company that's bought by a bigger company." As for her own profits, she says, "I'm making some, but I'm not getting rich."

The Community Preservationists

One hundred years ago, on the South Side of Chicago, George M. Pullman built what was to have been the model industrial town next to his railway sleeping car factory. That dream was interrupted in 1894, however, by a bloody strike that crippled the railroad industry. Pullman faltered. Eventually, the community was turned over to private ownership, and it became just another section of growing, sprawling Chicago, a sixteen-block rectangular island of red brick townhouses.

But Pullman *was* unique both in concept and execution, and five years ago note was taken of its special character when landmark status was conferred on the community. A small group of middle-class, white-collar young people, dissatisfied with the suburbs and fleeing escalating rents and small apartments in more prestigious sections of Chicago, had discovered low-income, blue-collar Pullman and its predominantly Italian and Polish residents. They purchased the plain, not-terribly-distinctive row houses, fixed them up, and settled down to see what they could do next to spark their adopted community.

One of those in the forefront of the Pullman renaissance was Patricia Shymanski. A native of a middle-class Chicago suburb, Ms. Shymanski and her husband moved to Pullman ten years ago when their North Side apartment became too snug for the couple and their two children. He was—and still is—a planner for an architectural firm. She was a doctor's assistant at the time.

It was the Shymanskis, with a group of their friends, also newly arrived in Pullman, who formed a committee to have Pullman declared a national historic landmark.

"Then it became evident that to do anything more we needed a more concrete vehicle," Ms. Shymanski explained. So in 1973 the volunteers were organized and chartered as the Historic Pullman Foundation.

For now their mission is saving the district's older, noteworthy properties that are in danger of demolition. They have purchased three such buildings. The Masonic Lodge is now a community center; the Market Hall, nearly gutted by fire, has been bought "for future development." It is situated in the center of an intersection that is, according to Ms. Shymanski, "an interesting urban kind of square." The hall was to have been torn down and replaced by a parking lot.

Finally, there is the lovely, Queen Anne-style Florence Hotel, once the gathering place for Pullman executives. Today only the restaurant and bar on the first floor are open to the public, the profits going into the foundation, which hopes to operate the entire building as a commercial hotel again soon.

Results of a feasibility study indicate there is a need for hotel space in the vicinity.

The Historic Pullman Foundation, with offices in the hotel, is a nonprofit organization depending on membership fees, contributions from neighborhood merchants, fund-raising activities, small foundation grants, and loans from local banks. Eventually the group hopes that profits from the hotel and their other buildings will help to establish a low-cost loan program for homeowners in Pullman to aid them with facade restoration. And of course they will continue with their acquisition program.

Pat Shymanski is coordinator of the Foundation, a post that evolved from her early volunteer efforts in organizing the community. She and her husband are also officers of the Foundation, which has a twelve-person staff, mostly volunteer. She is salaried, but she laughs that her $2.75 an hour stipend "just about pays my baby sitter. I do spend what amounts to a lot of volunteer time on the job even now."

Pullman has quite a bit in common with another proud working-class community that, like the Chicago enclave, has experienced a recent revival.

Hoboken, New Jersey, is a square-mile city fronting on the Hudson River across from the World Trade Center in Manhattan. Its 45,000 residents, predominantly blue-collar workers, make it one of the most densely populated areas of the country. About half that number are Spanish-speaking; the remainder, a mix of Italian, Polish, and Irish, with a sizable East Indian community.

In the 18th century Hoboken flourished as a resort for wealthy New Yorkers. One hundred years later the city entered its second phase as a major port city. Remember the movie *On the Waterfront?* It dealt with the lives of longshoremen in Hoboken in the 1950s, just about the time shipping lines on Hoboken piers were beginning to close or to move across the river to Manhattan. The city was losing its focus.

But what will probably be Hoboken's third rebirth started in the late sixties when it began receiving a huge outpouring of funds as one of HUD's Model Cities, a program that ex-

pired in 1974. Numerous older apartment buildings were 're-habed,' and even an old factory was converted to attractive middle-income housing. A low-interest rate loan program encouraged property owners to fix up their homes. And, as with Pullman, in the early seventies new people began moving into Hoboken from the suburbs and from Manhattan, attracted by the city's huge stock of attractive brownstone housing and low rents. The houses had never declined to slum conditions, but now there was a new sprucing up as houses were painted, flower boxes appeared, and trees were planted on long, narrow streets that had been broken only by crossed utility lines.

Some economic problems remain, but the city does have a new look. It is a citizens' committee that deserves a part of the credit and, although it takes more than one person to effect that much change, most people in Hoboken acknowledge that Helen Manogue is responsible for the success of that group.

A former department store buyer in Manhattan, Ms. Manogue moved to Hoboken in the 1960s when her husband began teaching at the Stevens Institute of Technology in the city. The couple had one child. Another soon followed and then another. Ms. Manogue stopped working.

When was the seed of activism planted?

"I guess it all started when I had the kids," she recalled. "I used to take them out rain or shine in strollers every afternoon. It infuriated me to see the insult that the people of Hoboken had to take from the dirty streets and the trash. What made me even madder was the dirty air. Every time I'd go out I'd think, 'Why doesn't somebody say something?' But then I thought, 'Well, a group of people would be better than just one voice.' "

The result of that thought process was the Hoboken Environment Committee, founded in 1970 by Ms. Manogue and two other concerned Hobokenites. Today the committee numbers more than 300 members, newcomers and natives alike. They have slain more than their share of Goliaths for so small a community, the most recent battle being the successful three-year fight to keep a huge oil tank farm from locating on the city's waterfront. They fought against an oil desulphuriza-

tion plant and won and they have succeeded in seeing a major coffee manufacturer in the city curb the bitter coffee-grounds odor that frequently hung over the city. Between battles at City Hall and at public hearings they have encouraged the restoration of brownstones and the beautification of the city's few open spaces.

Their approach is a major reason for the success of the group. "We've never been a scatter-shot, know-nothing group operating on emotionalism," Ms. Manogue explained. "We don't try to do everything ourselves because sometimes we can't. We call in experts. We called in a mechanical engineer who was an expert in air pollution, for example, in our fight against the desulphurization plant. You can't go into a public hearing, or anywhere else for that matter, and just flail around. We have a reputation for being a very sane, sensible type of citizen's group."

Repeatedly elected chairman of the increasingly active Environment Committee, Ms. Manogue also serves on a wide variety of statewide and local councils having to do with the environment or with urban preservation. She admits that the appointments came about through the caliber of her work and the work of the committee.

In 1975 volunteerism led to a paying position. Ms. Manogue heard that a Center for Municipal Studies, a HUD-funded project, was being instituted in Hoboken. There would be a Waterfront Redevelopment Division under its umbrella that would be concerned with finding alternate uses for the largely fallow strip of land along Hoboken's shore. Ms. Manogue is now the project coordinator.

"They were tickled pink that I had all this background. I knew the people at the Port Authority, I knew the people in Trenton."

The project coordinator has noticed a subtle change in the attitude of contacts—predominantly men—she is now calling on in her salaried position. It is difficult to pinpoint, she begins to explain, but perhaps now they take her a shade more seriously. "It certainly helps that I'm being paid now, but you

have to be much better informed than when you're a citizen activist."

The moral of the stories of Pat Shymanski and Helen Manogue? That volunteering can be its own reward, of course, but it is also possible to take community service one step further to a regular salaried position. The hours are long and the work sometimes tiresome and thankless, but the results these women achieve will mean positive and tangible change in the communities in which they live. That's quite a legacy.

How to Get Started

Those are just a few descriptions of jobs in preservation and its allied areas. There are other slots in the field, principally with local historical societies and with the state and federal governments. But employment is tight. It is also a so-called glamour field with would-be preservationists flocking to the few job openings that do arise. As you can see from the preceding pages, it is frequently necessary to dig around to find one's own niche, perhaps beginning as a volunteer to at least be on the inside to hear of openings. The way it works now, they are filled almost instantly.

The field is also a low-paying one, since many organizations are nonprofit and depend on various funding sources for their existence. High salaries are not considered necessary for their survival. In some areas, too, volunteers can be found easily, obviating the need for salaried employees at all.

It is possible now to prepare educationally for work in the field. A growing number of colleges and universities now offer degree programs in Historic Preservation. But at Columbia University, which offers a degree program in Historic Preservation, one woman knowledgeable in the field remarked that "they have sixty graduates coming up here and I have no idea where they'll all find jobs!"

So—as with museum work and publishing and the super-glamour arenas of television and the movies—the preservationist must forge her own way by her own wits. The intrepid will make it!

Other Career Guidance Sources

The National Trust for Historic Preservation
740 Jackson Pl., NW
Washington, D. C. 20006

This nonprofit group will send to interested persons a list of colleges and universities that can aid in a career in preservation. They can also provide details about their summer intern program, their bookstore catalog, and a free copy of the monthly publication *Preservation News*.

"Young Women in Historic Preservation," reprinted from *Mademoiselle Magazine*, September 1975. Available for 50 cents from the magazine at 350 Madison Avenue, New York, New York 10017.

8

Assessing the Appraiser

THE TALL YOUNG WOMAN ATTRACTED ATTENTION FROM PASS-
ers-by as she walked slowly around the somewhat dilapidated
suburban apartment building. No reason she shouldn't have,
since she was quite attractive, but she was also weighted down
with a shoulder bag, briefcase, and tape recorder; and while
she walked she spoke continuously into the microphone, her
eyes moving steadily across the complex:

> The subject property is known as 100 Great
> Bay Avenue in Bayswater, New York. The subject
> is on the south side of Great Bay Avenue and
> occupies most of the frontage of the south side of
> Great Bay Avenue between First and Second
> Streets. (Check legal description, but I believe
> that the distance from First Street is 200 feet.)
> The subject property is improved with a six-
> story-and-basement apartment house. The subject
> has a red brick facade. Windows are wood,
> double-hung. Air conditioning sleeves are set be-
> neath the windows.

There are twelve lines of balconies. Four in
front of the building, four in the rear of the
building, and two on each side. The balconies
are poured concrete with painted wrought-iron
railings. There are fiberglass panels separating
the balconies, which allows for privacy.

Automobile access to the building is provided
via two vehicular entrances, one on the east and
one on the west side of the Great Bay Avenue
frontage. . . .

Patricia Marshall's description went on. It eventually be-
came a seven-page report and included innumerable details
about the building: the style and condition of the heating
plant; the number of personnel attached to the building; the
rent roll; the fact that the landlord provides gas while tenants
pay for electricity; and a full description of two apartment
units—

Now inspecting apartment 5B. . . .

This is a four-room apartment. Room sizes are
adequate. Closet space and kitchen cabinet space
appear to be adequate. There are two baths. One
of the baths has a stall shower and the other is a
full bath. The bathrooms have a ceramic tile
floor. The full bath has wainscoting to four feet
and to six feet around the tub with painted plas-
ter walls above and a painted plaster ceiling, a
wall-hung basin set in a vanity, a flushometer, a
medicine cabinet, and a clothes hamper. The sec-
ond bath is off the master bedroom and does not
have ceramic tile wainscoting on the walls. In
addition, there is no vanity. It is equipped with a
medicine chest. The shower has a glass door.

It should be noted that the apartment has
hardwood oak floors, painted plaster walls and
ceiling. Air conditioners are supplied in the mas-
ter bedroom and the living room. The living
room is a good-sized room.

The kitchen is an eat-in kitchen. The kitchen has a vinyl tile floor, painted plaster walls, painted plaster ceilings, fluorescent lighting, and a window. Cabinets, both wall-hung and base, are wood. Base cabinets have a formica counter top. Electrical outlets seem to be adequate. There is a GE two-door refrigerator-freezer (sixteen-cubic-foot capacity), a gas four-burner stove (Royal Rose), a GE dishwasher, and a sink. The kitchen is a modern kitchen.

Ms. Marshall spent the better part of the day at the apartment complex on Long Island, walking around, taking her own notes, and talking to the on-site superintendent. But the visit was only the beginning of her appraisal of the property, a job the building owner had requested in his attempt to secure a lower assessment of the property—which could lead to lower taxes.

"That's not the meat, that's just getting the feel of the property," Ms. Marshall said later. She is vice-president of Theodore J. Powers Associates, Inc., a Manhattan appraisal and consultant firm.

The "meat" is the actual valuation; that is arrived at after hours of sifting through tax and sales records and similar data and weighing it all to come up with an analysis of the property's worth.

The Inexact Science

An appraisal is an estimate of opinion or value. Appraising has been described as an inexact science, but by analyzing facts—assuming their validity and accuracy and the competence of the appraiser—a fair estimate should emerge of the value of the property in question and there should be minimal differences of opinion should several different appraisers be studying the property. There are several types of value used in real estate, such as insurable value, mortgage value, assessed value. However, it is market value that is of the most interest: What is the highest price this property will bring on the open

market? A lot goes into determining that value, although there
is an old appraiser's axiom that value is mainly dependent on
three factors—location, location, location!

The beginnings of appraising go back to the England of the
sixteenth century, when the need arose for various complicated
real estate services beyond the handshake of the two princi-
pals. Known as "surveying" then—and now, for that matter—
it was based principally on agricultural land. A text dated
1523 quotes one John Fitzherbert in the *Book of Husbandry
and Book of Surveying* on many activities peripheral to the
purchase of farmland. The author went into his knowledge of
"castels and other buyldinges" and of "what the walles,
tymber, stone, sclate, tyle or other of coverynges is worth." He
knew the costs and varieties of construction materials. He was
probably appraising buildings as well as land.

From those days appraising grew into the specialized prac-
tice it is today. Most of the change has occurred within the
last twenty years. Prior to that, real estate brokers often offered
appraising as part of their service to clients. But the field be-
gan to grow complicated. Tax laws became more complex.
Court appearances were frequently necessary by those apprais-
ing, and while a broker would not mind writing an opinion
on property, he did not want to document it and he certainly
did not want to stand up to cross-examination in court.

"Until about ten years ago you didn't make a living as an
appraiser unless you were with the government," said Jean
Felts, president of Waguespack, Dupree, & Felts, Inc. in New
Orleans, and one of the most prominent women in appraising
nationally. "But now, as people find the world is more com-
plex they turn to specialists."

Over the last ten years appraising has evolved into a highly
skilled "inexact science," governed by an ever-tightening code
of ethics and its own recognition of excellence. There are doz-
ens of appraising societies, several in the area of real estate.
Almost all have degrees of professionalism within the society.
At the American Institute of Real Estate Appraisers, the desig-
nation Master, Appraiser Institute (MAI) is awarded members
in commercial, industrial, or residential appraising who have

fulfilled several requirements, one of which is working five years as an appraiser. The RM (Residential Member) designation goes to those strictly in the residential area of real estate.

Whom Do Appraisers Serve?
There are several reasons why an appraiser's services might be needed.

• For one, lenders usually require an appraisal before making a mortgage loan. Sometimes, when the lender is a large bank, this is done by their own appraising department. Otherwise a borrower is asked to have the property appraised by a recognized outside appraiser. A loan will be offered at a certain percentage of value.

• Real estate appraisals may also be required for determining the value of the property for tax purposes—for obtaining an assessment reduction, say, which could lead to an overall tax reduction.

• An appraisal may be ordered by a homeowner (or landowner) if the property is going to be condemned for some public purpose such as the widening of a highway, or an urban renewal project. The condemning authority will present the homeowner with an offer and if he or she does not want to accept it, it will be necessary for them to have their own appraisal to support their argument that the land is worth more.

• A homeowner who buys an older house may want an appraisal to see if the house's value after renovation will equal or exceed its potential selling price plus the renovation cost.

• A government agency will need an appraisal of a property that is to be foreclosed.

• An appraisal may be needed if a property is to be divided among heirs, or if a partnership is to be dissolved.

• Businesses sometimes use an appraisal for an updated valuation of their assets.

Just as there are several types of values used in real estate, the most popular being market value, there are several differ-

ent methods of appraisal. The most popular here is the comparison approach. That is based for the most part on analyses of sales of comparable properties.

Appraisers must go where work is. Although most need travel only within a sixty-mile-or-so radius of their home for assignments, sometimes the territory is a bit expanded. One appraiser she knows, says Jean Felts, accepts assignments from Albuquerque to Canada! But usually an appraiser's travels into unknown climes are infrequent. Getting away from the territory one knows so well, of course, presents a different set of problems for that particular assignment, but they can be challenging. Katherine Bryan Tanucci, in an article, "Highest and Best Use," published in *Appraisal Digest* (and it was a beautifully written, award-winning piece, by the way) described her own procedure for tackling out-of-town appraisals:

> An appraiser must learn how best to quickly assemble material on an unfamiliar area which will reveal the economic background within which a subject property is operated. In a new city, I ask to be taken to the top of the tallest building, for example, to get some perspective and feeling of the environs, and I ask what gave birth to this area; what has nourished it? Or from what disease is it dying? Where do the rich and poor people live? What are the landmarks? Why does this historic town have no movie theatre? Are the neighborhood boundaries economic, topographic, sociological? Where is the subject property from here? Where is its competition?
>
> If possible, in a new situation I try to see the subject property first and last. In between I go to the tax department, the zoning and planning departments—all the usual sources and as many more as I can uncover—the tallest building, and the local appraiser or Realtor (whom I have previously contacted for an appointment), who will give me the tour of his territory. He may be the

source of my comparable sales and can show them to me, or can help me understand why there are none.

Talking to appraisers, counselors, Realtors, local authorities, storekeepers, taxi drivers, shoppers, everybody I can—this I consider part of the highest and best use of my time as an appraiser out of town. In my own city the procedure is not too far different, except that there I am even more careful not to guess or presume, but, rather, to check it all out as if I were a stranger. One appraiser, to whom I often turn for the last word, urges his students to note all "within sight or hearing" and to ask the *why* of it all. Excellent advice.

Women—Welcome

There are several organizations of appraisers, but we'll consider just two—one because of its size and the other because of the volume of its services to members in the form of courses, textbooks, seminars, etc.

The Society of Real Estate Appraisers, based in Chicago, lists 20,000 members. Some 600 hold professional designations (granted by the society). A mere thirty-five are women, although according to Bonnie O'Brien, "every week we get more and more female members."

The American Institute of Real Estate Appraisers, a branch of the National Association of Realtors, lists 4,000+ members holding their professional designation. Twenty of them are women.

None of the above figures include, of course, the number of women working in the field without professional credentials from these organizations. It's still not many women, but things are looking up.

"Until about five years ago the local chapters had a lot to say about who got in," Jean Felts explained. "They could say 'We don't want women.' But that no longer exists. We've broken it wide open.

"Twelve to fourteen years ago I was the only woman in a course with seventy-five to a hundred men," she continued. "Today there will be as many as twenty women in a class.

"But many women are put off appraising by worrying that it is too technical. It isn't. It's a matter of confidence, really. Women just need confidence." To draw more women into the field, Ms. Felts has been conducting a seminar in various cities entitled "Women Do Succeed in Appraising." It is sponsored by the American Institute of Real Estate Appraisers.

Pat Marshall, who of course *has* succeeded in appraising, admits some discrimination does exist "and it still bothers me, to tell the truth." Ms. Marshall does not go to court, an appearance that is frequently required of appraisers. "I won't go. My partner goes. I won't because they think, 'She looks too young.' And you never know how that will affect the case. I have to do the best for my client, so Ted goes."

But while sexism is still present in many areas and in many offices, the increased visibility of women in the field "is good for all of us women," Ms. Marshall concluded.

How to Get Started

As noted earlier, appraising has been evolving over the last two decades and is only now becoming a structured, monitored practice. In most states no license is required to practice appraising; in some a broker's license is necessary; in a few states a salesman's license is required, and an almost insignificant number of states mandate an appraiser's license.

(For women already in real estate sales, Mary Jane Carlisle, an Alabama appraiser, offers some advice: "You're really doing some of the appraising work, so why not make it legitimate and profitable at the same time by seeking professional designation?")

A broker's license or a degree in real estate is a help to any beginner. Appraisers usually find jobs with banks, mortgage firms, the federal or state government, or as "fee appraisers" for the independent appraising firm. The former usually work a nine-to-five day and are salaried. Fee appraisers work in the style of real estate agents, i.e., on a commission basis.

It may be opening up to women, but appraising can still be difficult for the beginner to crack. Brenda Newell, a recent graduate with a degree in real estate, still has been unable to find appraising work in her native Connecticut. "It's saturated here," she said. "And I really hate to relocate."

The problem for those starting out in fee appraisal is that if business is slow the firm does not need additional employees. If business is very good, there is no time to train the beginner. And those in the field stress that on-the-job duties are different from textbook problems. Supervision and guidance are necessary.

So what's a beginner to do?

A newcomer will usually start as a "legman" or, to pretty that up, as a "research assistant" in an appraisal firm. Annelle Gaeta was Pat Marshall's assistant the day Ms. Marshall toured the apartment building on Long Island. While Ms. Marshall was inside the building, Ms. Gaeta took the car and made her rounds. First she checked the immediate neighborhood to see if there were comparable apartment buildings. She noted their locations. Then she went to the courthouse for sales figures for the building in question and for the comparable buildings. That was one day. (The property in question, by the way, was thirty miles from the women's office.) On other days, Ms. Gaeta, who is twenty-four and has no prior real estate experience, may be called on to stop at the local buildings department for the original floor plans of a building or to make any of a number of other stops to bring back material that will aid the appraiser in forming her evaluation. It is not "gofer" work. The assistant must know what she is looking for and must frequently spend hours plowing through bound volumes or musty papers. "You need somebody who does know how to draw floor plans or find a courthouse or read blueprints," said Jean Felts. "Sure, I still have to do that myself occasionally, but ideally there is someone on the staff to do it since it's so time-consuming." Ms. Gaeta spends little time in the office; most days it's sign in, then out to the car and off to city hall, or wherever.

"Just knock on doors," suggests Pat Marshall, who applied

for a certain research assistant job because the company re-quested "male only." "If they can't give you a job ask to be called when they have an overload. Or say, 'I'll do sales searches for you.' That's one way to get a foot in the door."

Full-time research assistants earn around $8,000-$10,000, al-though Jean Felts recalled, somewhat surprised, a trainee job recently offered at $16,000—and in the south yet, she added. Established appraisers should have no trouble earning $25,000 a year and some few have been known to top $60,000. It de-pends on how hard you work, and of course it takes time to build up contacts. It helps to own one's own business, too.

An important tip to all beginners from those who have done well: "Every successful appraiser was guided by at least one master. Get the best you can."

The Job Outlook

A nationwide survey conducted by *The Appraiser,* the publica-tion of the National Association of Real Estate Appraisers, disclosed that appraisers generally are surviving "fairly well" during the economic crises that have affected real estate in the mid-seventies. However, many have found that the nature of their assignments has changed. On the one hand, as the fi-nancing situation for new building became tighter, appraisers experienced a decline in appraisals for new projects, including housing. But then, as lenders and corporations became more concerned about their real estate holdings, appraisers have been called upon much more than they have in recent years to assignments dealing with foreclosed and other problem prop-erties, or simply for appraisals by companies wanting to know the value of their holdings, since dollars must be spent care-fully.

"People are more cautious these days," adds Jean Felts. "They need you before they make a decision on whether to go into something.

"And of course there's a variety of steady business. There's a certain amount of condemnation work, so if you have a gen-eral practice rather than just mortgages, it will go on. A top-flight appraiser is never going to make as much money at one

time as a top-flight salesman, but over all you will make more because you never have the ups and downs. It's steady."

Other Career Guidance Sources

American Institute of Real Estate Appraisers
155 E. Superior St.
Chicago, Illinois 60611

Offers career and educational printed material at no charge, textbooks and licensing information. The monthly publication is *The Appraiser.*

Society of Real Estate Appraisers
7 South Dearborn St.
Chicago, Illinois 60603

Offers career and educational printed material at no charge.

9

Property Management—Help Wanted

IN WEST LOS ANGELES THERE STANDS WHAT MIGHT BE DE-
scribed as the archetypal California apartment complex—sleek
two-story units of natural wood amid much greenery and
topped by random arrangements of the ubiquitous palm tree.
The tenantry is comprised of supposedly trendy single people.
It is called Woodcliff, and Helena Otzen is the resident man-
ager. She lives on the premises rent-free in a $380 two-
bedroom apartment, and in addition receives quite a substan-
tial salary. She earns it.

Across the country, Sharon Keilin is watching a new "city"
that will eventually house 25,000 people rise on the marsh-
lands of Jamaica Bay in Brooklyn. There are now slightly
more than 2,000 residents of Starrett City. As assistant man-
ager in charge of renting and residential and community rela-
tions, Ms. Keilin is guiding tenants, shopkeepers, and the sur-
rounding communities through the decision-filled first days. It
is a busy time that often becomes hectic.

Both young women are in the burgeoning field of property
management. It is a real estate specialty that is experiencing

growth generally, and one that has become especially receptive to women. Male management supervisors claim women "know how to take care of buildings," "can handle people," "have the personal touch," "can defuse tenants." (They come cheaper, too. But more about that later.)

As with commercial leasing and appraising, property management has been pretty much a male stronghold. But there has been a notable surge of interest among women in the field in the last few years. The professional credential is the Certified Property Manager designation, awarded by the Institute of Real Estate Management after the prescribed work in the field has been completed and an examination has been passed. Many property managers are working without the designation, of course, but today 3,071 men and 117 women can put the initials CPM after their names. No, that isn't many women, but almost all of them were accredited just in the last four years. Now working for certification are another 1,892 men and 205 women. The number of women CPMs will soon double.

So, one may conclude from the above figures alone, will the number of property managers in general, which is fine with property owners. In many areas of the country, demand far exceeds the supply of qualified personnel, especially in the new areas of condominium and cooperative management.

What types of property does a property manager manage? Apartment houses, office buildings, shopping centers, lofts, and single-family houses that are rented. A manager or management firm also handles the day-to-day workings of the cooperative or condominium, answering to the owners' association within the building. Managers are paid a flat fee or a percentage of the building's rent roll.

The manager leases space, collects rents, handles the assignment of repairs, purchases supplies, and handles staffing, payroll, advertising, accounting, and taxes. Owners of large buildings, more commonly apartment houses, hire management firms to run their projects, but smaller property owners can also utilize their services. One small, five-unit brownstone cooperative found itself drowning in record-keeping. They threw in the mini-computer and hired professionals.

In marginal neighborhoods where the property manager is called in, the problems may be acute. The block may be faced with abandonment, rents may be long overdue, new financing may be needed. Perhaps the property cannot, after all, be saved. It requires research, skill, and imagination on the part of the property manager to make a viable recommendation to the owner. Most buildings can be turned around. But some, in the words of one manager, "are so ill conceived that they do not deserve to be rescued."

At the average-size property management firm, there are, besides the letterhead executives, the clerical and accounting personnel, a staff of agents, each of whom is assigned a few properties to manage, and the supervisors who oversee the office staff and the resident managers working "in the field." Pay scales run from about $14,000 to the $30,000 bracket at the level of vice-president.

Some jobs are pretty much one of a kind. Beth Shelton is a property manager with Shannon & Luchs, a large firm with offices in Washington, D.C., Maryland, and Virginia. She has the rather rare supervisory position of rental manager for houses in Washington and Maryland. With the constant movement of government workers and foreign staff people into and out of the district, there is an ample market for the renting of private homes and the few condominium apartment units Shannon & Luchs manages. The listing of rental homes runs into "the thousands."

Ms. Shelton is a licensed real estate agent. While selling residential properties for a small realty firm in the mid-sixties, she was invited to join their just-developing property division. After some experience in management, she moved to Shannon & Luchs.

Although men and women can work through the ranks leading from apartment house manager, Ms. Shelton did not. "It never interested me," she explained. "I still think you need to be licensed or the professionalism is not behind you. Most resident managers see that and many of them do study for their licenses."

Licensed or unlicensed, there is a variety of management positions being offered these days, thanks to the burst of new

construction in the late sixties and early seventies. Apartment complexes, previously unknown in the suburbs, now comprise forty-five percent of suburban buildings. New shopping centers are continually opening, and moving farther out into exurbia. Industrial parks are bringing job opportunities to those living outside the cities. And condominiums are everywhere. Many, if not most, of these properties are managed professionally. To take a closer look at management responsibilities, we'll start with the apartment manager. Sometimes she lives elsewhere; sometimes she is the resident manager.

The Apartment Manager

Back to the palm trees and *joie de vivre* of the Woodcliff in Los Angeles, a 500-unit complex with 800 tenants.

Helena Otzen saw a visitor at the end of a typically busy day. The sun was setting, and although the seats around the three-story gazebo overlooking the pool looked inviting, so did the indoor game room with its plush chairs. The latter won. Inside it was cool, comfortable, and empty. The front of the room with its floor-to-ceiling glass windows faced the pool, now stirring with activity as tenants returning from work headed for a before-dinner dip.

Ms. Otzen, who is in her early thirties, manages a staff of five women working in the rental office on part- or full-time shifts, a cleaning crew and security guards. She is employed by Moss & Co., the largest property management firm in Los Angeles. Moss manages some sixty apartment buildings.

The young manager has been with the company for three years. Originally from Holland, she had been an airline stewardess. But she wanted to try something different, while still working with people. She saw a newspaper advertisement for a manager of a small apartment building managed by Moss. "In Europe these positions don't exist," she explained. "So I had no idea what the job entailed. But I had on-the-job training as a stewardess, so they let me try."

What the job did entail was running a fifty-unit apartment building in the San Fernando Valley, an opening usually offered the beginner. She was given a free apartment on the

premises and a salary of $150 a month. The tenantry was pre-
dominantly quiet, elderly people, so there was time to gradu-
ally absorb the ways of apartment-house management. She did
well, moved to a larger building, and was finally rewarded
with Woodcliff, an award-winning complex whose charms
have already been described.

Ms. Otzen lives in a ground-floor apartment with her hus-
band, an electrical contractor who does frequent jobs for
Woodcliff. The bookkeeper also lives on the premises in a
rent-free apartment, receiving a $550-a-month salary. So does
one other woman staff member earning $350 a month.

Ms. Otzen's hours are 9 A.M. to 7 P.M., with two days off
each week. But if something comes up at 1 A.M., guess who is
called? It goes with the territory. When she goes out she leaves
word where she can be reached, so is more or less always on
call.

Glancing out from time to time at the crowd around the
pool, squinting against the intense late-afternoon sun, Ms. Ot-
zen slowly recounted her day. It was average, she said with a
smile, the trace of Holland discernible in her voice, the peppi-
ness of the stewardess still apparent in her motions.

9-11 A.M. On the phone calling suppliers for
cleaning materials; finding someone
to fix a couple of broken windows;
seeing about some new furniture
(many of the apartments are rented
furnished).

11-1 P.M. Working with the bookkeeper going
over rents—who has paid and who
hasn't. This, along with keeping
vacancies low, is the most impor-
tant part of the resident manager's
job. Delinquencies show on the
manager's record. Moss's area man-
ager, who oversees several com-
plexes in his region of Los Angeles,
visits Woodcliff once a week to col-

lect rents and look over the delin-
quent list. For her part, Ms. Otzen
first sends a letter to those whose
rent is overdue, then pays them a
personal visit. It is delicate and try-
ing. "In that first building, with
the older people, it was much eas-
ier," she said. "Older people have
more of a feeling of responsibility
toward bills." The trick, she added,
is to be very careful in screening
prospective tenants so that poten-
tial credit duds are not rented
apartments.

Lunch Not really. A few minutes snatched
for two cups of coffee and a piece
of cake. She seldom takes a lunch
hour.

1:15-5:30 P.M. Going over bills to be paid. Show-
ing two apartments. Spending time
with vendors. One item she is look-
ing for is something to kill smoke
in the trash shutes. There will be a
party in the game room over the
weekend given by management. She
called to purchase liquor and
snacks.

5:30-6:40 P.M. Talked with a reporter.

Tomorrow, Ms. Otzen added, she would "walk the build-
ing," a tour she makes periodically to see if the carpeting
needs shampooing, if the light fixtures are working and the
model rooms are in order—in general, seeing that everything
is running smoothly.

She is studying for the real estate licensing examination.
With the license, she said, she could next become a district
manager for the company. "A district manager gets *out*," she
said, "and covers all the buildings in the district. Of course,

once I get my license I can look around and see what else is doing in real estate."

Moss, she explained, hires women almost exclusively for management positions at her level and below. Are they not then discriminating against men? Well—and this can be found nationally as well—the pay is not that great at the entry and middle levels. Women, either single or with working husbands, will take the jobs. Men with families will not.

Who Qualifies?

There are usually no education, work-experience, or age requirements for the position of apartment-house manager. A real estate license is not required either, unless the firm to which one is applying insists that its employees be armed with one. However, the professional with her eye on the next rung of the company ladder soon starts working for her Accredited Resident Manager certificate, another program offered by the Institute of Real Estate Management.

Managing the subsidized apartment building can be complex, but the apartment house built with private monies is wide open, employmentwise. Managers come from a variety of former occupations. The following considerations should be borne in mind, however.

Some jobs are full-time, others part-time. Projects with over twenty or twenty-five units require full-time management. And, although you will have set office hours, you will always be more or less available to tenants and the management firm or building owner. If the job is part-time, can you manage it along with your regular employment?

Look at the project. Will you be working with single people, young families, retired couples? Each has different needs.

Salaries vary widely according to the age of the complex, its size, the prominence of the managing firm or developer, the region of the country. Don't be taken in too quickly by the lure of a rent-free apartment. You'll work for it. And can you live on perhaps $50 or $75 or even $100 a week?

Disposition is important, as are a cool head and a fine sense of diplomacy. No favoritism must be shown any tenant. In fact, one manager claims close friendships are impossible in a

building. If you are invited to someone's apartment for a drink, she says, the few minutes of pleasantries are followed by a litany of complaints!

One development in recent years that has disturbed building owners has been the rise of tenant associations. Usually formed in the heat of anger over some injustice in the building (rising rents, lack of repairs), tenant unions are bringing more strain to always somewhat cool landlord/tenant relations. The resident manager, living among the tenants but a representative of the landlord, is caught in the middle. She must know enough about landlord-tenant law to protect the rights of both the owner and the residents.

Owners of a smattering of apartment complexes across the country have taken the ingenious step of hiring ordained Protestant ministers as resident managers of their buildings. The ministers, owners say, can defuse tenant wrath and are highly trained to deal with any of the sociological problems found in an apartment complex, which is, after all, a microcosm of society at large. Many of the ministers are women since female clerics are having a difficult time securing parish assignments. But one male minister working in a housing project in New York comments wryly that "they yell about things, minister or no minister." So bear in mind tenant ire these days. Can you cope with it?

How To Get Started

Call your local apartment association (e.g., Building Owners and Managers Association of New York, Houston Apartment Association) for information about openings in the field. Read the classified advertisements. These advertisements ran one weekday in the Chicago *Tribune*. They ask for experienced help, but experience in another managerial arena (head teller at a bank, manager of a small store, even teaching) might land you the job.

Rental Agent
and Recreation Director

Immediate opening for this position at large XXXXXX Estates apartment complex. Expe-

rience preferred. Must be personable, outgoing and able to deal effectively with all types of people. You will administer activity program and rent apartments. Good communication skills required for maintaining newsletter. Sales and rental ability required. Must work Sat. or Sun. Call——

Rental Manager

Experienced rental manager for large apartment project in W. suburbs. Salary, apt. + Co. benefits. Must be willing to carry out company policies. Room for advancement. Call——

It should be pointed out here that there is frequent overlapping in job titles and duties from one complex to another and in different regions of the country. The rental agent, for instance, does not always function as the recreation director as well. Usually that is a separate job.

Managing the Government-Assisted Housing Project

In working for the private developer, who constructs his building with no financial assistance from the federal, state, or local governments, there are only the two of you. He runs the building the way he likes and you run it the way he likes. Aside from the obvious intrusions—zoning ordinances in building, anti-discrimination statutes when renting—the government keeps out.

Subsidized projects are another story. In those buildings— constructed for low- or middle-income people with income limits and other restrictions for admittance—the U. S. Department of Housing and Urban Development (HUD) or the state or municipal agency contributes financially to the cost of construction and operation of the development. The agencies are always there to guide the developer and manager through the stringent regulation such housing entails: strict renting proce-

dures, background checks of prospective tenants, frequently a racial and ethnic balance to be scrupulously maintained and adherence to other, ever-changing procedures of the bureaucratic process. Especially in projects that are financed by HUD-insured or HUD-held mortgages.

Starrett City in Brooklyn, New York, is being built by developer Robert Rosenberg. A limited-profit housing program, it qualifies for assistance from HUD and from the state Mitchell-Lama program that assists middle-income projects. There are forty-six buildings and eight covered garages at Starrett City. The population, now at a little more than 2,000, will one day rise to 6,000 families. Already there is a hefty bi-weekly tabloid, the Starrett City Sun, and a total energy plant. Under construction are a community center, a twenty-four-store shopping center, and a school.

The development is rising on 150 acres of former marshes and garbage landfill along Jamaica Bay. It is near Kennedy Airport and also close to Italian and Jewish Canarsie. In another direction is a predominantly black community. But they are all off in a distance. Starrett City stands by itself, whipped by the winds from the bay, a stockpile of somewhat bland high-rise buildings with only a major highway immediately nearby. Who is moving into this new community? The early days of renting may set the tone of tenant composition for many years to come.

Sharon Keilin, assistant manager in charge of renting and residential and community relations, is walking a fine line in selecting that initial tenantry.

"Will Starrett City be a black community? Will it be lily-white? Will it be Jewish? My answer is that it will be diversified. Starting out like this gets into very substantive questions such as what racial mix leads to a stable community. The federal government says seventy percent white to thirty percent black and that's what we're aiming for. There's no breakdown of whites who have moved in but right now they tend to be Jewish."

Ms. Keilin manages a complicated renting procedure that generally limits income of those living in the development to

about $11,000 for single people to $18,000 for a family of six. Apartments run from $188 for a studio to $330 for a unit with three bedrooms.

"Subsidized developments are infinitely more complex than private housing," she explained. "There's ethnicity and economic diversity to be considered and a whole host of federal guidelines. You even have to give special thought to advertising and which media to use to get the right mix of people.

"Renting the units is the most frustrating aspect of the job. The nature of the federal and state subsidies narrows the band of eligibles, so of the great number of people needing good housing in the city, maybe one third will be able to live here."

Ms. Keilin does not live at Starrett City. She was offered an apartment on the site, which could have saved her close to $6,000 a year in rent, but she declined. "You can't be fresh enough if you're here all the time. I'm no less available because I live somewhere else."

The somewhere else is a one-hour drive to and from Manhattan, where she lives in another new community, Roosevelt Island—formerly Welfare Island—situated in the East River running along the East Side of Manhattan. Divorced, she shares an apartment there with her eight-year-old son. One of the pioneer residents of the island—there are still not many families living there—she is already president of the residents' association. On the island she is a spokesman for the renter, out in Brooklyn for the landlord.

At Starrett City, the day begins for the thirty-one-year-old manager at 9:30 A.M. The office opens officially at 10:30 and she stays in the evening until 6:30 or so to see working people on their return home. Later in the evening there are sometimes social events that require her presence—to check security, lighting, and the other details that go into putting on, say, an outdoor rock concert. "Sometimes we have 50,000 people here. It's important to bring in outsiders. Otherwise we're going to have a walled city."

During a brief few moments of relaxation at her piled-high desk in the rental office, Ms. Keilin, a small blond woman who in an earlier time might have been described as "pert,"

ran through the activities of the previous day that had nothing to do with the actual renting of apartments. She met with a representative from the telephone company about some installations, she said, and then went to a nearby store to pick out wallpaper for the new rental office. They're moving since the front buildings are now totally rented and it does not seem fair, as Ms. Keilin put it, for a busy rental office to occupy what is now a residential building. She talked with a Canarsie business machine company representative about purchasing a duplicating machine for a newsletter that goes out to tenants each week to keep them informed on construction progress and other matters. She wrote her column that appears regularly in the Starrett City *Sun,* then talked to a tenant delegation and the operator of a temporary deli on the site. Then it was time for some dictation.

All busy and necessary. It is the careful renting of apartment units, though, that is Ms. Keilin's primary responsibility. And it is one she is well qualified to handle, as her education and experience bears.

"I was educated at Sarah Lawrence, then Harvard Graduate School, majoring in political science. I was looking to be a professor, but saw that the real fun was out there making decisions. That lead to a job with the government—the city's Housing and Development Administration where I was a lobbyist at the Board of Estimate and at the City Planning Commission. I was responsible for preparing all formal submissions of program proposals for new city housing to the Board of Estimate because they had to approve it. Then I'd lobby it through. (Robert Rosenberg, builder of Starrett City, was first deputy commissioner of the HDA at the time.)

"After three years I went to the New York State Urban Development Corporation [a quasi-public organization that mostly builds housing units], first as assistant to the president for New York City affairs (including Roosevelt Island, a project of the UDC). I was his 'man' at various meetings, did research reports, then was appointed director of civic development at UDC. That meant projects like libraries, garages, youth centers. I did that for a year. I was responsible for a

project until it went into construction. I recommended an architect and engineer, followed through the various city approvals needed, did cost analyses, and worked with the community where the new project would be.

"I never read a book on property management. My theory is the best teacher is probably someone who's in the business. I used to pick up the phone to call someone at UDC who supervised thirty-three of these projects."

Not one to coast with a merely demanding, well-paying job, Ms. Keilin is now taking courses at New York University in building construction. "That's what I'd like to do—build. If I can ever get the money to do it. That's the most exciting thing to me—to put together a building."

As number-two person at Starrett City, working directly under developer Rosenberg, Ms. Keilin receives close to $25,000 a year. Also working under Mr. Rosenberg is another assistant manager, a man in charge of maintenance, security, rent collections, and commercial leasing. He is paid more.

"I'm trying like hell to do something about it whenever I get an opportunity. I know I'm making over $2,000 a year less than the other assistant manager. But I've never worked in the private sector before and I've discovered that in the private sector you can be fired on a whim. If you're not satisfied, they can get any number of people to take your job. That's definitely the way the employee is made to feel."

Who Qualifies?

At this writing strict requirements for managing federally assisted (HUD) and public (state and municipally subsidized) housing projects are being drawn up by those agencies. There will be education requirements, specialized courses to be taken, and special certification required. To alleviate high default rates, abandonment, vandalism, and other problems, HUD in particular is stressing good management these days. The federal agency is also inaugurating internship programs in housing management at several universities, among them Howard University in Washington, D. C., and Temple University in Philadelphia. For further information about job oppor-

tunities contact your local housing authority or your regional or area office of the U. S. Department of Housing and Urban Development.

The Recreation Director

Also new to the apartment picture in the last year or so is the huge inventory of unrented units in some sections of the country brought about by the optimistic overbuilding of the early seventies. In those regions competition is intense, with developers resorting to one gimmick after another to lure tenants. There is the one month's free rent, the swimming club, the on-site chaplain, the dozens of social activities.

So tenants moving into new apartment buildings these days can frequently expect more for their money than "6 rms riv vu." It pays the developer, even in a landlord's market, to hire a social director to see that everyone is kept happy. Happy tenants do not move, and moving and its accompanying nightmare of vacant apartments, even for a short time, mean a profit loss.

The social/recreation director manages the social life of the complex, cruise-ship style. She may edit the building newsletter, organize meetings and social clubs, arrange holiday parties and in general keep everyone stepping. Jenille Ivory of Stansbury Park, Utah, a new community twenty-five miles west of Salt Lake City, has organized a mixed bowling league, a community garden, and a program among residents to help one another in time of need.

With a background that included operating a dance studio and a long spell of nursing, Ms. Ivory was placed in charge of arranging entertainment for residents' outings when she and her husband—grandparents—moved to Stansbury Park. That lead to her present position, Community Activities Coordinator.

And that brings up another hat social directors must frequently wear these days. The homes at Stansbury Park carry one-year guarantees, and Ms. Ivory processes any problems relating to the new townhouses, which are built by Terracor. Seeking to head off problems before they mushroom into can-

celled sales agreements, law suits, tenant strikes, or worse, many developers are hiring trouble-shooters and many are actively seeking women for the positions. So soothing, they say. Sometimes the jobs are newly created. Remember the program a few years back where nonprofit and charitable organizations saved Green Stamps as fund-raising activities? Arlene La-Tourette was responsible for initiating and supervising it as manager of consumer relations for the Sperry & Hutchinson Co. in New York. Today she is Consumer Affairs Manager for Crestwood Village, a New Jersey adult community located in the Pine Barrens, a huge acreage of pineland running through the central part of that state. She is a company spokesman to the media, explains her immediate supervisor, the director of marketing, and she is also a public relations woman and goodwill ambassador to adult groups.

Down the road apiece, so to speak, Virginia Hagopian is Director of Customer Relations for Birchfield, a planned community in the southern part of New Jersey erected by a major builder in the area. Like Jenille Ivory in Utah, Ms. Hagopian will handle adjustments that may be required under the community's one-year service warranty. She also conducts pre-settlement inspections to make sure there are no defects in construction, fixtures, or facilities in the townhouses, and she helps coordinate residents' decorator selections.

A "social" position in that residents are kept happy, these jobs are also strongly allied with management in spotting problems before they become red ink on the company ledger and bad will elsewhere. A clever tactic.

Who Qualifies?

Social directors need no particular background or education, save what will satisfy their employer. They'll need energy, though, and optimism and empathy. A large economy size of the latter. "For many people moving is one of the most traumatic experiences of their life," said Evelyn Cohen, $15,000-a-year recreation director at Starrett City in New York. "Especially for senior citizens, it's literally like dying and being reborn again. You have to understand."

Customer relations managers, or anyone in a position where they will be dealing with those outside the housing complex, especially the media, will usually be required to possess public relations, journalism, or consumer affairs experience. They are important jobs in days of a high inventory of unsold homes. Only the very savvy need apply.

The Shopping Center Manager

At first we loved them, now we are taking a second look. Are they now perhaps a blight on the already cluttered suburban landscape—that tightly strung row of shops and services surrounded by acres of asphalt parking spaces? The shopping center is everywhere from Petaluma to Perth Amboy and has even, with peculiar irony, moved into the city where large vacant properties are now chopped up and rented under the banner of "mini-mall." The International Council of Shopping Centers estimates there are some 16,000 shopping centers around the country.

And a busy operation it is to run one. The manager, working for a property management firm or directly for the owner of the center, must principally see that all the stores are rented. At all times. A vacancy, especially in one or two larger "prime tenant" stores, can spell disaster for the entire lot. Security services must be provided. There must be cleaning crews. Special activities or sale days must be organized and promoted.

Ilene Pearl is digging into her new duties. She manages the Village Square Shopping Center in Hazelwood, Missouri, a suburb of St. Louis. It is typical of the genre—there is a junior department store (the prime tenant), plus a supermarket, bank, savings & loan association, Dairy Queen, and forty other shops and services. There are 250,000 square feet of space to keep rented and its tenants to keep satisfied.

Ms. Pearl is employed by Hardesty-Johnson Realty and Development Co. She has no real estate license—in fact her background is in promotion and advertising, very useful in running a successful shopping center. Obviously Jerry Hardesty,

her supervisor, thought so too. Previously, she had been medical and professional campaign division director for the United Way of St. Louis.

On the job less than a year, she is still finding her way around property management. The big challenge at the moment is to find a tenant for the vacant S. S. Kresge store in the center. Many shopping centers around the country are finding themselves in a similar quandary now that the bankrupt W. T. Grant Co. has closed 711 stores, many of them in shopping centers. Ms. Pearl and Mr. Hardesty traveled to comparable centers in other cities and have now arrived at a plan to subdivide the Kresge space into small concessions.

With her knowledge of promotion in mind, she is also trying "to get the merchants who've been here fourteen years to understand that the world is changing and that the thrust of advertising must change. We've an unusual advertising image. We deal direct to the public through mailers. I'm trying to prove to them that electronic media advertising will bring them greater profits.

"It's a busy job. The phones ring all day. I'm running back and forth across the complex to fix something or let someone in who's locked out. The other day we had a bomb scare and *that* was something."

Since the center opened in 1962 there have been male managers until her immediate predecessor, a friend who recommended Ms. Pearl for the job. Which brings up the old bugaboo. Was Ms. Pearl receiving the same salary as the men, allowing for the rise in wages over the years? There were a few moments of silence.

"No, I'm not," she replied firmly. "I know that's not right, but I've only been here six months and after another six months I'll go in to talk about it.

"You know, there was something else and I haven't forgotten it. When my boss was interviewing me he said he was thrilled there were a lot of sharp women in the world today. Then he said if a man had walked in and asked for the same job at the same salary he would have thought there was something wrong with him. I guess he meant for what I'm getting

a guy would have to be nuts to take the job. I've thought about that comment a lot. But I figure I didn't have the experience and I *would* be making more money than I did at United Way. My boss is truly chauvinistic, but he has opened doors for me and has put me totally on my own. From this job I can go anywhere."

Who Qualifies?

That depends. Some managers must hold real estate licenses, in other instances employers require only previous property management or, as in Ms. Pearl's employment, publicity experience. The pay range is wide, depending on the size of the center, the wealth of the developer, the region of the country. Generally, the manager of an average size property can expect to earn about $1,000 a month; the larger centers will pay $20-$25,000 a year.

Sue Robbins manages a large 700,000-square-foot project in northern California. She came to the Fremont Hub Shopping Center in 1968 as a temporary secretary. The woman she was filling in for had twins and decided to stay home, so Ms. Robbins stayed with the job, eventually becoming assistant manager of the center. When her male superior was promoted to district manager, the Hapsmith Co. offered her the position of manager. She accepted with alacrity. Her duties are "not too much different than they were as assistant, but I don't have Frank to lean on now." She is learning which type of asphalt should be put down on the parking lot, which type of roofing material to order, and other newly germane matters. Her responsibilities are similar to Ilene Pearl's with the exception of advertising and promotion. There is a woman in the office who handles publicity.

Something else about her job is similar to Ilene Pearl's. The pay. Is she receiving the same salary her recently departed predecessor started with?

"No, I'm not being paid as much as he was," she replied. "I'm not much of a women's libber, but as far as salary goes I think I deserve the same pay. I've stated my feelings to the president of Hapsmith but that's as far as it's gone. He said he

really hadn't given it much thought, isn't that something? "But I only took over the management of the center six months ago, so I'm hopeful my position will be reviewed at the end of a year. And I'm going for my CPM certificate in the next few weeks. Once I have that I feel I'll have more leverage. Actually, I'm perfectly happy with the salary itself, it's the inequity of the whole thing that bothers me."

Ms. Robbins also conceded that her own secretary could take over most of the managerial responsibilities. But these days shopping center managers do not come up through the secretarial ranks. Although Ms. Robbins' secretary might be given a crack at the top slot one day, it is a tedious wait. A woman with property management or publicity experience would still beat her to the job.

The Condominium/Cooperative Manager

Over the last decade, two styles of apartment ownership have had a brushfire effect on the American housing picture: the cooperative and the condominium. Both have been around a while—condominiums go back to ancient Rome—but they experienced a resurgence in an economy where the rise in the cost of a single-family house (both to the builder and to the home buyer) has made only the condo and co-op affordable to a large number of househunters.

A condominium purchaser owns his apartment outright, the same as a single-family homebuyer. He also owns an undivided interest in the common areas of the project. The townhouse development frequently operates in the same fashion. In both, unit owners join a homeowners' association, which makes all purchasing, maintenance, and other decisions about the operation of the project.

In a cooperative, the buyer purchases shares of stock in the cooperative corporation and is then issued a proprietary lease that allows him to live in his apartment. He does not own his apartment outright and is tied to the corporation, which is governed by a board of directors comprised of a number of his fellow residents.

Both systems mean ownership. There is no landlord, so re-

pairs to the building, payment of taxes, handling of staff and payroll, and myriad other details attached to running a multi-family dwelling fall to the unit owners, specifically the board of directors. Many of them know little about real estate projects and would just as soon not bother with their day-to-day workings. They turn it all over to the professional management firm some of which manage condos and co-ops exclusively. Even then they are not always happy.

"This is a shakedown period for condominiums, they're still so new," said Mary Ann Wands, an Illinois property manager. "While some complexes are running smoothly, in others there is constant friction among the unit owners, builder, board of directors, and managing agent.

"A lot of the time you're a mini-U.N. Parking space allotments—that's a sensitive area where quarrels can erupt. Since the agent is the only outsider and they're looking for a third party to mediate. . . . Garbage is another problem. So are dogs. I've had to write dozens of letters to unit owners about their problem dogs.

"What it boils down to is that a lot of people do not know what condominium or townhouse living entails. It is more than apartment living, but it still does not carry the independence of having a single-family home. Actually, it's all an evolutionary process, for the owner and for the management firm."

Ms. Wands is vice-president of Manageers, Inc., a property management firm in Hinsdale dealing exclusively with condominiums and townhouses.

Managing agents in a firm of any size are given two or three properties to oversee. They visit the complexes periodically to check roofing, lawn care, lighting—there is a set checklist. In the winter they are concerned with snow removal; in summer it's the maintenance of the swimming pool. In condominiums a regular check is made of hallways and the boiler room. The agents bump into homeowners on their tours, chat with them, and, hopefully, spread a little goodwill. Back at the office, it's paperwork—paying bills, doing tax work—and phone calls to repair people, fuel companies, and other suppliers. The man-

ager also attends meetings of the board of directors, which are usually held in the evening. He or she also sets up committees within the board and, frankly, does some arbitrating from time to time, as Ms. Wands pointed out.

For the service, the condominium or townhouse home-owners' association is charged usually a per-unit per-month price ranging from, say, $4.50 to $8 to $12. Some management firms provide a financial package for smaller developments that does not include a visiting agent, just paperwork services.

As stated before, condominiums are new and problems are still being worked out. One is the frequently low monthly maintenance charge the unit owner pays that covers his share of heat, light, repairs, etc., for the complex. Developers sometimes "low-balled" those figures initially to attract buyers. Now, two or three years later, owners are finding the costs skyrocketing, sometimes double the original estimate. They are angry, a wrath the management firm must deal with. When they get the chance. In an effort to streamline those rising charges the board of directors first begins hacking away at expenses. They frequently fire the management firm and undertake the running of the project themselves to save money. So while there is a need for good management, the agent or management firm bears in mind that in a bad economy the development may just give its professional managers the axe.

Ms. Wands, who herself lives in a condominium, adds: "Unfortunately in the early days some condo management firms were basically rental agencies and didn't know what in the world they were doing. They tried to develop along with the concept and unfortunately some serious errors were made, so now the management industry sometimes has a bad reputation and the condominium owners think they can do without management. If you have an apartment building or an office building the landlord is aware that he needs management, but then management has always been competent in those areas.

"Women are welcome in condominium management," she continues, although "some men wonder at first how she can know about lawn care or realize that the boiler isn't working properly."

Who Qualifies?

A real estate license is usually not required for condo/town-house/cooperative management, although most positions are filled by persons with some knowledge of this specialized housing area. Mary Ann Wands will hire only those agents with previous management experience. Her present three-man, one-woman staff have all been apartment managers. But Alfred Perlman, vice-president of Arthur Rubloff & Co. in Chicago, hired a young student as a janitor in a local condominium project. After graduation the newly qualified psychologist found himself over-educated for the existing job market.

"He came to me for a position as manager of condominiums," Mr. Perlman recalled. Remembering "how beautifully he got along with those people, sitting down with them to discuss their problems even though he was only a janitor," Mr. Perlman put him to work. He is now managing a 1,000-unit condominium and, according to his employer, "doing a fine job."

The Building Superintendent/Janitor

Which brings us to the crusty building superintendent ("super") or janitor, that cellar-dweller who is often the only contact the tenant in a small building has with his landlord.

The superintendent sweeps and mops the halls and laundry room, hoses down the sidewalk, mows grass and clips hedges. He or she does simple repairs around the building and takes packages for absent tenants. A janitor is notoriously close-mouthed to outsiders about all he sees, unlike those gabby souls interviewed by television detectives.

For satisfactorily carrying out the above count of chores, he or she is given a rent-free apartment and a small salary. And abuse, too, such as when the rent goes up and the hot water goes off.

As women increasingly enter occupations formerly off limits, they are discovering the advantages of maintaining the small apartment complex. Many are married women, with the supplement of a spouse's income. Some are students, used to living frugally.

Look for a job by calling your local apartment association or reading the classified advertisements. There are no requirements, although in some sections of the country you may be required to join a building service employees union. Pay runs from a very low $50 a month to over $100 a week, but many men and women add to that by doing odd jobs, such as installing shelving for tenants at extra charge. Janitoring is usually a part-time job, so there is free time to use as one will.

In some sections of the country would-be supers must go to school to receive a certificate for air pollution, boiler maintenance, standpipe, and oil burner permits. Some must enroll in air-conditioning refrigeration classes.

Naturally there are janitors who are counting the days until they can toss the broom aside. But, interestingly, many people love the job. It is independent work with no one standing over one's shoulder. The hours are usually flexible and no two days are exactly alike. It attracts free spirits.

Dorothy Speicher, a middle-aged woman who runs a garden complex in the Bronx, had a feisty answer when a New York *News* reporter asked her whether being a woman made any difference in the way she felt about the status of her job.

"Status," she replied with a chuckle. "When I mean 'spit' I don't like to say 'saliva.' So when I meet someone for the first time I tell them I'm a janitor and they gasp. What matters to me is that I like my job. They tried making janitors high-toned by calling them 'superintendents.' It didn't go. Everyone cut it down to 'super' and a super is just a janitor. My apartment is still down here and I move garbage, no matter what you call me. But I see a lot of things from the bottom up."

Professional Organizations and Other Career Guidance Sources

International Council of Shopping Centers
445 Park Ave.
New York, New York 10022
(212) 421-8181

ICSC is the trade association of the shopping center industry,

with 5,000 members in twenty-eight countries. Their brochure, "Basic Library of Publications for the Shopping Center Professional," is available at no charge. Publications offered include "Shopping Center Management: Principles and Practices" ($32 to nonmembers); "Shopping Center Promotions: A Handbook for Promotion Directors" ($35 to nonmembers).

> Institute of Real Estate Management
> of the National Association of Realtors
> 155 East Superior Street
> Chicago, Illinois 60611
> (312) 440-8630

Besides offering the Certified Property Manager (CPM) designation through courses around the country, the Institute also provides specialized courses, books, and periodicals to those interested in property management. Write for their free brochure. Books include "The Resident Manager" ($8.50); "The Property Manager's Guide to Forms and Letters" ($10.50); and "Principles of Real Estate Management," ($13.50), the standard text used in colleges and universities.

> National Center for Housing Management
> 1133 Fifteenth St. N. W.
> Washington, D. C. 20005
> (202) 872-1717

Established by Presidential Executive Order in 1972 to aid industry and government in professionalizing housing management, this nonprofit office works to improve management standards in both the private and public sector. They offer training programs and are working on a professional designation. Printed material available at no charge.

Glossary of Real Estate, Housing, and Planning Terms

Abandoned building—a structure, usually a multifamily dwelling, that has been given up by a landlord who considers his investment lost and has no intention of reclaiming the building.

Abstract of title—a summary of the history of the legal title to a piece of property.

Acceleration clause—requirement that the entire balance owed on a loan be paid when a payment is overdue.

Affirmative action program—local public housing authority procedure to comply with court rulings that low-rent housing be erected in outlying areas rather than the usual inner city. The objective is racial and economic integration.

Air rights—the title, vested in the owner of a parcel of land, to the use of the air space above the land. Frequently granted for the space above railroad tracks, highways, reservoirs, etc. Probably the most notable use of air rights is Madison Square Garden in New York City, which is constructed over Pennsylvania Railroad Station.

Amenity—feature of a property that makes it more attractive, especially to the buyer or renter—a swimming pool, proximity to schools, shopping.

Amortization—periodic repayment of the principal of a loan. A mortgage is being amortized when it is being paid off in installments. Unlike interest, amortization is not tax-deductible; it is merely the periodic repayment of a debt.

Ancillary income—monies coming into an apartment or commercial project from sources other than rent. Coin laundries, for example.

Apartment—a room, or a number of rooms, within a building rented or leased to a tenant. When referring to a multifamily dwelling, the term is apartment *house* or apartment *building.*

Apartment, garden—a unit with the entrance on the ground floor and the use of a back or front yard or terrace. Can also refer to a two-story development, usually in a suburban setting.

Apartment, railroad—indigenous to older buildings, these units are laid out so that one room follows another, railroad-car style.

Appraisal—the estimate of the value of real property that represents its most likely sale price or "market value." An appraisal is usually done professionally and is a formal, written evaluation, frequently quite detailed and based on a number of criteria, but always a matter of opinion, not fact.

Appreciation—an increase in value for any number of reasons, usually due to economic causes such as inflation.

Apprenticeship—the practice of learning a trade through association with a qualified skilled worker, most notably in use in printing and building trades. The apprentice is almost always salaried while learning.

Appurtenances—whatever is annexed to land or used with it that will pass with the conveyance of title; e.g., a garage, a gatehouse.

Arcade—an enclosed passageway along both sides of which are situated small stores or offices—a mini-shopping center.

Assemblage—the acquisition of land, or a group of buildings, usually contiguous, into a single development tract.

Assessed valuation—value placed on land and buildings by a government agency for tax purposes, usually a percentage of market value.

Assessment—tax levied on property by a taxing authority to pay for some new local improvement.

Assignment—transfer of one's title, contract, lease, etc., to another party.

"Balloon" mortgage—a long-term loan that is to be paid off in a lump sum at the end of a specified term, as opposed to a self-amortizing loan.

Binder—an advance agreement to purchase property, usually involving a deposit of money representing some or all of the down payment.

Blockbusting—an illegal practice of unscrupulous dealers in real property who seek to create panic in an area by playing on prejudices and misconceptions. Residents of a neighborhood are led to believe minority groups will move in and therefore depress property values. The owners then are frightened into selling their homes at below market value. The dealers snatch them up and sell them to minority groups, usually at inflated prices. (However, there is a fine line between blockbusting and a sincere effort to integrate a neighborhood.)

Brownstone—literally, a reddish-brown sandstone three- or four-story dwelling, but nowadays a generic term that describes any row house at least fifty years old, constructed of stone and having some architectural significance. Brownstone renovation is taking place in many inner-city neighborhoods. Frequently, those properties are now among the most expensive houses in town.

Buffer zone—an area that separates two or more types of land use from each other.

Builder, developer—terms used interchangeably to define one whose occupation is to erect buildings. The latter term is somewhat more popular these days since it suggests a large-scale operation (not necessarily true).

Builder's warranty—a written statement by a builder assuring that a building or other type of construction actually was completed in conformity with a stipulated set of plans and specifications. Purpose is to protect the purchaser from latent defects; the warranty usually has a one-year limit.

Building code—state or locally adopted regulation, enforceable by police powers, that controls the design, construction, repair, quality of building materials, use and occupancy of any building or structure under its jurisdiction.

Carrying charges—expenditure necessary to retain possession of a property. Includes cost of maintenance, taxes, and mortgage debt.

Certificate of occupancy—official authorization to occupy premises. It states that the use and conditions of a new or existing building undergoing alteration are consistent with the zoning ordinance of the locality.

Certificate of title—given to condominium unit owner to signify ownership of unit. Contains a description of the unit and its relationship to the condominium as a whole. In another context the term can be a document stating that the title to a property is clear of defects (not the same as title insurance).

Chattels—articles of personal property such as household goods, furnishings, and fixtures.

City, linear—a concept envisioning commercial, retail, and service facilities strung out in a narrow belt along or over a main traffic route. The residential areas would run on either side of that strip and facilities would be duplicated along the strip wherever the need dictates.

City manager plan—plan of municipal government wherein an administrative officer (called a "city manager") is appointed

by an elected council to manage the city's business, while policy-making remains with the mayor and council.

City planning, urban planning—shaping of the development, growth (or no-growth), and changes in an urban area to create a blend of the various aspects of city life—social, political, economic, educational, cultural, health. A constantly evolving process.

Closing costs—one-time charges paid at the closing day of a property transference, usually by the buyer. Can include charges for title insurance, title search, attorney's fees, property survey, mortgage service charge.

Commission—money paid to a real estate agent, usually by the seller, as compensation for finding a buyer. A percentage of the sale price, the broker's fee varies from one type of property to another.

Common area—in condominiums refers to the part of the complex that is not specifically held by unit owners— hallways, lobby, recreation areas, etc. "Common areas" hold the same meaning for the tenant in an apartment complex.

Common or undivided interest—joint ownership with other condominium unit owners of all land areas within the complex not defined as individually owned units. The resident owns a percentage of the total area, but it is not actually divided into individual parts.

Condominium—an apartment complex where the buyer owns his or her unit outright, much in the manner of the single-family homeowner, plus an undivided interest in the common areas of the development. Condominium purchasers secure their own mortgages on their units.

Cooperative—system of apartment living in which the buyer purchases shares in a corporation, which owns the building and holds the mortgage on it. Buyers do not own their apartments outright as they would in a condominium, but become tentant-shareholders with shares of stock in the corporation and a "proprietary lease" giving them the right to their unit.

Deed—the legal document that conveys title to real property.

Default—failure to meet certain contractural obligations, such as mortgage payment. Default can lead to foreclosure.

Density—number of dwellings and commercial units per acre of land. Can also refer to people; i.e., ten people per acre.

Department of Housing and Urban Development (HUD)—federal department organized in 1965 to provide for sound development of urban areas. Frequently mentioned HUD programs are:

> Section 8: leased-housing program for low-income families. Government subsidizes rental payments to owners. Projects can be developed by public housing agencies, state finance authorities, or private builders.
>
> Section 203(b): program for mortgage insurance for one- to four-family homes.
>
> Section 207: mortgage insurance program for rental housing of eight or more units.
>
> Section 213: mortgage insurance program for cooperative projects of five or more units.
>
> Section 221(d)(2): helps people displaced by government action or natural disaster and other moderate-income families purchase homes on terms they can afford.
>
> Section 221(d)(3): mortgage insurance for moderate-income multifamily projects.
>
> Section 221(d)(4): rental program for moderate-income families in which a forty-year mortgage is government-insured but not subsidized.
>
> Section 231: mortgage insurance for rental housing for the elderly or handicapped.
>
> Section 232: mortgage insurance for nursing homes for twenty or more patients.
>
> Section 234: mortgage insurance for condominiums.

Section 235: program to enable low-income families to buy a home or cooperative apartment.

Section 236: rental and cooperative housing for low-income families.

Depreciation—gradual loss in the value of buildings and fixtures (but not land) over a period of time, excluding accidents or other incidents. An allowance for depreciation is permitted by income tax law to be charged against the owner of an income property's net receipts, thus reducing his taxable income.

Discount points—see "Points."

Dwelling, multiple—building composed of three or more units, usually having common access. Often used interchangeably with "apartment building," although a multiple dwelling can also be a divided single-family home.

Easement rights—right of use of land owned by another, such as a common driveway, access road, etc. Water, sewer, and electric companies frequently have easement rights across property.

Ecology—the study of the interrelationships among living organisms and their environments. A branch of the biological sciences, ecology is concerned with the way plant and animal species adapt to one another and to the total environment ("ecosystem").

Eminent domain—the right by which a government may acquire private property for public use without the consent of the owner, but upon payment of reasonable compensation.

"Empty nesters"—term given older couples whose children are grown and no longer living at home.

Environmental impact statement—an evaluation of the nature and extent of an anticipated change to the ecosystem. Included in the statement: benefits to be derived from the change, effects that cannot be avoided, alternatives to the proposed change, short- and long-term effects.

Equalized assessed valuation—value placed on real property

for tax purposes by a local government, as corrected to approximate market price.

Equity—the value of property minus any outstanding mortgages or other debts. Equity increases with each mortgage payment a buyer makes.

Equity, sweat—the interest one acquires in property by contributing labor or services instead of money. Used frequently in renovating small apartment buildings, for example, where tenants do much of the work themselves. Sweat equity is allowed by law under certain federal housing programs, where sometimes the required down payment can be made either in money or in equivalent labor.

Escrow funds—money or papers held by a third party until the conditions of a contract are fulfilled. Apartment dwellers sometimes put rent payments "in escrow" until disputes with the landlord—a "rent strike"—are settled.

Exclusionary zoning—the abuse of zoning to exclude low-income and minority groups from desirable residential areas. Many court cases against suburban communities are coming up these days charging that zoning laws are creating economic and racial segregation.

Exclusive agent—one real estate broker given the right to sell a property within a specified period of time.

Exclusive listing—again, one broker with the right to sell a property, but if the seller makes the sale himself, he need not pay the broker's commission unless the broker has an "exclusive right to sell" listing.

Federal Housing Administration (FHA)—an agency of the Department of Housing and Urban Development (HUD) that insures mortgage loans, sets minimum standards for those homes and administers other housing-related programs at the federal level.

Federal National Mortgage Association—popularly known as "Fannie Mae." A private corporation under federal charter that purchases and sells residential mortgages insured by the

FHA or guaranteed by the Veterans Administration, as well as conventional home mortgages.

Fiscal year—a twelve-month period set up for accounting purposes. The federal government's fiscal year runs from July 1st to June 30th.

Foreclosure—a procedure instigated by a lender to deprive a person of the right to redeem a mortgage when regular payments have not been kept up.

Galleria—explosive interior space with glass or roof topping. Almost invariably has some form of balcony(ies).

Government National Mortgage Association—referred to as "Ginnie Mae," this federal agency within HUD provides a secondary market for certain housing mortgages under FHA and VA programs. It also provides a federal guarantee on securities backed by pools of mortgages.

Green belt—a wide band of countryside surrounding a city. Building is generally barred from the area.

Groupers—a number of persons, usually single and unrelated, who join together to rent a house or apartment. Particularly found in resort towns, many of which have established ordinances against unrelated people sharing a house.

High-rise—a building with enough stories to require elevator service. Usually five or more floors, but opinions differ. Some say eight floors. Local fire departments have their own definitions of high-rise buildings.

Holdout—property owner who refuses to sell, thus preventing the assemblage of a site from being completed.

Housing authority—a public body empowered to provide and manage housing, especially for low-income groups. Housing authorities clear slums, issue bonds, and in general carry out the public housing program of a city. All depend on federal subsidies, though a few also operate with state or municipal funds.

Housing code—local regulations setting forth minimum con-

ditions under which dwellings are considered fit for human habitation. Guards against unsanitary or unsafe conditions and overcrowding.

Housing, public—term used to denote housing for low-income families built and owned by a public agency, frequently the local housing authority.

Incentive zoning—in return for a greater gain, usually in the form of additional permitted bulk, a builder agrees to provide specified amenities for the community.

Industrial park—an area ranging from a few hundred to several thousand acres zoned for industrial uses, usually with common services for tenants. Many are low buildings in suburban or exurban park-like settings.

Impact zoning—the assessment—economic, ecological, and population-wise—of the development potential of an area *before* development or construction.

Industrialized housing—dwellings that are assembled from large components in a factory.

Infrastructure—the basic equipment, utilities, installations, and services necessary for running a city. Includes roads, railways, utilities, and, on the larger scale, the country's military installations.

"In rem" foreclosure—legal action to take property ownership from a person who has not paid taxes for a specified period of time. The city or local taxing authority then becomes owner of the property and frequently disposes of it by auction.

Joint tenants—persons sharing ownership of a property in such a way that in the event of the death of one party the property reverts to the surviving tenant(s).

Journeyman—worker who has finished learning his or her trade in an apprenticeship program.

Key money—a cash payment made to secure a dwelling unit. Key money is sometimes asked by brokers in apartment-scarce

areas, sometimes by tenants leaving behind furnishings or extensive renovations. So far, no law against it.

Key tenant—prestigious renter in a commercial shopping center or office building whose presence, it is hoped, will bring in other tenants.

Land, raw—land available for building, but lacking utilities or improvements.

Land, underemployed—good land that is not being utilized for its best purpose—small stores in the commercial center of town, for example, that could be replaced by a multistory office building.

Land use plan—official formulation by a community of how it will use its land in future years, for residential, commercial, industrial, institutional purposes.

Lease-back—a transaction in which an owner sells a property, then leases it back from the buyer.

Lien—a claim recorded against a property as security for payment of a debt. If the lien is not removed, or the debt is not cancelled, the property may be sold to satisfy the lien.

Light industry—businesses that require less land than heavy industry and those with little noise, truck traffic, etc.

Managing agent—person or firm managing property for an owner. The agent operates the building, makes repairs, rents units, and collects rent, charging a commission on rents to the owner.

Master plan—a comprehensive, long-range guide to the physical development of a municipality, providing for its improvements, future growth, housing, business, industry, transportation, recreation, health, and welfare. Usually a large document, a plan contains maps, drawings, charts, etc. It is never followed by the community down to the letter—too many changes occur over the years.

Mayor-council plan—a form of city government in which the legislative and executive functions are separate, with both in

the hands of elected officials. For another type of management, see **City manager plan.**

Megalopolis—the larger urban area that has resulted from the melding of separate cities, giving the appearance of one continuous string of cities. The Northeast Corridor, extending from Boston, Massachusetts, to Washington, D. C., is one example.

Mobile home—a manufactured house equipped with all amenities (and sometimes furnished) that can be moved by attaching it to a truck or automobile. Few mobile homes are moved from their original site, however, principally because of their size these days—frequently as wide as twenty-five feet. Less expensive models start at around $5,500; deluxe homes can go as high as $50,000 and over. Not to be confused with "camper" or "recreation vehicle." And the word "trailer" is definitely out of style.

Model Cities—a five-year federal program that provided funds to improve physical, social, and economic conditions in the nation's inner-city neighborhoods. Recently phased out and supplanted by provisions of the 1974 Housing and Community Development Act.

Mortgage—a contract under the terms of which legal title of property belonging to one party is conveyed conditionally to another person as security for the payment of a debt.

Mortgage, conventional—a mortgage loan not guaranteed by the FHA or the VA, thus with no restriction on the rate of interest.

Mortgagee—the lender (bank or other savings institution) to whom the property is mortgaged.

Mortgage, open-end—debt with a provision that permits borrowing additional money in the future without refinancing a loan or paying additional financing charges.

Mortgage, purchase-money—loan given by the seller to the buyer at the time the property is acquired to help finance the

purchase. Frequently, single-family home and condominium developers offer such mortgages to attract buyers.

Mortgage, second—a lien on property beyond an original mortgage. Since it offers the lender less security than a first mortgage, it usually calls for a higher interest rate and a shorter repayment period.

Mortgagor—the borrower under a mortgage.

Municipal bonds—tax-exempt bonds issued by cities, towns, housing authorities, port authorities, and other political subdivisions responsible for providing and maintaining schools, hospitals, housing, and highways.

Multiple listing—real estate brokers sharing certain properties up for sale. The commissions for selling them are split between the listing broker and the one who actually sells the property.

New town—a new community built on previously undeveloped land that provides homes and commercial and industrial facilities. Not to be confused with Planned-Unit Developments, which provide only residential communities, new towns are self-governing, and supply jobs.

Nuclear family—husband, wife, and children. This is the immediate family as opposed to the "extended family," which consists of grandparents, aunts, uncles, and other relatives.

Off-site improvements—those construction activities taking place away from the building site, such as installation of sidewalks and sewers that will ultimately be used by those in the building under construction.

Option—the exclusive right to purchase or lease a property at a stipulated price or rent within a specified period of time.

Park, vest-pocket—a playground or resting place built on a small parcel of vacant land, usually in a city. Sometimes maintained by the municipality, sometimes held in private ownership for the exclusive use of the surrounding residents.

"Pipeline"—expression used to refer to funds, usually coming from the federal government, that are at some point in the application process: "The money's in the pipeline."

Planned Unit Development (PUD)—a residential complex of mixed housing types. Offers greater design flexibilities than traditional developments, which frequently brings economic advantages. PUDs permit clustering of houses, sometimes forbidden under standard zoning, utilization of open space, and a project harmonious with the natural topography.

Points—one-time charges that the lender charges the borrower for making the loan. The buyer and/or the seller pay points to entice a lender to make a loan that might not otherwise be granted due to economic conditions, location of the property, etc. One point is one percent of the amount of the mortgage loan. The federal government forbids points on FHA-VA-insured loans.

Public domain—land owned by the government.

Public hearing—a meeting open to everyone that is required by law before land may be acquired for a project that requires public funding. Provides an opportunity for citizens and community organizations to present their views on the proposal.

Real Estate Investment Trust (REIT)—an unincorporated business trust or association that owns real property or mortgages, but does not manage them directly.

Red-lining—alleged practice of some lending institutions involving the refusal to make loans or to issue insurance policies on properties in areas they deem to be bad risks.

Rendering—a drawing showing how a proposed construction project will look when completed.

Rent control—regulation by a government agency of rental charges. "Rent leveling" is another form of rent control, with increases based on a rise in the Consumer Price Index. Usually enforced in areas with vacancy rates of under five percent. Annual increases under rent controls are usually set by another formula, but the vacancy rate there too is tight.

Resident manager—person in an apartment complex or building who is responsible for renting apartments and managing the project. Despite the word "resident," he or she does not, according to specific management policies, have to live in the project.

Revenue sharing—federal financial assistance to state and local governments, based on the allocation of a portion of the receipts of the federal government.

Riparian rights—the right of a property owner whose land abuts a body of water to swim in the water, build wharves, fish, etc.

Rent supplement program—a federal practice by which payments are made to owners of authorized multifamily rental housing projects to supplement the rents that the eligible low-income families can afford to pay.

Scatter-site housing—multifamily dwellings dispersed in small numbers throughout a middle-income community by a local housing authority to achieve economic and/or racial integration.

Security deposit—sum of money, usually one month's rent, paid at the start of a lease by the tenant to the landlord. The money protects the landlord in the event of damages to the apartment by the tenant or delinquent rent payments. At the satisfactory expiration of lease or other agreement, security money is returned to the tenant.

Seed money—initial capital required to start a business or other operation, or to develop preliminary plans and feasibility studies.

Semidetached house—one structure containing two dwelling units separated vertically by a wall.

Settlement costs—all-inclusive costs paid by both buyer and seller in the transfer of property. Different from closing costs, settlement charges include insurance and tax transfer payments, special assessments, broker's commission.

Split-level house—one designed with the two levels less than a full story apart.

Square-foot cost—used in commercial leasing. The figure is arrived at by dividing total building cost by the total number of square feet. Size of buildings or of leases is determined not by floors occupied but by total number of square feet.

Squatter—one who occupies another's property illegally.

Statutory tenant—one whose lease has expired but who is still protected by its provisions.

Sublease—a lease between the lessor and a third party.

Superblock—a very large block, usually in an inner-city area, that has been formed by combining or consolidating several smaller blocks, and in the process upgrading them.

Survey—an exact determination by a surveyor of just where an owner's property starts and ends.

Time-sharing ownership—plan whereby a condominium shopper can purchase a percentage of a finished unit, based on the time period he wants to live in it—one or two weeks a year or longer. Usually in effect in resort areas.

Title—evidence, usually in the form of a deed, that a person is the legal owner of the property.

Title insurance—a contract to make good a property's loss that could be incurred from defects in a title.

Title search—detailed investigation to assure that any property is bought from the legal owner and that there are no liens or special assessments against it. Lenders frequently require both title search and insurance.

Townhouse—a two- or three-story city rowhouse of some architectural merit, or an apartment complex operating under the condominium form of ownership.

Turnkey—housing initially financed and built by private sponsorship, but then purchased by local housing authorities

for low-income families. (The original builder "turns the key" and walks away). There are several programs under the "turn-key" umbrella.

Urban escape hatch—the entertainment section of a city, where one can find theatres, restaurants, and other amusements. Fisherman's Wharf as a section of San Francisco is one, so is all of Las Vegas.

Urban renewal—the renovation or restoration of a section of a city—demolishing slums, rehabilitating housing, building up the commercial center, providing more and better amenities.

Vacancy rate—ratio between the number of vacant apartment units and the total number of units, either in a specific building or complex or in an entire city. When the vacancy rate falls below three to five percent, there is usually considered to be a housing crisis. The figure is difficult to determine, however, because some units are considered no longer habitable and vacancies checked with utilities and telephone companies fluctuate.

Variance—a specially granted departure from prescribed zoning requirements.

Veterans Administration (VA)—operates a loan guarantee program (GI loans). Honorably discharged veterans can obtain low-down-payment loans at controlled interest rates.

Zoning—procedure that classifies real property for a number of different uses—residential, commercial, etc., in accordance with a land-use plan. Ordinances are enforced by a governing body or locality.

There are excellent glossaries on the market containing housands of real-estate, housing, and planning terms of nore specific interest. They are:

"The Language of Cities," by Charles Abrams. Viking Press, © 1971, 353 pp., $10.00. Beautifully written glossary of terms by a former planner of-

fered with wit and wisdom. Detailed, too. Some definitions run to four pages. Can you define Lex Adickes? What's a trystorium? (Just what you think.)

"Dictionary of Development Terminology," by J. Robert Dumouchel. McGraw-Hill, © 1975, 278 pp., $9.95. The technical language of builders, lenders, architects and planners, investors, real estate brokers and attorneys, appraisers, land-taxing and zoning authorities, government officials, community organizers, housing managers, urban renewal specialists. Some 2,300 terms in all.

"Mortgage Banking Terms—A Working Glossary," published by the Mortgage Bankers Association of America. Over 750 definitions in the area of real estate finance. Single copies are $5 from the Department of Education and Training, Mortgage Bankers Association, 1125 15th St., N.W., Washington, D.C. 20005.

"Real Estate Appraisal Terminology," edited by Dr. Byrl N. Boyce, as a joint effort of the American Institute of Real Estate Appraisers and the Society of Real Estate Appraisers. 300 pp. Cost is $12.50 from the Ballinger Publishing Co., 11511 Roosevelt Blvd., Philadelphia, Pennsylvania 19154.

"Illustrated Encyclopedic Dictionary of Building and Construction Terms," by Hugh Brooks. 366 pp., $24.95. Over 2,400 terms, separated into subject areas. Contains frequently used formulas, charts, and tables; many definitions are given "mini-text" treatment that provides a condensed overview of the subject.

Index